ARTWORKS AND PACKAGES

ARTWORKS AND PACKAGES

HAROLD ROSENBERG

The University of Chicago Press
Chicago and London

The quotation from "Anecdote of the Jar" is taken from *The Collected Poems of Wallace Stevens* with the permission to publish by Alfred A. Knopf, Inc., © 1954 by Wallace Stevens.

The University of Chicago Press, Chicago 60637
The University of Chicago Press, Ltd., London

89 88 87 86 85 84 83 82 1 2 3 4 5

Library of Congress Cataloging in Publication Data

Rosenberg, Harold.
 Artworks and packages.

 Reprint. Originally published: New York: Horizon Press, 1969.
 Includes index.
 1. Art, Modern—20th century. 2. Art—Technique.
I. Title.
N6490.R592 1982 709'.04 82-13406
ISBN 0-226-72683-5

Dedicated to Tom Hess

CONTENTS

INDEX TO ILLUSTRATIONS

Note: The two photographs of the Albright-Knox Art Gallery on page 183 include works by Anuskiewicz, Herbin, Ellsworth Kelly, Kuwayama, Leon Polk Smith, Smithson, Sophie Taeuber-Arp, Vantongerloo, and Vasarely.

ARTWORKS AND PACKAGES

One of the achievements of Pop Art—perhaps its major intellectual achievement—was to cross the line that for a hundred years had seemed to separate the fine arts from the so-called media, that is, the art forms of popular entertainment, information and propaganda, including advertising.

I say "seemed to separate" because the division between the arts and the media has never been very firm.

The high arts—literature, painting, concert music—have been the blood-bank of the commercial crafts, while the arts of the street, Rimbaud's "poetic junk," have constituted a flea-market out of which artists have fished innumerable novelties.

One thinks, too, of artists who have operated on the border between the opus and the commodity—Poe, for instance, with his detective stories and thrillers, Daumier with his caricatures, Toulouse-Lautrec with his posters. Today, we have Saul Steinberg, a borderline artist in the deepest sense, as popular as a comic strip and as esoteric as a treatise on semantics.

In our century, infiltration between the arts and media has been continuous. For more than fifty years there have been art movements devoted to the deliberate adulteration of traditional art forms, as by pasting newspaper photographs into paintings, working slogans and popular songs into poems, injecting film sequences into plays, composing serious imitations of Nick Carter or Horatio Alger. At present, this adulteration of forms is the most vanguard development. It is called mixed media and environmental art.

Pop Art carried the mixing process to a new stage. It executed what in military jargon is called a reconnaissance in force, which, if my understanding is correct, means that the position reached in enemy territory will, if possible, be held. Pop intended to stay popular. In fact, with Pop the traditional notion of the commercial and popular arts as the "enemy" no longer applies. The artist's old ruse of raiding street art for its effects and retreating with the loot to the picture gallery has given way to the idea of moving into the mass media as a friendly competitor or even collaborator. The Pop artist is eager to have a place—preferably, of course, a privileged one—in the entertainment business and the communications. Thus, in addition to painting and sculpting, he does not hesitate to devote himself to making movies, acting in plays or organizing public-relations events.

At any rate, through Pop—and through Op Art, too—the close tie between the arts and the media has been brought to the surface. Objects are being produced by both that have the same style, the same look—though their qualities and purposes are occasionally somewhat different.

Also, painting and sculpture increasingly partake of the identifying characteristics of the media, which are reproduction and mass distribution. Hogarth initiated the popular print business in the 18th century and voluminous castings of metal sculpture in the 19th century coincide roughly with the rise of the popular press. Today, as everyone is aware, reproductions of paintings in catalogues and magazines and on slides, play a larger role in art appreciation and art education than the painting themselves. The same is true of music reproduced on records and tapes. Enterprises keep springing up to expand painting and sculpture into such areas of reproduction as banners, coins, stamps, plastic reliefs.

None of this is in itself new. The difference between reproductions in the present and the past is largely a matter of volume—and in the active collaboration of the artist. Twenty years ago fabric shops were offering *La Grande Jatte* of Seurat by the yard and in all colors. Seurat, however, had not accepted print goods as a medium. Recently, however, a New York gallery showed an artist who had.

Today, every artist lives under the pressure—and enjoys the advantages—of changes wrought in the conditions of aesthetic culture, and in art itself, by the mass media. Quantity has been transformed into quality. Unquestionably, the rapid popularization of American abstract art owed much to the attention paid to it in mass-circulation news and fashion magazines, to radio and TV

interviews, to new, active museum programs and travelling art exhibitions, which are, of course, also organs of the mass-communications system. Through these media, the status of art and of the artist has been transformed and with it the conditions of creation. For instance, the prestige of Picasso as a celebrity among multitudes ignorant of painting would be impossible without the mass media.

The effect of the mass media upon art has been much deeper and more permanent than mere change of social status. Local, regional and even national limits have been dissolved by the simultaneous appearance of new art works and new art styles in countries throughout the world. Earlier international styles centered in a few capitals. Though influential elsewhere, each style carried the flavor of its site of origin, as in the art of the pre-war School of Paris. To grasp the essence of a new mode, artists and art appreciators had to transport themselves physically to the creative center and become sojourners there for an indefinite period of time. Obviously, this put a limit upon the rate of speed at which new art could be disseminated, and upon the depth at which it could be absorbed in other places.

Today's styles are, increasingly, global in both conception and transmission. They are picked up everywhere at the same instant—and are shot back and forth from continent to continent as items of the total communications package.

In a word, art has entered into the media *system.*

This does not mean that the situation of art has become more complicated or subtle. A global system is not necessarily more complex than the organization of a town. Indeed, in being more abstract the world-wide mechanism is likely to be simpler than a community that sprang into being out of concrete living conditions. In UN headquarters in New York, gentlemen from Zanzibar, Siberia and Brooklyn have the same tastes in martinis and ideas; and their national costumes—the fez, the burnoose, the homburg—seem to have come out of the same theatrical wardrobe. One of the new problems of art is the power of quantity to determine value in art as a medium. The number of times an artist is mentioned and his work reproduced or shown becomes the measure of his importance. Circulation is in itself a merit beyond discussion.

Given the similarities between works of art and the art products of the media, what is the distinguishing feature of art? What makes one work a work of art, another merely an object of entertainment or information designed for daily consumption? Apart from the difference in size, what is the

real difference between a comic-strip Mickey Mouse and a Mickey Mouse painted by Lichtenstein?

The answer is: art history.

The Lichtenstein was created with an eye to art history and to the ideas of art historians regarding twentieth-century developments in the aesthetics of drawing, composition, motif, color. The sum of it is that Lichtenstein had his eye on the *museum*, while the original comic-strip draftsman, at least as expert as Lichtenstein in traditional drawing and composition, worked as a member of a trade outside of art history, and was intent on amusing the kids and their parents and increasing the circulation of the papers that bought his product. The difference is in the two professions, each with its own past.

Today, what distinguishes art objectively from the crafts of the media is the art-historical destination of the former. The power of defining art is vested in art history, whose physical embodiment is the museum. Malraux conceived the museum as the ultimate destiny of art—and being admitted to the museum as the ultimate ambition of all modern artists. What is art goes into the museum; what goes into the museum is art. The soup label or the tire advertisement, though it is the product of a skilled craftsman and is designed to attract and move the spectator through form and color, is not art in that it lacks rapport with art history and exists at a distance from the museum. The shortcomings of the commercial label were, however, overcome by Pop artists who brought it into harmony with identifiable items of art history. By slightly altering the image as it appeared on the store shelf or the billboard, Pop Art shifted it to the art gallery and, ultimately, to the museum, thus qualifying it to meet the contemporary definition of art with the minimum sacrifice of its original visual and intellectual qualities. The purity of Pop Art—if one may use such an expression—lies in its depending as exclusively as possible on this aesthetics of displacement.

The principle of defining art by its art-historical or museum context was established 50 years ago by Duchamp when he converted toilet bowls and window frames into art by the act of signing them and exhibiting them in an art gallery. Duchamp's act constituted a recognition of the fact that as an object a work of art may be aesthetically identical with a work that is not art. If formal criteria are applied to pictures on billboards or to commercial products or lighting displays, every quality may be found in them that makes art of novelties in the art galleries. Since then, location in the museum—and in Malraux's museum-without-walls, that is, in the system of reproductions that con-

stitutes world art history—is what defines an object as fine art as against the art work of the street, the department store and the advertisement. Critical theories notwithstanding, we know what is art by the place where we find it.

But this capacity of the museum to determine what is art by acting as the personification of art history seems to me to be temporary. In totalitarian countries art history has in several instances been brought to a halt by social force. The mass media too are a social force capable of absorbing the arts and terminating their independent existence. Today, the museum itself is being transformed into a mechanism of mass communication. Formerly, it was a place where objects dug out of the past, and thus wearing an aura of permanence, were re-interred with appropriate intellectual honors. The museum's glass cases and worn marble floors were synonymous with *the* Past—the function of its curators, or keepers, was to conserve. It is as the Past lifted above time that the museum becomes absolute in Malraux's scheme—as absolute as the eternal, as death.

But Malraux's conception of the museum is already out of date—and most obviously perhaps in the United States.

Today, the museum has lost its character of a tomb and has taken on that of an educational institution and a distribution agency—as well as of a community center and a public relations bureau. *The strongest force for ending the role of art history as a judge of art is the kind of art history now represented by the museum.* Art manufactured for the museum enters not into eternity but into the market.

The orientation of the museum is no longer toward the past, with its slow drifts of change marked off in the evolution of forms from generation to generation. The museum today and the art historians who direct it are turned toward the future, toward new trends—if these are not present, the museum endeavors to create them. Its representatives circulate around the globe in the hope not of excavating art history but of *making* art history. They seek a role in the historical drama similar to that of artists—and perhaps superior to it, since it is they who determine what art is through making choices from the limitless range of works, past and present. Museum officials, though still called curators, have no interest in preservation—on the contrary, they are among the first to pronounce the death sentence on works that have fallen out of fashion.* Also, in order to fit works into their programs, they do not hesitate

* See "Time in the Museum," pages 100–112.

to strip them of their original character. Masterpieces of all ages are put into competition for public attention by presenting them as *news*. Exhibition rooms have traded the atmosphere of the cloister for that of the midway or the marketplace.

In sum, today's museum is an active agency, whose action competes with the action of art. It is not a final resting place but a testing ground for novelties capable of intriguing the museum's ever-expanding public. In its vocabulary even the word "new" has lost its temporal character. "New" means new according to the museum's interpretation and showmanship. Everything is new: Egyptian statuary, Minoan figurines, Romanesque panels, Russian icons. The museum today is the place where all of history becomes contemporary in being made accessible to the media-trained mass. The *Mona Lisa* or Michelangelo's *Pietà* is put before millions as a starred item of "our art heritage today," with the Florentines providing the brand of historical pageantry popularized by the Sunday supplements. In the media, time blends with space as a tourist attraction—history is what you find when the ship docks or the plane lands. It is a place to go. "Give us a few hours," said a recent Pan Am ad. "We can take you back two thousand years. Back to Rome when Rome meant Caesar. . . ."

Since the museum has thus become a cog in the global system of the new, it will not be able to continue indefinitely to authenticate art on the basis of its continuity with the past. Critical references to aesthetic tradition become increasingly ideological, that is, contrived for the purpose of affecting decisions, tastes and actions in the present. As a mechanism of communication dedicated to audience-building, the museum is engaged in synchronizing art production and distribution with the rhythm of the cultural commodity market and its insatiable demand for "revolutionary" innovations. Thus the pace of its reputation-building tends increasingly to match that of Broadway and Hollywood. Formerly the stronghold of the principle of conservation, the museum becomes instead the major source of instant accreditation of works, styles, attitudes, and personalities.

Once the museum has gone completely hip, the only identifiable difference between art and the media will be the size of the mass to which art appeals. At present art is still a medium for a relatively small mass, though one capable of expanding indefinitely, as has been happening with guitar playing, folk dancing, strobelight shows, underground movies.

To maintain the size of this mass and if possible to augment it, art has developed its own kind of public relations: catalogues, releases, human-interest sto-

BARNETT NEWMAN, *ANNA'S LIGHT*, 1968, OIL AND ACRYLIC
ON CANVAS, 9 X 20 FT. COURTESY M. KNOEDLER & CO.

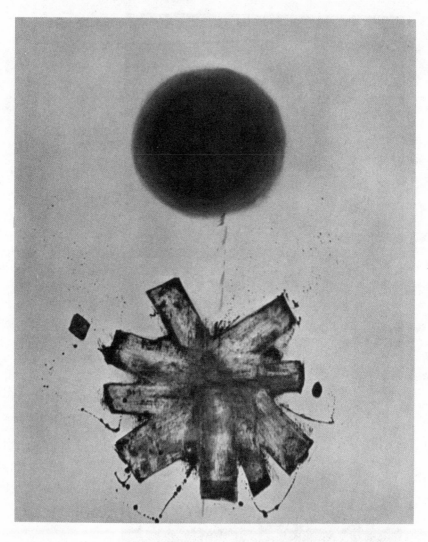

ADOLPH GOTTLIEB, *RED AND BLUE #2*, 1966, OIL ON CANVAS,
60 X 48 IN. COURTESY MARLBOROUGH-GERSON GALLERY

ries, interviews, picture biographies, lectures, statements by the artist. Promotion has become the vital center of aesthetic discourse. In this context the function of criticism, where it is not itself promotion more or less disguised, is to lend variety to the monotonous chant of the builders and disseminators of reputations. For art to be fully accredited among the media, it is only necessary that the art audience shall be large enough for private investment in the production, exhibition and marketing of art to become profitable on an industry-wide basis (instead of, as at present, in a few galleries).

Neither by the museum nor by art criticism can art be kept separate from the media. Not only does art keep approaching the media by way of pace, promotion and the other similarities I have noted; the media, for their part, take on the features of art. I see, for example, a promising future for media museums which should be able, without too much effort, to establish a roster of heroes comparable to those of the arts or of invention. Still-photos and movies are recognized by the Metropolitan Museum, the Museum of Modern Art, and most other art institutions as fine arts. So are poster making and industrial design. It seems inevitable that comic books, billboards, pulp magazines, and radio tapes should soon be accorded aesthetic reappraisal. A comic-strip world *Bienal* is being organized in Buenos Aires. Such apparently knotty problems as whether Lichtensteins are to be assigned to the painting section or hung among the comic books may, under conditions of advanced aesthetic desegregation, cease to exist. Lichtenstein himself has attempted to settle the issue by treating Cézanne, Mondrian and Expressionist painting as if they were different kinds of comic books.

The refusal to see any difference, except as a means of presentation, between works of art and the products of the media is raised to the philosophical level by Marshall McLuhan. To McLuhan the arts *are* media: the book or the canvas is simply a tool of communication that has been largely rendered obsolete by the new electronic media that arose in the last century with the telegraph and has now attained Comsat. Put another way, for McLuhan yesterday's medium is today's art. Painting used to provide information about people and places; today, out-distanced by the camera, it turns to abstraction. Or one can say that the arts are lagging media. People still try to communicate through catgut in the age of electronic tape. A book looks backward to the culture of reading; TV encompasses the book and marches straight ahead. McLuhan sees some virtue in the lagging of the brain that prompts it to go on painting pictures or writing novels or poetry: reading helps people to "prog-

ram" their senses at a gradual trot instead of risking being knocked off balance by the wild gallop of unrestrained electronics. Yet McLuhan's axiom that "the medium is the message" means that whatever a book does to the reader, it does it as a book not as a *good* book, or as a work of art. Moreover, the book, good *and* bad, like the painting, the play, live music, is, in McLuhan's scheme, destined to be devoured by the new "total" media which keep messaging or massaging our senses of sight, sound, touch, as well as our nervous system itself, and pulling them into new shapes.

In the ideas of McLuhan the encompassing of the arts by the media is carried to its logical conclusion in the metamorphosis of the spectator. The nearsighted owl or bookworm, the lonely art-loving protagonist of what McLuhan calls "eye culture," is transformed into Ionesco's rhinoceros galloping with the herd. In time, even if painting and books were to remain, there would be no one in McLuhan's Utopia physically capable of perusing them—the eye would no longer follow the contours of a form or the rows of type.

The archetypal creation of the media is the *package*, whether it contains cornflakes, a 240-horsepower motor or a retrospective exhibition of the paintings of Jackson Pollock.

The virtues of the package are: economy and reliability in production, standardization of quality, convenience in delivery, ease in assimilation. Traditionally, art has none of these characteristics; indeed, it tends to emphasize antithetical ones. Art production is wasteful and the completion of the work is not to be depended upon. Its quality fluctuates from artist to artist and from work to work. It communicates itself slowly and in different degrees to different individuals. In short, the production and consumption of art occur under the handicaps of the human organism and the human psyche, rather than with the advantages of more efficient mechanisms.

Thus there arises the attempt to define art in terms of the natural irreconcilability of the human being and the machine. From this viewpoint, what identifies an object as art is its inefficiency, its clumsiness. A good deal of art today is art because it does not work. Tinguely's junk machines are more "human" than a B-52. The fabric washbasins and soft office equipment of Oldenburg appeal to the same anti-machine bias. Their efficiency is nil, and this qualifies them to be objects of aesthetic contemplation. Oldenburg's art is a sentimental refutation of Duchamp's ready-mades, which had only to be transferred from the supply house to the art gallery to become art. With Oldenburg the industrial object needs to lose its character in order to gain an aesthetic identity.

But if art has to fall back on being handmade, it becomes indistinguishable from the handicrafts, in which stitching or chisel marks are featured as signs of the personal touch. A good deal of art today is simply handicraft grown more sophisticated—and, one might say, argumentative.

But a contrary movement has also come into being in recent years—to make art according to the most advanced industrial techniques. Following the methods of the media art today is often an efficiently conceived, factory-produced, self-explanatory aesthetic package.

But whether art is made as a package or as an antithesis to the package, it takes on the character of the package in its mode of transmission to the public, that is, through the communications system of the press, including the art press, the museums, galleries and other distribution and educational mechanisms.

The prospect of the vanishing of the arts into the media is, on its face, not too alarming. Most Americans, including most intellectuals, have, visually speaking, been getting along quite happily with the media alone, and Europeans and sophisticated Asiatics are entering the same condition. Moreover, as noted earlier, many artists are reconciled to mass-media methods, and artists since the beginning of the century have been looking beyond painting to mechanical ballets and spectacles employing the new technologies. One strain of current avant-garde art aims at breaking down the last barriers between art and life and transforming painting and sculpture into "events" in which other idioms play a part, such as light shows, mixed-media performances and Happenings.

Philosophers may be alarmed at the possibility that the total victory of the media will lead to the monopoly of a single type of imagination, that in which creation is dominated by the craftsman's idea of what his public wants. Yet pleasing a public may in time become less restrictive as society is divided into a larger variety of taste groups—the craftsman could then choose to work for the one in which he felt most at home.

The end of art as an enterprise separate from the media by no means implies that the human imagination will have ceased to function—that could happen only in the reign of reason, which is something radically different from the reign of the media. The media are image-makers, too; they engage in a good deal of fantasizing and know the formal principles by which images are rendered appealing. Advertisements, motion pictures, comic strips reach into the collective imagination, with its dreams of luxury and its nightmares of violence, in a manner closer in most respects to the consciousness of the times

than the displays in art galleries. The mass media are the "double" of the arts, able to bring into play every aesthetic element whose function can be rationalized. Whatever art has conceived the media can re-conceive in endless variations—it may well be that, taking into account all the art works of different times and places brought to the surface in the twentieth century, enough art has already been accumulated to keep the media active for the next millennium.

In reaction against the increasing dissolution of the boundaries of the arts and the blending of the arts into the media, a revival of the idea of "pure" art has gained prominence in the sixties. Its aim is to attain the "art-object-as-such," an object whose definition and reason for existence are derived from the history of art conceived as an evolution of forms. As pure art-historical essence the work of art is purged not only of all references to nature but also of any feeling, perception, idea or manual trace. A statement issued by the Museum of Modern Art in connection with its "The Art of the Real" exhibition of the Summer of 1968 conveys the concept. "The contemporary artist," says the statement, "labors to make art itself believable. The spectator is not given symbols, but facts, to make of them what he can. The new work of art is very much like a chunk of nature, a rock, a tree, a cloud, and possesses much the same hermetic 'otherness.'" The *ding-an-sich*, as described here, exists, of course, only in the mind of metaphysicians (the Museum of Modern Art should read *Hamlet* on the subject of clouds). Art "believable" strictly as "fact" belongs in an Eden of credulity. Besides, if the work of art is "like a chunk of nature" why bother to make it? Pure art of this sort is actually a turn around the circle that leads back to the found object. Ironically, the products of the new movement tend to resemble architectural elements, fabric designs, commercial containers—that is, the utilitarian objects and images from which their "purity" was supposed to separate them.

The sum of it is that the history of art as a distinct category of artifacts seems to have reached a dead end. If art is to survive as an activity different from that of media craftsmanship it will have to find a more fruitful basis than mere interest in itself and its past. We are speaking of the affirmation by art of its metaphysical justification under the conditions of today.

In my opinion this justification can be found primarily in the kind of consciousness art brings into play. Unlike the media, whose processes and results are rationalized to the maximum degree in the interests of the predictable production of the package, art sets in motion previously uncontrolled, or even

undiscovered, powers of the mind. Every artist is in a sense a primitive, a *naif*, as Baudelaire thought of him, *ce civilisé édénique*, as Mallarmé called the poet. The élan of the paintings and sculpture of the past fifty years has arisen from the tension between the creative act, with its core of spontaneity and unrationalized insight, and the object produced by it, which cannot be prevented from falling into categories created by modern mass society. An expression of this tension has been the art—from Cubist collage to current "accumulations"—that tears open the media package and treats it and its contents as raw material. The media turn art into media—art retaliates by turning media products into art.

What makes a spade not a spade is the art-conscious intervention of the artist. The spade signed by Duchamp owes its existence as art to the original *event* introduced by the artist into art history in exhibiting it. It is by the artist's act that the object produced in a factory is brought into relation with paintings of madonnas. In this act timing is decisive; the object itself is a mere souvenir of an occasion.

Duchamp's signing thus inaugurates a new art history, that in which the signature-bearing spade mocks the hierarchy of forms by which art had sought to elevate itself above the crafts, and in which the artist's act (e.g., the signing and exhibiting) enters into the web of creative acts, regardless of when performed, the totality of which constitutes the identity of art. It is as the token of the attainment of a new stage in the history of human fabrication that Duchamp's "ready mades" stand out from among the mass-produced duplicates among which they originated. As visual objects their value is exactly equal to that of similar urinals and spades in the hardware store. As symbols commemorating the end of the separate existence of art objects they are unique and impossible to duplicate. To understand the signed spade is to grasp an intrinsic development in human culture; to contemplate the spade is senseless—that museums exhibit Duchamp's spade, or an exact reproduction of it, as a work of art is typical of the fatuousness of an institution that has lost its bearings.

Vital art works of this century are symbols of activities of mind that extend beyond the skill involved in their production. It is the presence of this active consciousness, of which the works as objects can only be a clue, that in each instance disengages the painting or sculpture from the mass of fabricated doubles.

DEFINING ART

A bow in the direction of the Dadaist subversion of art has been part of the etiquette of aesthetic innovation since the First World War. The avant-gardist must behave as if art were to him a matter of indifference, if not of outright annoyance. Among minds seeking liberation from the past, the erasing of a de Kooning drawing by Robert Rauschenberg is the most significant creative gesture of the last two decades. The rule followed is: If it's art, it's obsolete. To be new, paintings and sculptures must disguise themselves as ordinary objects; at a recent Whitney Annual almost half the sculptures endeavored to pass as machine or building parts, as those of two or three years earlier passed as billboards or comic strips. Art's denial of its identity ought not, however, be taken at face value. Rauschenberg's erased de Kooning was done in imitation of Duchamp's *Mona Lisa* with a mustache, of some forty years earlier, and both "works," signed, were included in the recent "Art in the Mirror" exhibition at the Museum of Modern Art. The building blocks, the segments of staircases, the discs, and the vacuum hoses at the Whitney referred back to solidly established aesthetic precedents. Many years have passed since artists seriously wished to do away with art. Certainly collectors, dealers, and museum directors do not want to do away with it. "There is no such thing as painting, sculpture, music, or poetry," cried the Futurist Boccioni in 1912. Ah, but there is, there is. Today, renunciation of art has become a ceremonial gesture. A kind of collusion is involved between artist and spectator—the pretense that "this time things have gone too far." Both know,

ROBERT RAUSCHENBERG, *ERASED DE KOONING DRAWING,* 1953, ERASER, 15⅛ X 11⅞ IN. OWNED BY THE ARTIST

JEAN TINGUELY, *HOMAGE TO NEW YORK*

however, that the violation is a formality—that the spectator recognizes the art-historical background of the "atrocity," and that artists, whatever else they dedicate themselves to, have an eye on the museum and on their place in art history. The bland display by conservative curators of relics of subversion like the bemustached *Mona Lisa* and the obliterated de Kooning (de Kooning himself obliterated a good many de Koonings) has the effect of heightening the cohesion of the art world. The repudiation of art by art makers and art lovers may prevent an answer to the question: What is art today? But the absence of a theoretical definition bothers only outsiders and does not at all prevent art from being defined quite strictly in practice—indeed, much too strictly. To judge by art magazines and museum programs, nothing new has been done in the past few years but Happenings, optical displays, and so-called primary structures and reductive paintings. Yet many other modern styles, presumably finished long ago, are constantly being brought back to life in the studios and galleries. To say which of these styles, if any, is the "newest" would require investigating the dynamics of revival. The emphasis on certain modes at any given moment is determined by the public relations of art and the influence of prevailing social conditions. Beyond this, though, everyone is aware that works are accredited as art by art history and that art history includes objects that thumb their noses at art.

Having closed a retrospective exhibition of the all-black (not quite) paint-ings of Ad Reinhardt, the Jewish Museum displayed all-blue paintings by Yves Klein. Evidently the public was to be given a thorough indoctrination in one-color aesthetics. Klein, who died a few years ago at the age of thirty-four, is an excellent example of what may be called ritualistic vanguardism. He was artist to the art world in the sense that one speaks of tobacconist to the king. A highly inventive showman, he used art, art ideas, and vanguard-audience attitudes to build a career in painting and sculpture as spectacular as one in Hollywood or the Via Veneto. His best-known works are monochrome paintings, sponge sculptures, and reliefs saturated in a color close to what is popularly known as royal blue but which Klein, perhaps introducing a slight tint of his own, reëntitled International Klein Blue and publicized throughout the globe as IKB. The blue is one of the lushest of colors, and it is laid on canvas after canvas in thick, uneven icings studded with lumps like almonds and caramels. (Some parallel streaks were to be noted here and there, but whether this was a departure from IKB or the result of fading could not be

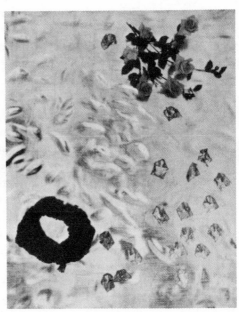

YVES KLEIN, *THE GRAVE — HERE LIES SPACE*, 1960, MIXED MEDIA, 49¼ X 39⅞ IN. COLLECTION MME. YVES KLEIN, PARIS, COURTESY THE JEWISH MUSEUM, NEW YORK

YVES KLEIN, *ANT SU 2*, 1961, IMPRINT, OIL ON CLOTH, 54¾ X 29⅝ IN. COLLECTION MODERNA MUSEET, STOCKHOLM, COURTESY THE JEWISH MUSEUM, NEW YORK

determined.) IKB was also the pigment in which Klein arranged to have nude girls dip themselves and then imprint their torsos and thighs on unprimed canvases. The blue served Klein as a trademark by which he could, simply by the act of staining, appropriate as his art any object he found attractive; besides the girls, his bluing took over antique casts, Michelangelo's *Dying Slave*, and the *Victory of Samothrace*. From IKB, Klein advanced to gold, a color no more modest in its appeal than the blue. He also "painted" by burning the surfaces of canvases and by exposing them to the wind and rain, and he wrote copiously about his poetic and metaphysical conceptions, which centered on the notion of living dangerously and keeping himself in a state of psychic incompletion. Undoubtedly, Klein was touched by the poetry of the empty sky and the Heraclitean elements; this was enough to set in motion the post-Dada machinery that lay ready at hand. His works have a gross romanticism of the order of taste that keeps an ocelot for a pet. Anticipating adverse judgment, Klein referred to his works as "ashes" and pointed away from them to the experiences that had brought them into being. "No matter what one thinks," he wrote, "all this is in very bad taste, and that is indeed my intention. I howl it from the rooftops: 'Kitsch, Corn, Bad Taste;' this is the new notion in art. And while we are about it, let's forget art altogether." Klein's gesture toward the "void" is said to have been the prelude to the self-destroying sculpture of Tinguely, which, logically, failed to destroy itself in the garden of the Museum of Modern Art.

Klein's talent lay neither in his works nor in the originality of his ideas but in his way of staging them and himself. For one of his shows he completely re-did his Paris dealer's gallery and devised a spectacular, including blue cocktails, that brought thousands to his opening. Literature distributed by the Jewish Museum declares that he is now considered "one of the prophetic artists of his generation." I prefer to think of him as a forerunner not of the artist of the future but of the new museum director, who is adept at using whatever works come to hand to establish a glamorous décor.

Another artist whose works, accessories to his showmanship, also presuppose the anti-art etiquette of the vanguard audience is Red Grooms, a pioneer of the Happening. Though young, Grooms is an art-world veteran and a firm tradition. His "act" is at the pole opposite to Klein's intellectual pretentiousness; he plays the country boy, and the word for him is "fresh." In one of his exhibitions were broadly sketched portraits of early movie personages—

RED GROOMS, *GLORIA SWANSON*, 1966, ACRYLIC/
WOOD, 78 X 37 X 15 IN. TIBOR DE NAGY GALLERY

RED GROOMS, *JUST IN TIME*, 1966, ACRYLIC/WOOD,
TIBOR DE NAGY GALLERY

Fairbanks, Pickford, Chaplin, Griffith—and props for a short film, *Fat Feet*, whose jerky Mack Sennett Comedy rhythms, as well as the participation in the cast of Grooms' "family" of friends, carried out the theme of childhood and nostalgia. The film was shown with the paintings and sculptures, and all that was lacking was ice-cream cones and lollipops. Both the artwork and the film are executed in a lighthearted, sophisticated primitivism that belies their painstaking craftsmanship. As human actors, wearing Grooms' enormous papier-mâché shoes, mingled on the tiny screen with his cutout props and figures against the painted stage sets, the effect had the charm of a puppet show when the puppeteer himself rises into it like an unreal giant of flesh. Grooms' originality consists in continuing the game of mixing art and reality brought into prominence by Surrealism and Pop Art, yet without being stylistically bound to either. His work is a step closer than Yves Klein's toward a frank melding of painting and sculpture into an entertainment medium for the audience recruited in recent years for vanguard art.

In the same category of new-media entertainment, though relying on completely different effects, are exhibitions that convert art galleries into hallucinatory environments or science pavilions (depending on the degree of audience participation exacted) through high-intensity light beams, prismatic distortions, color suffusions, film projections, sound effects. In the light shows, which often come to the art galleries directly from the laboratory, art splits its identity between sober technical demonstrations and appeals to our delight in shiny, moving things.

In its struggle for existence against the two great powers of contemporary society—technology and the mass media—art is constantly engaged in pilfering from these powers effects developed by them in connection with purposes that have nothing to do with art. "My initial interest in kinetic sculpture," writes Charles Mattox, a West Coast maker of machines with marvellously moody movements, "was stimulated by a desire to explore aspects of our technology and apply them to art forms." Of course, technology itself had borrowed forms from art, whether in designing machines or in turning paintings into picture postcards. If the mustache on the *Mona Lisa* was the defilement of a masterpiece, it was, literally speaking, the recovery for art of a reproduction turned out by the millions of copies. The incessant interplay of art and non-art causes each act of self-immolation by painting—through burning canvases, gashing them, pasting objects into them, writing on them—to take on

the character of an act of creation, as it does the fabrication of any image, object, or spectacle that does not fall into an existing category. Through negative and positive processes, art enters into a state of limitless expansion. At the same time, the identification of objects as art by their aesthetic qualities becomes increasingly uncertain through, among other things, the constant fallout of works into their mass-production doubles—for example, the reappearance of Albers' *Homage to the Square* as a panel design on a dress fabric.

In our time, every vanguard, in widening the horizons of art, introduces the threat of an ultimate dilution that will do away with art entirely, whether that widening takes the form of turning art toward industrial design, psychic action, or movie comedies. To some, it is the dilution, not the broadening, that is the issue: it seems to represent a corruption of standards that is all but synonymous with moral depravity. The suspicion of hoax and fraud hovers at the edge of modern art movements like the abyss of the medieval mariners. In the past decade, overnight reputations and the accelerated turnover of styles have thickened the atmosphere of wire-pulling and dissipation of values. To this state of affairs what is called minimal or reductive art has been offered as an antidote. The assumption of its fundamentalist aesthetics is that at least art ought to define what it is not. It was Ad Reinhardt's tireless promotion of this assumption, through his repeated lists of negative definitions (art is not nature, not life, not self-expression), and his doleful tirades against corruption that, as much as his square black all-alike paintings, qualified him to be the ancestor of the new art-for-art's-sake. As against art as decoration, as action, as self-revelation, as Happening, the minimovement affirms the independent existence of the art object as meaningful in itself. Unlike the other vanguard movements of the past fifty years, this one is dedicated to art and to nothing else. In this sense, minimalism is post-vanguard; it reflects the new situation of art as an activity that, having left the rebellious semi-underworld of bohemia, has become a profession taught at universities, supported by a public, discussed in the press, and encouraged by the government. As a profession, it needs to know what it is about.

"Basic" paintings and constructions are simple in design and usually composed of a few geometrical elements in primary or neutral colors. Explanations of their aims vary from artist to artist, but the novelty of the movement, which has preoccupied leading New York galleries and contemporary-art museums, lies in its materialistic interpretation of painting rather than in the paintings themselves; like other "new" styles, geometric painting and sculp-

ture go back at least half a century. The minimasters and their critical allies redefine painting in terms of the stretcher (its size and shape), the canvas, the liquid density of the paint, the lines that affirm the borders of the painting as an "object." The exclusion of images or textures likely to stimulate feelings and associations is intended to produce a response that is exclusively aesthetic. "They exhibit," writes a practicing minimalist of the works he finds basic to "the recent history of painting," "a penchant for presenting materials factually and for employing a numerical set as something signifying nothing but itself. The content of these paintings is a certain quantity, an accumulation, and they are sometimes quite witless." (Witlessness in the art world is not taken as lack of wit.) The concern of minimal artists is with problems of quantitative relations; in general, the spirit of engineering prevails among the younger "object" artists, though, unlike the art of the kineticists and electronics specialists, their work is confined to wall decorations and freestanding solids. Like many engineers, an artist of this school will occasionally reflect on the spirituality of space and numbers. But the deliberately dehumanized aestheticism of minimal art is summed up by another of its practitioners, Tadaaki Kuwayama: "Ideas, thoughts, philosophy, reasons, meanings, even the humanity of the artist do not enter into my work at all. There is only the art itself. That is all."

The attempt to cut art down to the bare bones of its material elements is a recurrent recourse of artists in the confusion of a changing culture. According to a celebrated anecdote, Mallarmé once advised Degas that poems were made of words, not ideas. Most significant painting (though not all) since Matisse's *Joie de Vivre* (1905–06) has been reductive. Reductivism does not belong to any one style; it is as operative in painting conceived as a gesture as in painting cut down to a line or a square. The traditional aim of reduction, however, even at its most extreme, has been to augment through compression the emotional or intellectual statement. In slicing away residues of imagery or manner that have lost their relevance, the artist seeks, as a European writer recently put it, to transform the apple into a diamond. The novelty of the new minimalism lies not in its reductionist techniques but in its principled determination to purge painting and sculpture of any but formal experiences, and even of resonances of experience. There is left the void—not Yves Klein's empty sky (though formalist critics have not been slow to link IKB monochromes with the red or white "color fields" of the minimalists) but empty art, correct and clean. It is a void that seeks the cancellation of art as it has

been until now and its supplanting by works from which adulterating impulses have been purged. The inspiration of the minimasters is art criticism; many of these painters and sculptors began as writers on art. Describing a recent minimal exhibition, a reviewer noted that of the artists represented "four at least have been fairly systematically engaged in critical writing." The rigor of the engineering concept is complemented by a polemical intensity through which runs the vein of a moral crusade against romanticism and impurity. Regardless of formal resemblances, the true historical background for this approach is not the tradition of the pure colorists and geometricians—Malevich, Mondrian, Albers—but the Dada assault on art, here mistaken for a return to aesthetic fundamentals. If Warhol's Brillo boxes are Dada, the boxes without Brillo of Robert Morris, the most subtle of the minimalist dialecticians, are super-Dada. The point is reinforced by the practice of many of the primary-structure makers of having their ideas ("Ideas . . . do not enter into my work at all") executed in carpentry or machine shops, while others advertise as a radical departure that they nail their pieces together themselves.

Obviously, serious intellectual response to works of this kind, as to those of Klein and Grooms and light-and-film spectacles, depends upon the collusion of the art world in accepting them as phenomena retinted in the vat of art history. Without the omnipresent memory of Dada, nothing could induce the celebration as a new "advance" in art of Reinhardt's black squares, with their dead, fish-eye glint, or the painted planks and stair steps at the Whitney.

The difference between historic Dada and the current fundamentalist version lies in their treatment of the spectator; instead of goading him into indignation at the desecration of art, the new Dada converts him into an aesthete. The monotonous shapes and bleak surfaces presented to him as objects wrapped in their own being compel him, if he is not to back out of the gallery, to simulate a professional sensitivity to abstruse contrasts of tone, light, and dimension. The more a work is purged of "inessentials" the closer the scrutiny required to "see" it and the more precious the sensibility required to react to it. A reviewer of paintings consisting of a few large forms recently put the matter in blunt terms: "To appreciate this difference [in the thickness of their contours] fully it is necessary to get very close to these sizable canvases and examine them as if for blackheads." Similarly, the author of the Jewish Museum catalogue for the Reinhardt exhibition complained that, as a result of "overlighting" the gallery, "noses and fingers are rubbed against the surfaces [of the paintings] . . . the impatient viewer sees nothing immediately and

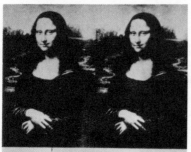

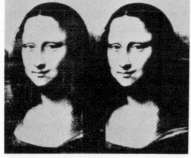

ANDY WARHOL, *MONA LISA*, 1964, SILK SCREEN ON CANVAS, 43¾ X 29⅛ IN. THE METROPOLITAN MUSEUM OF ART, GIFT OF HENRY GELDZAHLER, 1965

AGNES MARTIN, *THE TREE*, 1964, OIL AND PENCIL ON CANVAS, 6 X 6 FT. COLLECTION THE MUSEUM OF MODERN ART, NEW YORK, LARRY ALDRICH FOUNDATION FUND

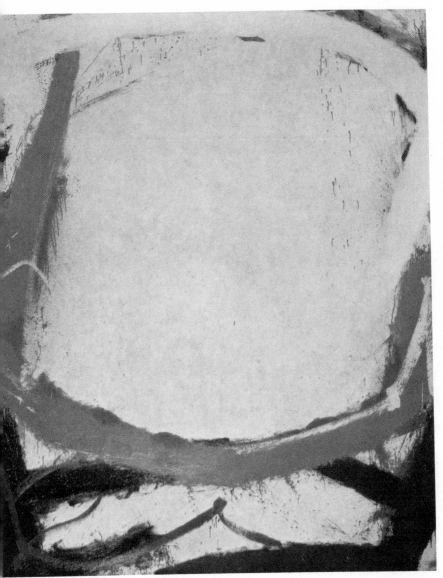

NORMAN BLUHM, *AGLAONICE*, 1966

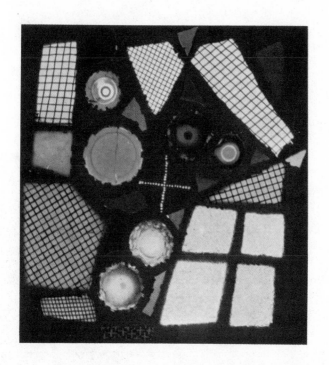

JOSEF ALBERS, *RHENISH LEGEND*, 1921, CONSTRUCTION OF
BROKEN BOTTLES MOUNTED ON BRASS, 18¾ IN. HIGH

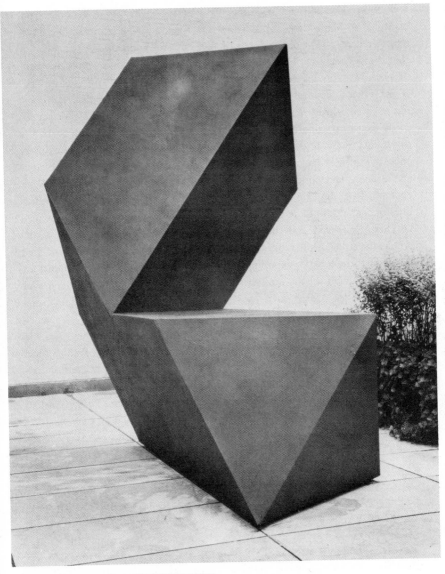

TONY SMITH, *AMARYLLIS*, 1965, PAINTED PLYWOOD MOCK-UP OF SCULP-
TURE TO BE MADE IN STEEL, 11 FT. 7½ IN. X 8 FT. ⅝ IN. COURTESY THE
MUSEUM OF MODERN ART, NEW YORK

feels constrained to touch instead of look." (Apparently, this over-stimulated critic has not considered McLuhan's thesis that over-all painting like Reinhardt's represents the obsolescence of "eye culture" and calls for a response of the central nervous system.) What the new aestheticism, in its didactic insensitivity to the ironies inherent in twentieth-century art, fails to take into account is that to its ideal spectator art would have become unnecessary. A table top of three boards hung on a wall could yield an almost inexhaustible supply of the aesthetic minutiae discovered in minimal masterworks—effects of the slight unevenness of the surface, the illusion of depth thus created, the differences in width of the crevices between the boards, the function of these crevices as lines, their control of the surface as parallels and as verticals and horizontals (depending on which way the work is hung), the relation of these lines to the edges of the table, the character of those edges (whether worn, bevelled, or sharp) and the degree of austerity they communicate to the whole, the color of the table as against that of the wall, the changes produced by framing the table or exposing its thickness, the—and so forth. Minimal art is Dada in which the art critic has got into the act. No mode in art has ever had more labels affixed to it by eager literary collaborators; besides being called minimal art, it is known as "ABC art," "primary structures," "systemic painting," "reductive art," "rejective art," and by half a dozen other titles. No art has ever been more dependent on words than these works pledged to silent materiality. The subtleties with which the retinal sensations of examining a set of gray cubes or a graph-paper composition are broken down and recombined in a rhetoric pieced out with historical analogies have produced a literature of sententious comedy worthy of Molière or Ionesco. It is as if Walt Whitman's apostrophe to an axehead were rewritten by a German art historian who imagined himself Oscar Wilde. The rule applied is: The less there is to see, the more there is to say.

In contrast to the polemically depleted works of the minimalists are the monumental "presences" of Tony Smith. Smith's simple shapes, which draw on the geometric and Constructivist sculpture of the early decades of this century, and are assembled out of precut plywood sheets painted black, create, except up close, an impression of massive solidity (in being thus illusory, the hollow structures negate the first rule of minimal art: factuality). Taken as a group, Smith's constructions, for all their feeling of weight, communicate a sense of intangibility. The geometrical compositions are beautifully angled to

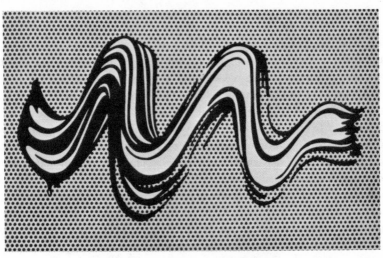

ROY LICHTENSTEIN, *BRUSH STROKE*, 1965, ENAMEL ON STEEL, 26¼ X 42⅛ IN. COLLECTION RICHARD BROWN BAKER, NEW YORK, COURTESY THE MUSEUM OF MODERN ART, NEW YORK

MARCEL DUCHAMP, *VALISE*, 1943, LEATHER CASE WITH CONSTRUCTIONS AND MOVEABLE SCREENS, CONTAINING REPRODUCTIONS OF DUCHAMP'S WORKS, 16½ X 14¾ X 4½ IN. COLLECTION THE MUSEUM OF MODERN ART, NEW YORK, JAMES THRALL SOBY FUND

infuse into their immediate surroundings a sense of gentle motion, as of a ship at anchor. In scale larger than man but not huge, the black structures refrain from overwhelming. Again unlike most "primary" constructions, the forms often suggest incompleteness; in several a plinthlike section thrusts outward in a gesture of seeking. Smith's refusal to close his structures may produce a preliminary feeling of frustration, but it has the virtue of communicating, like a sketch or partly unpainted canvas, the openness of the creative act. To accomplish this with ready-made parts and in an idiom of monumentality is no easy feat. An architect, draftsman, teacher, old-time friend of Jackson Pollock and Barnett Newman and aficionado of *Finnegans Wake*, Smith, after long meditations on art and spirit, found in the simplifications of Constructivist aesthetics a subtle vocabulary that suddenly projected him, at the age of fifty-five, into an authoritative position in American sculpture.

With the Symbolists of the turn of the century, "pure art" was an art of metaphysical essences. Smith's structures are pure in this Symbolist sense, as quiet and solitary as the space under a viaduct at midnight. Minimalist constructions have an exactly opposite character; stripped of metaphysical intimations, they assert their purity by confronting the art public with an aggressive challenge to its expertness, like something offered "as is" in an auction. Primary art is environmental and audience-participation art to no less a degree than a kinetic fun house or a Happening. In it aesthetic education has taken the place of eye-dazzle and unfamiliar doings. An exhibition of ABC paintings and structures transforms the gallery into a lecture hall. At the opening of such an exhibition, what is most in evidence is the crowd; with the crowd gone, there are the benches and blackboards. The solemn efficiency of the setting is not enough to dispel the traditional presence of the Dada joke.

Paul Klee is the unequalled theoretician of twentieth-century dynamics in painting. More important than his theories, however, are the experiments through which he translated them into formal principles and into actual works of art. With the thoroughness of the founder of a new science or a new political order, Klee carried on the systematic conversion of the elements of painting—line, plane, color, depth—into charges of energy. The Klee exhibition at the Guggenheim Museum, the largest ever presented in this country, was, as the neighbor of the Andrew Wyeth show at the Whitney, like an atomic reactor set down in a cow pasture. Many of Klee's oils and watercolors illustrate technical exercises developed by the artist in connection with his lectures at the Bauhaus and described in his essays and notebooks; an immense collection of these writings and visual demonstrations was published in 1956 under the title *Das Bildnerische Denken* and was issued in English in 1961 as *Paul Klee: The Thinking Eye**—the New York art world seems to find thinking less objectionable if it is done with an organ other than the mind. Not only is *The Thinking Eye* the most thorough theoretical exposition by an artist of the action approach to painting; it contains the richest laboratory investigation of its technical possibilities. For instance, one of Klee's most striking paintings, *The Grey One and the Coast*, which was done two years before his death and bears overtones of the passage over the Styx, is reproduced in *The Thinking Eye* in a section headed "Different Pos-

* George Wittenborn, Inc., New York.

sibilities of Movement—Types of Rhythmic Structure—Terrestrial and Cosmic Examples" and is accompanied by the following note: "Give rigid rhythm to the individual and flowing rhythm to the structure, and let them work against each other." The note then refers to another composition of jagged and arrested motions, the similarly myth-laden oil *Heroic Strokes of the Bow*. Springing from his analytical exercises, Klee's paintings and drawings, which total almost nine thousand, are like entries in the logbook of a continuing investigation of the formal properties of a kind of painting usually associated with an indifference to form. Each creation embodies a hypothesis that in being realized pictorially opens the way to a new hypothesis. Or, instead of being the outcome of an idea, a work constitutes a detour into surprise, since Klee, while constantly pushing on with his formal analysis, was neither a formalist ("Formalism is form without function," he wrote) nor a rationalist but an intuitive artist with feelers extended toward the unknown and toward the human content of his inventions. The footnote to *Temptation*, a remarkable linear abstraction done in 1934, says, "There are also projections that cannot be explained, because the artist sometimes shows a faculty for projecting inner images in such a way that they become almost real or entirely so. You have to take care not to write the law simply and unimaginatively by itself but to put yourself in motion round the law." The last sentence ought to be engraved upon the portico of every contemporary art school.

Ever since the foreshadowing of the First World War by the Futurists, action had been the pledge upon which vanguard art movements arose and split apart. For Klee, what was called for was not an activism of the streets but a revolution in the forms of art and in the conception of the artist and the spectator. Each problem in *The Thinking Eye* has to do with moving, tensing, falling, balancing, straining, shifting, intensifying, recurring, resisting, self-isolating. Color, line, plane are translated into verbs. Having abandoned the imitation of appearances, Klee sought pictorial equivalents of the changing inner-outer world of man. In his "Creative Credo," he offered a physiological and philosophical basis for his dynamic conception of painting: "In the work of art paths are made for the eye of the beholder which moves along from patch to patch like an animal grazing. . . . The work of art arose out of movement, is itself congealed movement, and is perceived by movement." For Klee, the action comprehended by painting ranged from the physical and psychological to what his friend Kandinsky called the spiritual. "Problem: the ethical character of movement. . . . The main thing is freedom . . . a free-

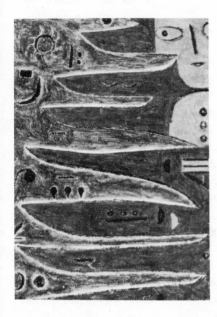

PAUL KLEE, *THE GREY ONE AND THE COAST*, 1938, COLORED
PASTE ON BURLAP, 41 X 27⅝ IN. COLLECTION F. K., BERN

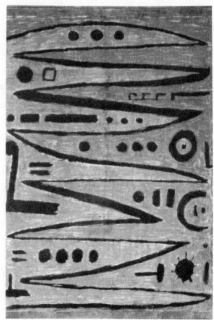

PAUL KLEE, *HEROIC STROKES OF THE BOW*, 1938,
TEMPERA ON PAPER WITH GESSO BACKGROUND,
28¼ X 20¾ IN. PRIVATE COLLECTION, NEW YORK

dom which insists on its right to be just as inventive as nature in her grandeur is inventive."

Stylistically, Klee's works fall into categories determined not by the usual biographical "periods" that reflect the artist's moods and private life but by the shifts, pauses, recapitulations, and leaps of his consciousness-expanding process (if one may borrow a term from those who hold that insight can be distended by drugs without the effort of thinking). His formal inventiveness is so profuse as to make creation appear a natural function of the mind. Klee spun off enough pictorial clues to keep New York studios on the trail for the next twenty years. Most artists who discover a mode keep digging in it until it forms a crater that encompasses them—for example, Chagall, Mondrian, Rothko. In contrast, Klee cut analytical trenches from one mode to another to construct a seemingly endless labyrinth. He conceived compositions of rectangles of color (*The Harmony of the Northern Flora*), not as Cubist divisions of space but as back-and-forth "color actions"; of snarls of line (*Dame-Demon*) to serve as "intineraries of the eye"; of light-generating gradations of tone (*Double Tent, Ambassador of Autumn*); of rows of dots fading into contours (*Classic Coast*); of "reductive" signs and marks (*ABC for Wall Painters*); of geometrical planes opening upon other planes and upon a solid-color ground (*The Gateway to the Depths*); of emblems and pictographs (*Around the Fish*). He demonstrated the contrasting emotional effects of flat strata, mounting strata, and receding strata; of changing a ruled contour into a freehand one; of transposing a composition from paper to board or to burlap. He incorporated letters of the alphabet, numbers, arrows, leaf shapes, eye shapes, moons, stars, sails. His works call to mind contemporary painters and art movements seemingly irreconcilable with one another: Hans Hofmann and Dubuffet; Baziotes and Anuszkiewicz and Ferren; Gottlieb and Saul Steinberg; Franz Kline, Pollock, Op, and Pop. There are even ingredients in Klee that, not inconsistent with his years at the Bauhaus, have proved useful to advertising art—for example, his directional rhythms and zigzag profiles. The particulars of Klee's influence are a matter for historical and biographical research; what arouses our admiration is that he should have placed himself at the source on which so many different minds and temperaments were to draw.

That source is revealed in the semi-mythical ("almost real") subject matter of Klee's compositions. "I begin logically with chaos . . . because at the start I may myself be chaos," he wrote. In post-First World War Europe, "chaos" had a historical dimension. It was defined in the attacks made by Klee's con-

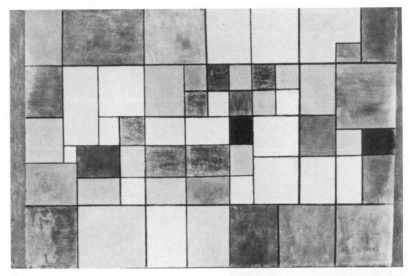

PAUL KLEE, *THE HARMONY OF THE NORTHERN FLORA*, 1927, OIL ON CHALK-PRIMED PAPER MOUNTED ON BOARD, 16⅜ X 26⅜ IN. COLLECTION F. K., BERN

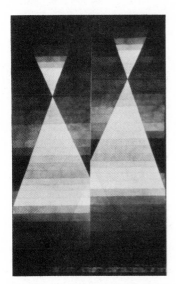

PAUL KLEE, *DOUBLE TENT*, 1923, WATERCOLOR, 19⅞ X 12½ IN. COLLECTION ANGELA ROSENGART, LUCERNE

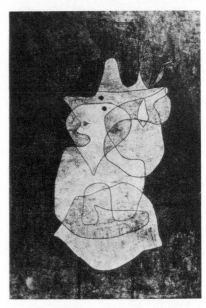

PAUL KLEE, *DAME DEMON*, 1935, WATERCOLOR AND OIL ON BURLAP, 59½ X 39¾ IN. COLLECTION BERNER KUNSTMUSEUM

PAUL KLEE, *CLASSIC COAST*, 1931, OIL ON CANVAS, 31⅞ X 27⅛ IN. COLLECTION MR. & MRS. STANLEY RESOR, JR., WASHINGTON, D. C.

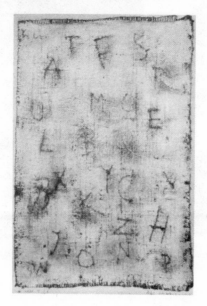

PAUL KLEE, *ABC FOR WALL PAINTERS*, 1938, OIL ON GESSO-PRIMED BURLAP, 22 X 14⅞ IN. COLLECTION ANGELA ROSENGART, LUCERNE

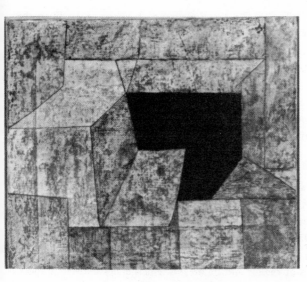

PAUL KLEE, *THE GATEWAY TO THE DEPTHS*, 1936, WATERCOLOR ON VARNISHED BOARD, 9½ X 11⅜ IN. COLLECTION F. K., BERN

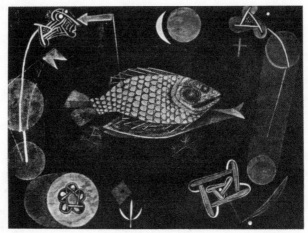

PAUL KLEE, *AROUND THE FISH*, 1926, OIL ON CANVAS, 18¾ X 25⅛ IN. COLLECTION THE MUSEUM OF MODERN ART, NEW YORK, ABBY ALDRICH ROCKEFELLER FUND

temporaries on the hollowness of the Renaissance heritage—the "Burn the museums!" slogan of Marinetti and Aragon. For Klee, the cultural vacancy of Europe implied neither the end of art nor an aesthetic based on the conservation of fragments. Because all forms of life and thought had become volatile, what was required, he saw, was the introduction of time into painting. An art of static harmonies, even as modernized by Cubism, was out of key with the experience of the epoch. The aesthetic of the twentieth century had to be based on motion and change. The epigraph of *The Thinking Eye* is a statement Klee wrote in 1914, a month after the beginning of the war: "Ingres is said to have created an artistic order out of rest. I should like to create an order out of feeling and, going still further, out of motion." An order created out of motion might be able to breast the tide of the chaos that the artist felt himself to be "at the start." Thus, with Klee the shakiness of Europe was manifested not in Dadaist parody or Surrealist dissociation but in images of balance-unbalance: tottering structures, scaffoldings without foundations, abstract impulses, cities of the air and of dreams, emergences out of darkness, submarine wanderings, personages and landscapes sprung from movements of the pencil or brush. The objective, Klee repeated again and again, is not form but form-making. Neither in nature nor in art nor in the self is there to be found a point of completion. In a world soluble in time, all forms, past and present, float together in a sea of potentiality. Regretting, like Rimbaud, "Europe with its ancient parapets," Klee turned to the arts of Africa, of antiquity, of the Orient, of Islam, to the drawings of children, madmen, and untrained eccentrics, to the culture of the city streets, and to that other antagonist of traditionalist art, modern science. Beyond inherited styles and values there exists the art act as the irreducible essence of art and of man, whether performed in ancient Babylon, in the jungle, in the kindergarten, or in the test tube.

Klee was aware that his unremitting experimentalism was forced upon him by the nature of the times and that it carried a price. "There is no culture to sustain us," he wrote in 1924, explaining why, though he often dreamed of "a work vast in scope, spanning all the way across element, object, content, and style," he and his contemporaries were unlikely to achieve more than "parts." Artist and spectator alike passed from discovery to discovery, from possibility to possibility. Reality, however—at any rate, synthesis—lay out of reach. For the artist in this predicament, his own continuity would be best embodied in the notebooks wherein he recorded the ongoing activity of his mind—the ac-

tivity of which the work of art represents only a "moment" of concentration and chance. Comparing *The Thinking Eye* with the notebooks of Leonardo da Vinci, the Italian historian-critic Giulio Carlo Argan paraphrases Klee himself to point out that both artists are "concerned not so much with the art object as with the manner in which it is produced." Argan might also have compared Klee's pictorial researches with the lifelong note-taking of his contemporary Paul Valéry, for whom Leonardo, as the personification of "method," provided the link between the Renaissance and the twentieth century, and the key to the survival of the arts in the midst of our "intellectual crisis." Parallel to Klee, Valéry established as his first aesthetic axiom that "a work of art is an act," and declared, "I regard methods with much more affection than results."

Historically, Klee stands between the pre-First World War Futurists, among whom pictorial animation became confused with depicting physical motion, and the post-Second World War American Action painters, whose energy-charged compositions were a direct response to the situation of American art instead of being inspired by any aesthetic program. Klee is closer to the Futurists stylistically in his finished surfaces and his derivations from Cubism, but he is more akin to the Action painters in his mastery of, among other modes, nonfigurative abstraction, in his refusal to carry the art act beyond the canvas into street demonstrations and politics, and in his search for inner unity through painting. His greatest differences from the Americans are in the role in his paintings of the conceptual and in the related matter of their physical size—the notebook sensibility being unlikely to seek solutions through the blockbuster. On the grounds of both excessive consciousness of what he was doing and the small size of his characteristic works, it is stylish to dismiss Klee as overrated (as if every artist were not overrated today, if he is rated at all) and as at least as much a mere thinker, and even a "literary man," as an artist; his philosophizing, writing, and teaching are held against him. He is identified with the stereotype of the formula-maker, the man in the white coat. (As luck would have it, a photograph of Klee in *The Thinking Eye* actually shows him in a laundered white smock neatly buttoned up to the neck like a druggist.) An objection to Klee on a different plane stems from the fact that giving art a metaphysical aim offends the American sensibility just as it excites the German.

The role of the intellect in creation is, of course, a real issue. Yet the contrast between Klee's analytical procedures and American spontaneity can be

exaggerated. For example, the late Franz Kline was always quick to denounce any suggestion that theory played a part in his work; if it did, we may take Kline's word for it that it was not his theory. To set out from an idea, as Klee often did, would have revolted Kline. Kline's spontaneity, like that of Pollock and Hofmann, is currently being played down by critics, in order to present art as picture planning. That this is nonsense by no means implies that Kline charged at his canvases with loaded brushes. He carefully weighed the positions and stresses of his strokes, and his oils often show traces of considerable reworking—areas shifted and toned to "get the picture right" in terms of his trained sensibility. While Kline was thus engaged in calculation, Klee, in refusing, despite his theorems, to exclude the unexpected, was committed to spontaneity; a colleague at the Bauhaus accused him of "working too much with his abdomen."

The nub of the issue is that the notion of an opposition between the artist as thinker and the artist as man of feeling belongs to the ideology of modern art more than to its practice. Each artist thinks in the way that is best suited to his temperament, his training, his cultural situation; if he doesn't find the way that is best for him, he fails as an artist. Where Klee theorized in advance of the act of painting and subsequent to it, Kline theorized mainly in the doing. Kline had absorbed, of course, the thinking of predecessors that is always physically present in the visual discourse of modern art—for instance, his much-discussed use of white as a "color" equal in value to his blacks inherits its meaning from Klee's concept of colors as energies. For an artist to have his ideas come to him from the past provides certain advantages. Klee's *The Cupboard*, built of a rectangle of four strokes, is no match in clarity, tension, and forthrightness for Kline's similarly executed *Yellow Square* and the drawing *Untitled* done on a page of a telephone directory. Kline, for his part, was incapable of Klee's formal transitions—for example, from the rectangle of *The Cupboard* to an image like *Drummer*. In our time, one may ask: Whose theory and how applied? But no art today is created without theory—and without overcoming it.

Besides suspecting Klee for his intellectualism, Americans are bothered by the small scale of his works—many important ones are in the neighborhood of nine inches by twelve. Alongside the wall-size canvases that have been in vogue in New York during the past fifteen years, Klee's tiny proscenia cannot avoid creating the impression of being pinched. What is small tends to seem picayune as well, if not trivial. The almost notebook size of Klee's composi-

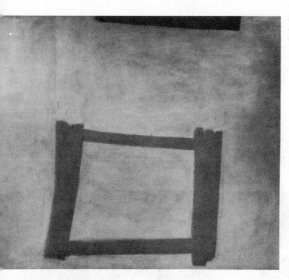

FRANZ KLINE, *YELLOW SQUARE*, C. 1952, OIL ON
CANVAS, 65½ X 79⅝ IN. COURTESY MARLBOROUGH-
GERSON GALLERY, NEW YORK

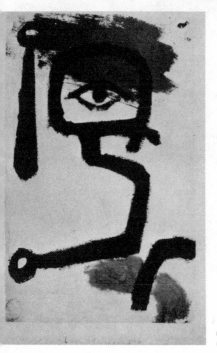

PAUL KLEE, *THE CUPBOARD*, 1940, COLORED PASTE
ON PAPER MOUNTED ON BOARD, 16⅜ X 11⅝ IN.
COLLECTION F. K., BERN

PAUL KLEE, *DRUMMER*, 1940, COLORED PASTE ON PAPER MOUNTED ON
BOARD, 13½ X 8½ IN. COLLECTION BERNER KUNSTMUSEUM

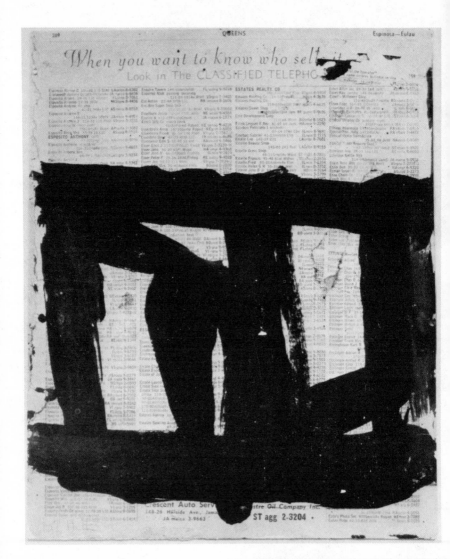

FRANZ KLINE, *UNTITLED*, C. 1952, OIL ON TELEPHONE BOOK PAPER,
10¾ X 9 IN. COURTESY MARLBOROUGH-GERSON GALLERY, NEW YORK

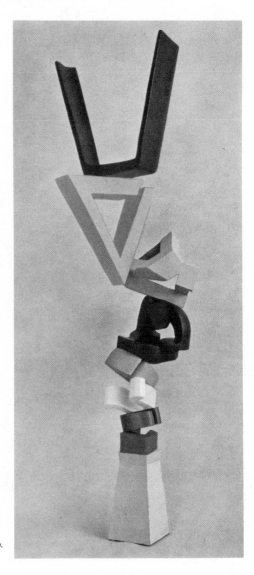

GEORGE SUGARMAN, *C CHANGE*, 1965, LAMINATED WOOD,
110 IN. HIGH, COLLECTION ALBERT A. LIST, NEW YORK

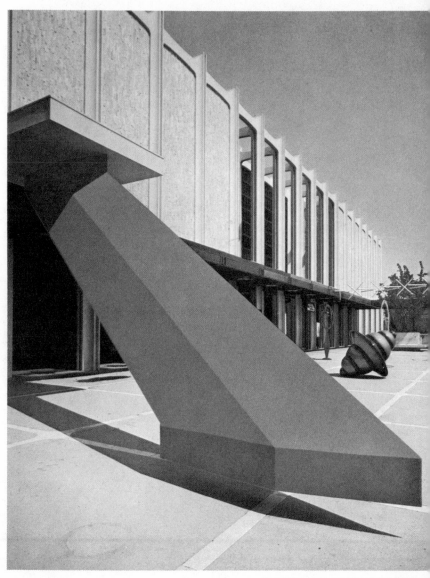

ROBERT GROSVENOR, *STILL NO TITLE* (FOREGROUND), 1
PLYWOOD, FIBERGLASS, STEEL, 13 FT. HIGH

tions also emphasizes their tentativeness. A painting appears to be in a state of being superseded by one based on a different conception or by a different version of itself. In their totality, Klee's works suggest the jottings of a seeker, not the "major statement" of one who has arrived at finality; a critic accustomed to Fifty-seventh Street absolutes recently brushed Klee aside as "too inventive." The big picture solves the problem of cultural vacancy by a stroke of force. Sheer magnitude can bestow upon a work the character of a final act. The temptation to bring art to an end—the temptation that has moved so many artists since 1914—is, as we have seen, lacking in Klee. His work assumes the continuation of art and of reflection about it. It is art for the long run, and, as such, is not likely to be outdistanced. Also in his favor is the fact that the influence of painters is increasingly disseminated through reproductions, in which the size of the original work doesn't count. If on the walls of a gallery Klees are perused like pages of a book, the same is done with thirty-foot paintings when they leave the walls for permanent residence in art books. The problem of the artist, Klee wrote, is "how to enlarge space"—again a problem of dynamics, not soluble in terms of mere length and breadth.

The weakness in Klee's work is due not to intellectualism or to modesty of scale but to the artist's accommodation to the pressures of the aesthetic prejudices of his time and place. "I can only hope that the layman who keeps looking for some favorite object in pictures will gradually disappear from my surroundings," Klee wrote. This layman did not disappear. On the contrary, he made himself present in Klee's work itself through Klee's transformation of pictorial concepts into images designed to make them acceptable to him; by turning a zigzag into a profile or by adding feet, eyes, and descriptive titles to abstract compositions Klee provided "the layman" with comic pictures, caricatures, fantasies, and romances. To appreciate such original linear-planar constructions as *The Twins* and *Diana in the Autumn Wind*, the spectator is compelled to ignore irrelevant cartoon elements that make them accessible as "subjects." The snake's head appended to the beautifully errant line that defines the forward plane of *Snake Paths* is a vulgarism that converts a brilliant painting into an illustration. This is not to condemn Klee's use of thematic associations as such but to object to superimposed ideas that mar the intrinsic conception of the work. In contrast to the distressing snake of *Snake Paths*, the dim iconic head in *Sphinx Resting* (its features reappear in *Flower Girl*, done six years later) is locked into the positive and negative space of the picture's formal structure in a way that deepens the profundity of the whole;

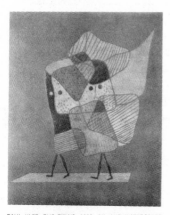

PAUL KLEE, *THE TWINS*, 1930, OIL AND WATERCOLOR ON CANVAS, 23⅞ X 20 IN. COLLECTION MR. & MRS. HENRY T. KNEELAND, BLOOMFIELD, CONN.

PAUL KLEE, *SNAKE PATHS*, 1934, WAXED WATERCOLOR ON CANVAS, 18½ X 24¾ IN. PRIV COLLECTION, BERN

PAUL KLEE, *SPHINX RESTING*, 1934, OIL ON CANVAS, 35⅞ X 47⅝ IN. COLLECTION BERNER KUNSTMUSEUM, PAUL KLEE-STIFTUNG

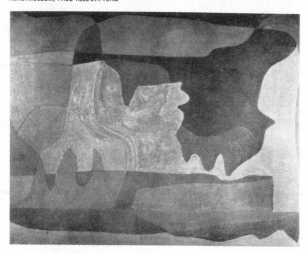

PAUL KLEE, *ARAB SONG*, 1932, OIL ON B LAP, 36 X 25¼ IN. PHILLIPS COLLECTI WASHINGTON, D. C.

similarly integral to the composition are the eyes in *Three Masks* and *Arab Song*. As for Klee's celebrated poetic titles, they, too, function unevenly; some expand the overtones of the work with a finely phrased metaphor, others narrow its meaning and tempt the spectator—as exemplified by Will Grohmann in his book *Paul Klee*—to regard the painting as a literal rendering of the title. For Klee the "symbolic correspondences" of his abstract constructions carried hints of limitless significance; they seemed to open the imagination to that doubled world of the senses revealed, he thought, to children, madmen, and savages. Yet Klee was aware that in passing from pictorial conceptions to "images of nature's potentialities . . . fantasy is my . . . greatest danger," and he noted that "whenever I have succumbed to fantasy for the fun of it, or because it's so easy, I have felt pretty rotten about it." The fact that much of Klee's popularity is founded upon these lapses—if we may judge both by writings about him and by the paintings most widely chosen for reproduction—obscures the generative power of his principled art. Perhaps he chose the mask as a recurrent motif because he knew that his art itself was masked. How else could he make such radical novelties wanted by society as a whole?

THE MYTHIC ACT

Jackson Pollock's chief public statement about his work, a three-paragraph note written in 1947, is devoted entirely to method; it contains no reference to the paintings or to what he was trying to achieve through them. Apparently, he assumed that the value of what he did lay in his way of doing it—an assumption common to scientists and to celebrants of sacred rites. He had found the means, he believed, to generate content beyond what the mind might supply. A work could be initiated without idea or subject by a simple act of will—the will to make a painting. Any gesture with paint or crayon was sufficient to set up a situation that would then engage the artist's latent impulses. Once reciprocating action had begun between the artist and the canvas, an image laden with meaning for both the painter and his public would be brought into being; Pollock, who had been psychoanalyzed, often spoke of "reading" a painting. What was essential in creation, he declared, was to maintain "contact" with the totality that was in the course of being formed. So long as the contact was sustained, the picture would take care of itself. "I have no fears about making changes, destroying the image, etc., because the painting has a life of its own. I try to let it come through. It is only when I lose contact with the painting that the result is a mess." The action of the artist thus blends into the "activity" of the canvas in a kind of feedback process that excludes error. Later, Pollock claimed that his method also excluded chance or accident—a claim that is logical if one conceives of a painting as an invisible being, a kind of demonic form, that uses the artist and his strokes or casts of

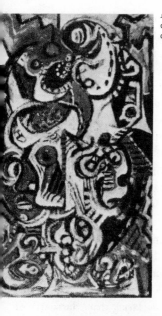

JACKSON POLLOCK, *MASQUED IMAGE*, 1938, OIL ON CANVAS, 40 X 24 IN. COURTESY MARLBOROUGH-GERSON GALLERY, NEW YORK

JACKSON POLLOCK, *GUARDIANS OF THE SECRET*, 1943, OIL ON CANVAS, 48⅜ X 75¼ IN. COLLECTION THE SAN FRANCISCO MUSEUM OF ART

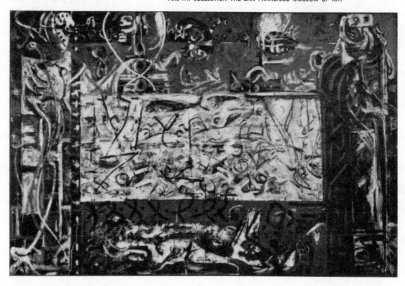

paint to materialize itself in the visible world. Correcting mistakes and abolishing chance, "contact" also eliminates conflict. As long as the silver cord holds, "there is pure harmony, an easy give and take, and the painting comes out well." As Kierkegaard might have put it, the teleology or destiny of the painting suspends the ethics of the painter and his need for a principle of choice. For Pollock, the aim of painting was to achieve not a balance of antagonistic factors, as in de Kooning, but a state of grace.

Pollock's way of working raises the problem of the role of consciousness in art. "When I'm *in* my painting," he wrote, "I'm not aware of what I'm doing." As an inhabitant of the alienated realm of the canvas in progress, the artist exercises his craft, as it were, blindly, like a woodcarver working from inside the wood. More abstractly, he resembles an organic force; Pollock's wife quotes him as saying in reply to an observation about working from nature, "I *am* Nature." The implication is of being almost completely obedient to automatic impulses (though miraculously beneficent ones), like a person caught in the sweep of an event or moving under the influence of drugs. Pollock is thus an ancestor of Happenings and of psychedelic art. He himself provided the basis for derivations of that sort by declaring that "the source of my painting is the unconscious." Since, to those who accept the Freudian theory, all art originates in the unconscious, this could only be his way of repeating that he painted without being aware of what he was doing. One is invited to see his paintings as gigantic doodles. Or, in more romantic terms, as direct products of being carried away or inspired. The element of involuntarism, of being possessed by the work as by a fetish with a "life of its own," cannot be excluded from Pollock's art without violating the artist's purpose and falsifying the content and meaning of his creations. To picture Pollock as the solver of certain formal "problems" of art history is precisely to blur his part in the history of painting and the desperate efforts of artists in the twentieth century to revive art's ancient powers. The concept of the doodle as the "model" of Pollock's paintings is, naturally, an over-simplification: doodles are not done in a condition of alert intentionality, any more than ideas are conceived in a state of narcosis. But even a doodle ought not to be mistaken for a product of pure automatism. Automatic drawing by a person who is wide-awake inevitably absorbs into itself some degree of imitation and judgment. If the doodler is an artist, his image-forming will draw upon the whole range of his experience of art. Moreover, the longer one "works" on a doodle the more one sees in it and the more possibilities arise for conscious intervention. Disturbed children,

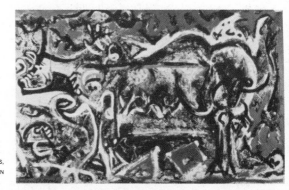

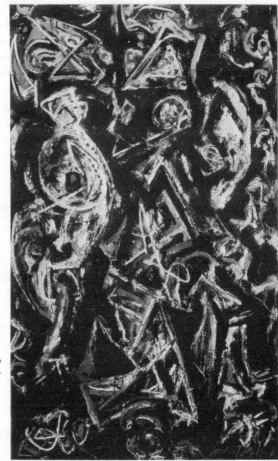

encouraged to let themselves go in drawing, were soon found to be painstakingly copying examples of spontaneity presented to them by their teachers.

Pollock designed his method as a means for resisting mental calculation. With him, automatism served in the first place to unlock the activity of painting and release it from dependence upon concepts. Once the artist had entered into motion, his transaction with the canvas would carry him through varying stages of awareness. Though his painting began with random gestures, his consciousness of it would grow as the work progressed. "After a sort of 'get acquainted' period," Pollock explained, ". . . I see what I have been about." But to maintain spontaneity as a power of continual refreshment, it was necessary to hold himself aloof from rational or aesthetic decisions. Only in the arena of the action could the artist's psyche be wound up to the unrealized demands of the picture. Thus, having declared that in his painting "there is no accident," Pollock completes his credo by adding, "Just as there is no beginning and no end." In photographs of the artist at work, he wears an expression of extreme concentration, on occasion almost amounting to anguish, and his body is poised in nervous alertness as if he were expecting signals from above or behind. He seems about to dart into movement; in the most eloquent of the photographs (one by Hans Namuth) his feet are crossed and his right arm is flexed to fling the paint in a gesture that belongs unmistakably to dance. With his paint-saturated wand, he will draw lines in the air, letting flecks of color fall on the canvas as traces of his occult gesticulations. His consciousness is directed not toward an effect determined by notions of good painting but toward the protraction and intensification of the doing itself, of the current that flows between the artist and his marked-out world and whose pauses, drifts, detours, and tides lift him into "pure harmony."

Obviously, Pollock was an artist with a secret. He knew how to make magic—a peer of the Navajo sand painters (invoked in the statement I have been quoting), who rolled their patrons in their glittering compositions as a cure for disease. His colleagues talked; Pollock had, as he liked to put it, "something to say." Being a painter was to this medicine man to some degree a masquerade. He preferred to play the laconic cowboy—a disguise that both protected him from unwanted argument and hid his shamanism behind the legendary he-man of the West.

To conceive of art as a form of incantation is not unusual in modern thinking—especially since the Symbolists, *The Golden Bough* and the writings of Freud. Why Pollock's magical procedures should upset people, including

those of his admirers who wish to transform him into a hero of technological progress in painting, is a problem not of art criticism but of the deficiencies of American education. The notion of the artist as a "seer" guided by outside forces is implicit in the classical conception of the madness of the creator—a conception resurrected by Rimbaud in his celebrated axiom "I is another." Pollock read Rimbaud in translation, and a quotation from (if my memory is correct) *A Season in Hell* appeared in large letters on the wall of his wife's studio in the early forties. The principle of the displaced ego of the creator, adopted by the Surrealists as a primary article of belief and disseminated by them in New York in the years before the war, provided sufficient hints for Pollock's "When I'm *in* my painting, I'm not aware of what I'm doing."

The originality of Pollock lay in the literalness with which he converted theoretical statements into painting practice. What to others was philosophy or metaphor he dealt with as material fact. Since in his view the driving force in painting was "contact" between the artist and his canvas, he concluded that creation could be dissociated from the formal history of European art and brought about through concentrating on techniques for making that contact more immediate and complete. In order to be literally "*in* the painting," Pollock renounced the easel and tacked his canvas to the floor. His other innovations stem from a similar substitution of contact for tradition. Pouring the paint from the can or dribbling or throwing it off the end of a stick was a means for gaining closer touch with the medium than was possible through applying paint with a brush. Refusing to work from preliminary drawings or sketches was an assertion of the primacy of directness in each individual composition. From the desire to be totally encompassed by the work came the wall-size dimensions of the drip canvases, so suggestive to later "environmental" painters and sculptors.

Leonardo, the Surrealists liked to point out, had called the attention of painters to the significant shapes evoked from the unknown by cracks in plaster and water stains on paper. Yet painting had lagged behind poetry in resorting to free association. Words, in their immateriality, are more responsive to psychic states than are mediums requiring the use of tools. Pollock's modifications of painting tend toward an emulation of writing. In throwing, dribbling, and blotting his pigments, he brought paint into closer approximation of the resiliencies of verbal utterance. The essential form of drip painting is calligraphy. In tying to the picture surface color layers of different depths, Pollock produced the visual equivalent of a play on words—a standard feature of

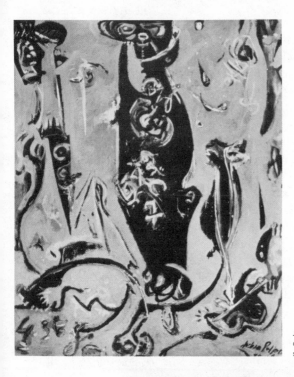

JACKSON POLLOCK, *TOTEM LESSON II*, C. 1945, OIL
CANVAS, 148¾ X 140¾ IN. COURTESY MARLBOROUGH-G
SON GALLERY, NEW YORK

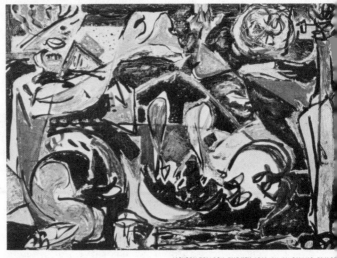

JACKSON POLLOCK, *THE KEY*, 1946, OIL ON CANVAS, 59 X 8
IN. COURTESY MARLBOROUGH-GERSON GALLERY, NEW YO

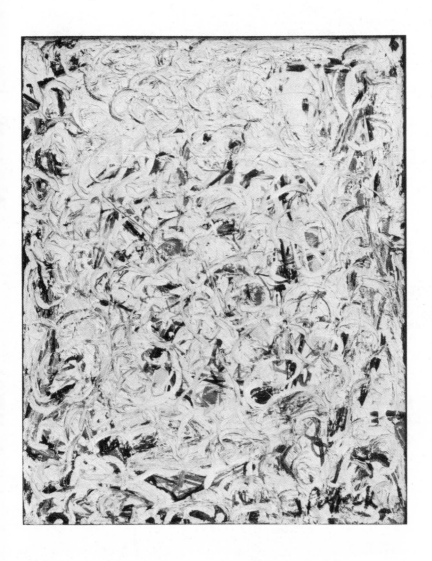

JACKSON POLLOCK, *SOUNDS IN THE GRASS: SHIMMERING SUBSTANCE,*
1946, OIL ON CANVAS, 30⅛ X 24¼ IN. COLLECTION THE MUSEUM OF
MODERN ART, NEW YORK, GIFT OF SIDNEY JANIS

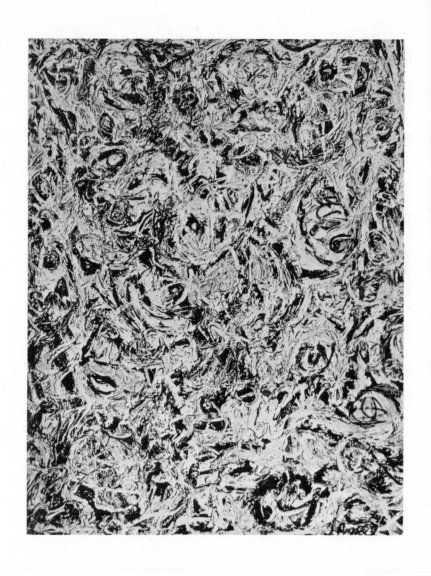

JACKSON POLLOCK, *EYES IN THE HEAT (I)*, 1946, OIL ON CANVAS, 54 X 44 IN.
COLLECTION PEGGY GUGGENHEIM, VENICE

oracular pronouncements. Masterworks like *Full Fathom Five* and *Lavender Mist* transform themselves from sheer sensuous revels in paint into visionary landscapes, then back again into contentless agitations of materials. Their immediate derivation is not the work of any painter but Pollock's favorite readings, from Rimbaud to *Finnegans Wake*. The thought of being influenced by other artists made Pollock uneasy, and he shook off his teachers with an impressive degree of success, but he eagerly identified himself with Hart Crane and with Joyce and Dylan Thomas.

Pollock's most spectacular accomplishment is his large drip paintings. Since they almost go over the brink into non-art, these works have provided a bonanza for post-Dada critics engaged in shuffling paintings into various patterns of aesthetic evolution. Thus the drip paintings have been separated from the inner continuity of Pollock's creation and the drama of his adventure with mythic powers. Happily, the exhibition at the Museum of Modern Art, the biggest ever assembled of Pollock (or of any American painter there), restored the drip paintings to the context of Pollock's effort. That the core of this effort lies in the tradition of art as ritual is made explicit by the titles of the chief works of Pollock's early maturity—*The Guardians of the Secret, The She-Wolf, Night Ceremony, The Night Dancer, The Totem*, all done in the first half of the forties; also among the paintings of this period are *Masqued Image, Magic Mirror, Circumcision, The Key*. Typical of most of these paintings is a curious rectangular or circular structure suggestive of plaques or medallions. The paintings tend to be crowded with incomplete shapes, vanishing faces, and arbitrary emblems, and are sprinkled with inchoate writings, signs, and numbers. Forms are contoured or cut by thick black lines, and the dark and heavy pigment upon a ground of rather sinister gray creates an atmosphere of primitivism and psychological disturbance not unlike that in some of Klee's last paintings. For an artist just turned thirty in the wartime United States, these paintings show a remarkable inner sophistication and sense of purpose; they emanate from a region of Pollock's imagination to which he was to return in his last years.

The totems, masked mirrors, and night ceremonies adapted from Mexican mural painting and the Left Bank poetic kitchen are replaced in 1946, a year after Pollock moved to East Hampton, by the nature mysticism of compositions like *Sounds in the Grass: Shimmering Substance, Sounds in the Grass: The Blue Unconscious* and *Eyes in the Heat*, in which hidden creatures peer out between ridges of high-pitched yellow and blue paint. From these appre-

hensions of presences and energies in nature Pollock passed into union with them through releasing paint in fluids that directly record his physical movements. In the drip paintings, his striving toward an overwhelming symbol is lossened and breaks down into the rise and fall of rhythms rebounding from the canvas on the floor. He has discovered the harmony of the "easy give and take" and has condensed it into a style belonging exclusively to him. The state of abstraction into which Pollock has entered, as well as the origin of that state in the flowing of natural energies, is, as before, conveyed by his titles; with a few exceptions, like *Autumn Rhythm* and *Lavender Mist*, which look back to the intuitions of 1946, the drips are identified only by numbers or are called simply *Painting* or *Black and White*.

Bringing the drip paintings into focus with the earlier totemic compositions provides a measure of both their strength and their weakness. What was radically new about the method of the drips was that the method was all there was to them. By discarding all traces of symbolism or visual mythology, exemplified by Surrealist dream pictures and the abstract figures of Gorky and Klee, Pollock pushed toward a purging of the imagination—or even its elimination. The catharsis implied by this technique establishes a connection between the matted undergrowths of *Blue Poles* and *Full Fathom Five* and the expansive vacancies of the work of Pollock's friends Barnett Newman and Tony Smith or the unyielding surfaces of Clyfford Still. It was myth without myth content—a pure *state*. It joined painting to dance and to the inward action of prayer, as Cubism had joined it to architecture and city planning.

What proves most remarkable is Pollock's range, an effect of temperament, physical ebullience, and integrity of purpose. For this "sand painter," the painting was medicine for the artist himself, not for a patient brought out of his tent to be cured for a fee of two goats. Contact was Pollock's salvation, and he tried to make it appear afresh in each painting. Whatever slackness and repetition occur are attributable less to Pollock's character than to his method. In its "easy give and take" the artist could only win or lose, without struggle. Its goal of "harmony" induced a settling down of psychic method into aesthetic process; this is clear in the work of Pollock's followers, for most of whom relaxed floatings or daubings of paint produce a mere simulation of the master's outer-controlled tension. Drip-painting contact contains no principle of resistance. It offers the temptation to roller-coaster thrills. A painting like Pollock's *Number Seven, 1950*, analyzed layer by layer, amounts to a record of glides and turns whose major quality is headiness. Lacking Pollock's magi-

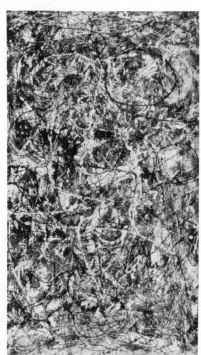

SON POLLOCK, *FULL FATHOM FIVE*, 1947, OIL ON CANVAS, 50⅞ X 30½ IN. COL-
ON THE MUSEUM OF MODERN ART, NEW YORK

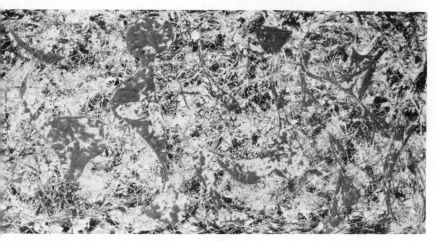

ON POLLOCK, *OUT OF THE WEB*, 1949, OIL AND ENAMEL PAINT ON CANVAS
CUT-OUT COMPOSITION BOARD, 4 X 8 FT. COLLECTION STAATSGALERIE,
GART, GERMANY

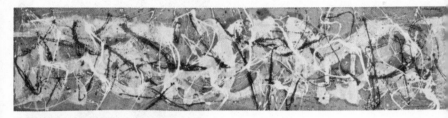

JACKSON POLLOCK, *NUMBER SEVEN*, 1950, OIL, ENAMEL AND ALUMI-
NUM PAINT ON CANVAS, 24¼ IN. X 9 FT. 1¾ IN. COLLECTION MR. &
MRS. JOSEPH SLIFKA, NEW YORK

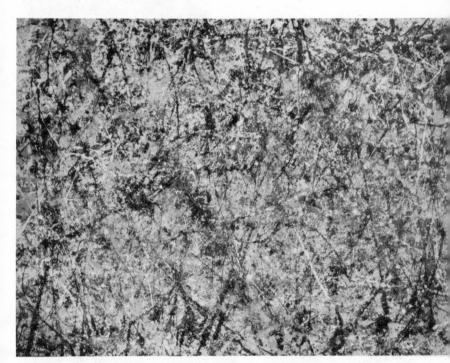

JACKSON POLLOCK, *LAVENDER MIST*, 1950, OIL ON CANVAS, 7½ X
10 FT. COLLECTION ALFONSO A. OSSORIO AND EDWARD F. DRAGON,
EAST HAMPTON, NEW YORK

JOSEPH CORNELL, *COCKATOO: KEEPSAKE PARAKEET*, 1949-53,
20¼ IN. HIGH, COLLECTION DONALD WINDHAM, NEW YORK

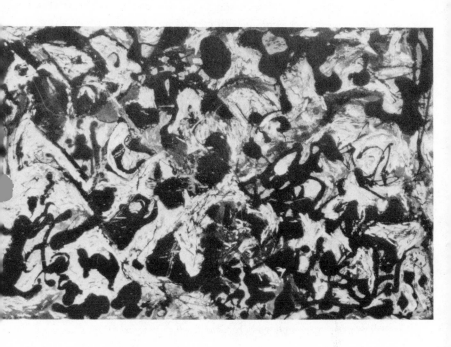

JACKSON POLLOCK, *SEARCH,* 1955, OIL ON CANVAS, 57½ X 90 IN.
COLLECTION MR. & MRS. ALBERT F. SPERRY, NEW YORK

cal mission, such paintings fulfill themselves exclusively in the aesthetic and represent his jazz music for the avant-garde art world.

Pollock himself, after the first excitement of his plunge into the abstract world of liberated pigment, found its harmonies less than satisfying. Already in 1949, only two years after lighting upon his new method, he deliberately defaces a typical drip painting with cutouts of flat, sharp-edged shapes and entitles the work *Out of the Web*, intimating an escape from the tangle of unmitigated responsiveness; in two other works executed in the same year—*Cutout*, a painting distinguished by his peculiar gracefulness, and *Shadows*—he repeats the motif with human shapes emerging out of the jungle of interwoven vines of paint. Turning to the rigors of black and white, to collage and massive drawings of classical heads, he signals his awareness of the limits of visual "gorgeousness" as represented by *Lavender Mist* and other joyous isles gleaming with shreds of blue and aluminum. By 1953, the year of *Blue Poles*, a painting attractive because of a degree of naturalistic grossness, Pollock is in full swing back to the denser intuitions and more refractory images of his early-forties paintings. The flow of paint gradually dries up; his works take on references to paintings of contemporaries; execution becomes tighter and more tentative. He begins consciously to display skill—a necessary preliminary to a new departure but bound at the start to act as a handicap. Abstract titles like *Number Twelve* and *Black and White Painting* give way to a new set of riddles: *Four Opposites*, *Easter and the Totem*, *Portrait and a Dream*, until the list ends, with uncanny appropriateness, in *Search*—apparently the last oil painting he completed before his death.

OBJECT POEMS

The boxes of Joseph Cornell are primarily descendants of the slot machine. The tall, narrow portraits in the "Medici" series of boxes are kin to reflections in the mirrors of penny-candy dispensers (when Cornell discovered a particularly brilliant chewing-gum machine in the Thirty-fourth Street station of the B.-M.T., he rushed around urging his friends to go see it). The boxes comprising rows of bins that contain cubes, jars, or smaller boxes (*Multiple Cubes, Pharmacy, Nouveaux Contes de Fées*) recall the glass-covered cells in the Automat. Other Cornell objects are assembled in containers that derive from showcases, jewel caskets, and the old-fashioned drygoods-store cabinets of tiny drawers for thread and buttons. But among Cornell's variety of compartments the candy slot machine carries the most significance. It is both receptacle and contraption, storage space and toy. Offering its contents to all in an apparatus for prompt delivery, it yet isolates them from the crowds of passersby. It also isolates the customer by engaging him in the game of inserting coins and pulling or turning knobs, and further accentuates his separateness by giving him a glimpse of himself in the glass. *Medici Slot Machine*, one of Cornell's masterworks, combines bustle—represented by strips of film bordering the central figure, a compass under his feet, maps papering the walls and floor of the box—with timeless meditation. In the major vertical compartment, equivalent to the mirror of the penny machine, appears the artist's self-image, transposed into the almost full-length portrait of a big-eyed Renaissance princeling, sword at his side, encased behind crossed lines as in a gunsight. In

JOSEPH CORNELL, *MULTIPLE CUBES*,
1946-48, COLLECTION MR. & MRS. E. A.
BERGMAN, CHICAGO

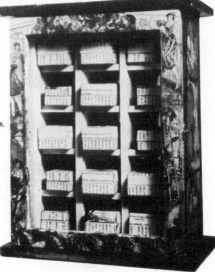

JOSEPH CORNELL, *NOUVEAUX CONTES DE FEES*, C. 1948,
COLLECTION MR. & MRS. E. A. BERGMAN, CHICAGO

JOSEPH CORNELL, *PHARMACY*, 1943,
COLLECTION MRS. MARCEL DUCHAMP

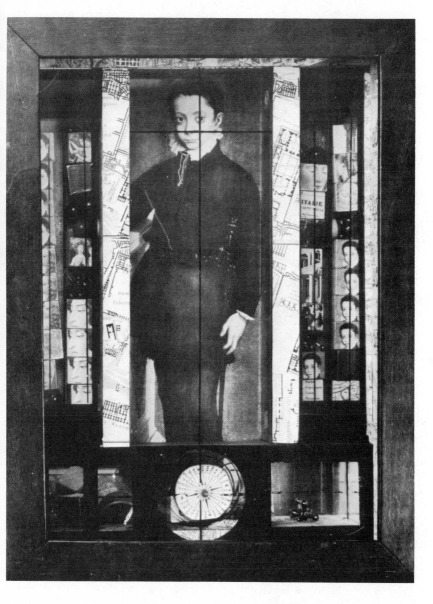

JOSEPH CORNELL, *MEDICI SLOT MACHINE*, 1942, COLLECTION MR. & MRS. BERNARD J. REIS, NEW YORK, COURTESY THE SOLOMON R. GUGGENHEIM MUSEUM

smaller compartments on both sides of the prince, vertical rows of Renaissance faces in frames of movie film, and jacks and balanced balls, are poised as if to slide out when the mechanism is started. If the machine could be worked, it would yield a magical jackpot: self, a noble birth, the romance of the Renaissance, love, scientific discovery, entertainment.

The slot machine in which Cornell encases his symbolic accretions is thus itself his most inclusive symbol. It represents his means of participating in the common life while holding himself strictly apart from it. He becomes a member of the crowd by making anonymous use of its games. Probably the most self-secluded artist in America—the catalogue of an exhibition of his work begins by declaring that "Little is known of Joseph Cornell's early life," and it contains none of the usual revelations provided by artists for such occasions—Cornell has always been drawn to popular-art products, but only when they have ceased to be popular; he has been a devoted collector of old movie films, old phonograph records, old picture postcards. His adaptation of the vending and amusement-park machine as the setting for his compositions, as well as his use of junk, printed matter, and ready-made commodities, has led to the linking of his work with the billboard and comic-strip images of the Pop painters and sculptors. But though it is founded, like theirs, upon the artifacts of the street, Cornell's art belongs to an entirely different aesthetic and emotional order—one might almost say a different culture. Warhol, Wesselmann, Lichtenstein, Rosenquist manipulate the soup label, the comic-strip "box," the photographic blowup as tokens of the public realm; Oldenburg's aggrandized pies and hamburgers outshout anything in Horn & Hardart. Cornell, by contrast, converts hardware-store goods—curtain rods, glasses, a piece of wire mesh—into elements of his inward, once-occurring vision that is both displayed and hidden in its container-theatre, as if one glimpsed it through a peephole. His materials are available to anyone, but in his use of them they take on an entirely subjective character. Each object enters his imagination carrying a large cargo of associations—in the box, it is redefined so as to become a term of a unique metaphor.

Nor do Cornell's displaced clock springs and illegible scraps of printed matter, though they draw on Duchamp's Dada experiments, have much in common with Dada or Surrealist assemblages. Cornell balances a ball of cork above a pair of rings and a broken clay pipe, not in order to induce a quiver of dissociation and disorder—or, like Duchamp, to construct an absurd machine —but to unveil secret affinities; his aim is not shock or "black humor" but to

pin down a state of being in the concreteness of things. In *Deserted Perch*, one of his more obvious compositions, the suggestion of diagonal movement from the lower-left-hand joint of the box, through a block affixed to the rear wall of the box, to a coiled spring and a decorative curved piece of wood at the upper-right-hand corner conveys with simple immediacy the flight of the vanished bird and the desolation of absence, before one notices on the floor of the box some colored bits of what must be plumage.

Cornell's ties with Surrealism are biographical rather than aesthetic or ideological; he began his career in 1932 by exhibiting in Julien Levy's Surrealist gallery on Fifty-seventh Street, and in one of his earliest collages he pays tribute to Surrealism by including the sewing machine and operating table which the Surrealists had taken from Lautréamont as a trademark, though the oilcan and ears of corn Cornell incorporates in his composition seem to hint at irreverence. He also made a few attempts at Surrealist metamorphosis; another early collage represents a sailing vessel sprouting a cloudlike rose with a spider web inside it. By temperament, however, Cornell has more in common with New England spareness and transcendentalism, with Emily Dickinson's

> If I could see you in a year,
> I'd wind the months in balls,
> And put them each in separate drawers,
> Until their time befalls

than with Surrealist diabolism, and he quickly abandoned nightmare, tricking the eye, and manipulation of scale in favor of the suggestive power of real things and lucid placement. To identify his boxes with the assemblages of Man Ray, Ernst, Dali, or Duchamp, or with recent "combines" of unrelated things, is to risk distorting the poetic dimensions of his work. Miss Diane Waldman's introduction to the catalogue of the Cornell exhibition at the Guggenheim Museum in 1967 seems to me to overstress the part of Surrealism in Cornell's imagery—probably out of fidelity to the historical record of his association with Surrealists; in her perceptive and informed readings of the boxes, they become, however, typical Symbolist creations. *L'Égypte de Mlle. Cléo de Mérode* is an open chest of oak lined with cream-colored marbled paper and containing twelve jars sealed with the same paper. "A description of one of the bottles," writes Miss Waldman, "gives some idea of its contents: *Sauterelles* (grasshoppers or locusts) contains a cut-out of two camels and bedouins from an old photograph of the Pyramids and a small green ball, both

JOSEPH CORNELL, *DESERTED PERCH,* 1949, COLLECTION
JEANNE REYNAL, NEW YORK

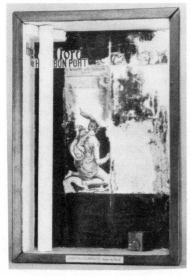

JOSEPH CORNELL, *HOTEL DU NORD,* C. 1953, COL-
LECTION WHITNEY MUSEUM OF AMERICAN ART,
NEW YORK, COURTESY THE SOLOMON R. GUGGEN-
HEIM MUSEUM

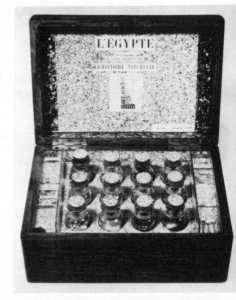

JOSEPH CORNELL, *L'EGYPTE DE MLLE. CLEO DE MERODE:
COURS ELEMENTAIRE D'HISTOIRE NATURELLE,* 1940

set in yellow sand. Cléo de Mérode was a famous ballerina in the 1890's. The goddess Hathor, pictured on the inside lid, is the goddess of love, happiness, dancing, and music, also goddess of the sky. Cléo in the title is also Cleopatra of Egypt. The composition of the box can be paralleled to the Egyptian involvement with the tomb and the afterlife, to the custom of securing in the tomb the articles most required by the deceased in his life after death," and so on. *L'Égypte*, a synthesis of romantic fact (the ballerina of the eighteen-nineties), mysteries casually introduced (the goddess, the photograph of the Pyramids), and metaphysical overtones (love, death, eternity), belongs to the family of Thomas Mann's black gondola in *Death in Venice* and of the lovers exchanging their chest X-rays in *The Magic Mountain*.

To Cornell, a sliver of mirror or some sticks nailed to a board are equivalents of the sunlit oceans and glistening temples of the Symbolist poets. He responds like Valéry to the infinity of the night, and shares with Mallarmé the idea of art as a cosmic game of chance. His objects are, to adopt the Symbolist phrase of Malraux, "money of the absolute." Sand, firmaments, and figures of the zodiac recur in the boxes done in the fifties, in which strips of sky starred by flecks of white paint replace the portraits of the *Medici* boxes. It is almost as if these works were responses to Baudelaire's lines in "The Voyage":

> Show us those caskets of your rich memories,
> Those marvellous jewels made of stars and ether.

In the constructions called *Hôtels* that Cornell did in this period, French names and settings that are suggestive of France's African colonies—parrots, adobe walls, sinister entrances, signs partly erased—evoke the Moorish paintings of Matisse, but with luxury changed to shabbiness. Structurally, these boxes, crudely nailed together out of rough-surfaced pieces of found wood, and papered with old maps or covered with thick white or yellow paint, tend —with their columns made of a dowel or slat—to parody classical architecture in the manner of provincial buildings. Shallow in depth, airless as Poe's House of Usher, with their old-fashioned lettering, words like "Piano Forte," and names affixed with dripping glue, they diffuse an atmosphere of poverty and aging. In this context, Cornell's fondness for French titles places him in the tradition of American writers and painters, from Poe to Max Weber, who were immersed in the romance and decay of the Old World. His much-noted nostalgia is a longing less for childhood and his own past, as in the early collages of Rauschenberg, than for an order by which broken and faded things

might be rescued and renewed. They are mementos of an abstract past comparable to the objects stripped of particulars in Eliot's "Rhapsody on a Windy Night": *

> The memory throws up high and dry
> A crowd of twisted things;
> A twisted branch upon the beach
> Eaten smooth and polished . . .
> A broken spring in a factory yard.

The "game" boxes (for example, *Dovecote*, with its balls and open and closed apertures), which have most influenced younger artists, and the sandboxes are, like *Medici Slot Machine*, toys of a mind playing with possible relations and regaling itself with invented landscapes. The success of a Cornell depends upon the inner references of the objects as objects and of their spatial arrangement within the preconceived limits of the box. His few attempts at external statement, as in the collages for the "Americana Fantastica" issue of *View*, in which an Indian in a headdress, a levitating drummer boy, a tightrope walker, and a trapeze act are posed against a background of Niagara Falls, are astonishingly weak, and some recent commentary collages, such as *Interplanetary Navigation*, which features angels and doves (of peace?), are rather superficial in conception and dissolute in color. These failures underline the distinction between mere messy juxtaposition and "simultaneity," which constitute so much of current "assembled" art, and the translation of objects into unique, untranslatable symbols that occurs in Cornell's best work. The power of his boxes lies in the recognitions of affinities that are unexpected yet as absolute as the placement of a line by Mondrian or a stroke by Kline. To have attained remoteness and fixity in everyday things, thus enabling them to serve as a language of signs, is Cornell's most remarkable achievement; his transmuted trash liberates metaphysical art from reliance upon traditional poetic emblems—fauns, swans—and mathematical forms in a manner comparable to the colloquialisms and snatches of song in "The Waste Land."

If, with Cornell, objects are transformed into signs, in the art of Claes Oldenburg they become more material and public than they were to begin with. Oldenburg's plaster slices of cake, five-foot tubes of toothpaste, soft typewriters and washstands make visible what anyone cannot help seeing—an additional twist to the comedy of illusions. Oldenburg is the Columbus of the

* From *Collected Poems 1909-1962*, by T. S. Eliot, Harcourt Brace & World, Inc., New York, 1963.

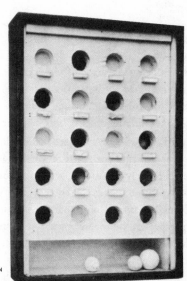

JOSEPH CORNELL, *DOVECOTE*, 1952, COLLECTION
MR. & MRS. ARNOLD MAREMONT, CHICAGO

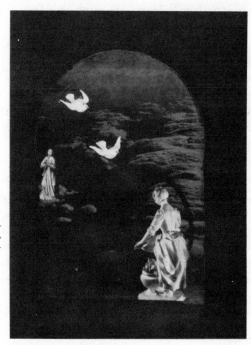

JOSEPH CORNELL, *INTERPLANETARY NAVI-
GATION*, 1964, COLLAGE AND WATERCOLOR,
11⅜ X 8½ IN. COLLECTION THE SOLOMON R.
GUGGENHEIM MUSEUM

underfoot. His recent sculptures include a terrace covered with cigarette butts as big around as the knees of an elephant, a *Swedish Light Switch* (four feet in diameter, made of vinyl and foam rubber), a massive model of a toilet float designed to rise and fall with the tides of the Thames, and drawings and paintings for a monumental drainpipe to be located out of sight. Oldenburg designs minimonuments, too—an ear to place in taxicabs or things to trip over in the street. A project that might arouse ambiguous feelings is his "modest monument" for Adlai Stevenson, in the form of the statesman's fallen hat set in the paving stone near Grosvenor Square where he was stricken. Oldenburg, whose bawdy, irreverent, and socially oriented humor contrasts with Cornell's retiring, puritanical sensitivity, is a practitioner of Kenneth Burke's "perspective by incongruity"—a formula he probably never heard of but one that describes his manner of making things stand out through exaggeration and inappropriateness. To Oldenburg, objects can be endlessly transformed without losing their identity; his wit lies in the variety of ways he can think of to make them over. One of his challenges to himself is seeing how far he can carry the estrangement of a familiar thing while preventing it from turning into something different. His *Giant Soft Fan*, designed for the United States Pavilion at Expo 67, is as successful a piece in this respect as any he has done. Made of black vinyl, wood, and foam rubber, it is, visually, a jumble of simple volumes, of the planes of the fan's thick, pulpy blades, and of the interweaving lines of the "electric" cord, the whole being suspended from the ceiling by chains and anchored to the floor by the weight of the "plug" and its huge wooden prongs. This non-fan is poetic in a way that complements the poetry of Cornell's boxes; like them, it extends the object into a universe of possibility. But whereas Cornell achieves an added dimension through converting material things into intangible signs, Oldenburg projects his typewriters and fans into a new material existence in which their forms are detached from utility. Once the electric fan was invented and became a presence in our visual world, our conception of it no longer had to be restricted to the proportions and substances required to make it work. In the vinyl fan, Oldenburg subverts the world of mass-produced commodities by means of homemade and useless equivalents. Against the artifice of the machine he matches those of the free mind, obviously confident that it will always be able to produce a worse mousetrap.

In creating formal equivalents to nature, Oldenburg is a traditionalist—the strongest position for a comedian. In the main, his novelty has depended upon

CLAES OLDENBURG, *POSTCARD STUDY FOR COLOSSAL MONUMENT: THAMES BALL*, 1967, ALTERED POSTCARD, 3½ X 5½ IN. COLLECTION CARROLL JANIS, NEW YORK, COURTESY SIDNEY JANIS GALLERY, NEW YORK

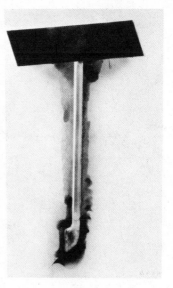

CLAES OLDENBURG, *STUDY FOR COLOSSAL MONUMENT: UNDERGROUND DRAINPIPE*, 1967, PENCIL, SPRAY ENAMEL, CASEIN, 40 X 26 IN. COLLECTION M'CRORY CORPORATION, NEW YORK, COURTESY SIDNEY JANIS GALLERY, NEW YORK

CLAES OLDENBURG, *SMALL MONUMENT FOR LONDON STREET — FALLEN HAT*, 1967, GRAPHITE, 23 X 32 IN. COLLECTION MR. & MRS. JOHN G. POWERS, NEW YORK, COURTESY SIDNEY JANIS GALLERY, NEW YORK

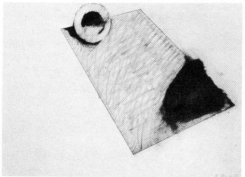

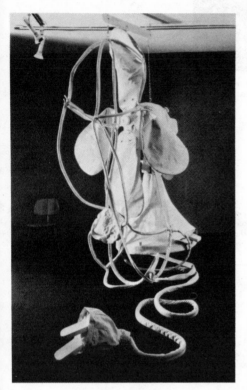

CLAES OLDENBURG, *STUDY FOR COLOSSAL MONUMENT: MOVING PO*
BALLS, CENTRAL PARK VERSION, 1967, PENCIL AND CASEIN, 28 X 22
COLLECTION MR. & MRS. JOHN DE MENIL, TEXAS, COURTESY SIDN
JANIS GALLERY, NEW YORK

CLAES OLDENBURG, *GIANT SOFT FAN*, GHOST VERSION, 1967, CANVA
WOOD, FOAM RUBBER, 120 X 124 X 76 IN. COLLECTION UNIVERSITY
ST. THOMAS, COURTESY SIDNEY JANIS GALLERY, NEW YORK

CLAES OLDENBURG, *COLOSSAL MONUMENT: KNEE FOR THAMES ESTUAR*
SIDE VIEW, 1966, PENCIL AND CASEIN, 15 X 22 IN. COLLECTION MR. & MR
JOHN DE MENIL, TEXAS, COURTESY SIDNEY JANIS GALLERY, NEW YOR

his handling of the man-made; for while it is taken for granted that the sculpture of a horse need not be of the same dimensions and substance as the horse, the application of a similar rule to the sculpture of an electric fan arouses surprise. Unlike many of the new object-makers, Oldenburg draws well; his sketch of moving pool balls was one of the best items in a recent show. Other works include projects and drawings based on "nature"—*The Knees Monument* ("a set of knees to be erected on the Victoria Embankment," explains Oldenburg, who writes very well, in commemoration of the naked knees the artist was so much aware of in London in the summertime) and the drawing entitled *Looking Up Two Girls at Expo 67 Looking Up at a Giant Baseball Bat*. Oldenburg is the liveliest artistic intelligence to emerge in the United States in the last ten years. In an environment that to many is overwhelmingly monotonous, he has discovered objects familiar to all that contain seemingly inexhaustible sources of illusion and irony.

RETOUR DE L'U.R.S.S.:
A METAPHYSICAL EXCURSION

A trip I took to Leningrad in the Spring of 1967 was too brief to reveal anything new about Soviet art, but it did make more concrete the radical difference between art in the U.S.S.R. and art in America. This difference is not merely a difference in prevalent styles; it rests upon a fundamental dissimilarity in attitudes toward the *new*, in life as well as in art. It involves a different sense of time—and it proposes for our epoch a choice between continual effort at preservation and restoration as an antidote to change, and continual effort at creation and novelty. In Leningrad, there was no Abstract Expressionism, no Op, no Pop, no Happenings, no mixed media, no light ballets; also no display advertising, no new design, no cars lined up against the curbs, no cocktail lounges, no miniskirts. The contemporary-art section of the Russian Museum contains portraits of political leaders and other famous men, together with harmoniously composed pictures of such subjects as valiant sailors on board a Soviet cruiser, or a war-stricken village at night highlighted by the flames of a burning cottage. In the Soviet Union, art is unqualifiedly artistic; paintings are paintings, sculptures sculptures—not boxes of old keys and broken dolls, plastic bubbles, surfaces sprayed with dots of color, combinations of machine parts. At the Kirov Theatre, the wildest applause during an opera by Rimski-Korsakov was aroused by an empty stage set showing a storm in a forest, with huge trees rocking back and forth against a sky split by lightning while the world's most lifelike rain beat upon the foliage.

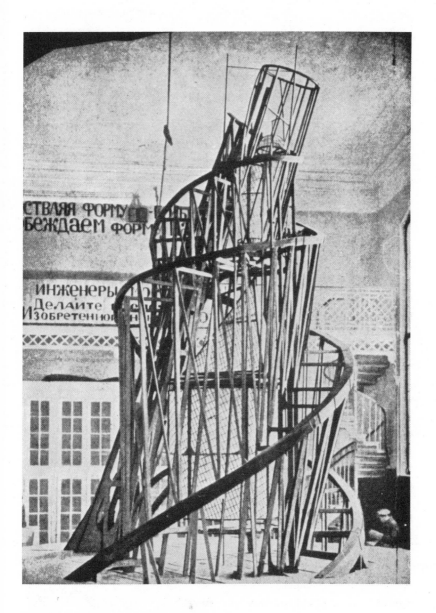

VLADIMIR TATLIN, *MONUMENT TO THE IIIRD INTERNATIONAL*, 1919-20,
WOOD, IRON, GLASS. REMNANTS OF THIS MAQUETTE ARE STORED IN THE
RUSSIAN MUSEUM, LENINGRAD

The success of art in Leningrad in maintaining its traditional identity appeared to me to point, by contrast, to the essential feature of Western modernism. For at least half a century, advanced painting and sculpture in Europe and then in America have been undergoing a revolution of de-definition. Step by step, every attribute by which paintings have been identified as paintings—including pictorial subject matter, composition, drawing, color, the painting surface, even suspension of the picture on the wall—has been stripped off. Comparable developments have been taking place in sculpture, which has lately risen in favor among artists largely because its materiality cannot altogether be wiped out. (When the image is totally eliminated, as by the artist who recently appended to the wall of his gallery a wall that simulated that wall—including its ventilators, light sockets, and so on—the work becomes a "sculpture" by the mere fact of being there.) The persistent denuding of the arts has prepared the ground for mixing them together (e.g., painting with sculpture, film, sound) and merging them into objects and situations of actual life. The reductive trend in art, whether it takes the form of abstraction, Happenings, assemblages, or light patterns, moves in the direction of destroying the identifying marks by which painting, sculpture, or music might hold on to its past; in terms of the future of art, a "purist" like Albers is in the same boat with junk salvagers like Rauschenberg or di Suvero.

None of these processes manifest themselves in present-day Soviet art, despite the fact that forty-five years ago an "end-of-easel-painting" exhibition was held in Moscow, and Constructivist painters turned to designing clothes and kitchenware. In Russia, the traditional categories of activity—and of things and people—have been reëstablished and are firmly maintained. Art is art, a spade a spade, a proletarian a proletarian. Experiment belongs in scientific laboratories, not in the studios of painters and sculptors. Applying the Soviet measure to American artists, the verdict would be: Wyeth to the museum, Albers to the paint industry, Rauschenberg to a rehabilitation camp. In the U.S.S.R., a "primary structure" would be a building that kept out rain and cold, not an example of materialized aesthetics on the floor of an art gallery. "Minimal" art, if the Soviets had any, would be art for the retarded or for midgets. The literalism of Soviet aesthetics presupposes a world of common sense, as against the tendency in modern art to convert objects into metaphors, reduce them to ambiguous shapes, or, under the inspiration of physics and mystical philosophy, conceive them as charges of energy. Like antimodern thinking elsewhere, Soviet criticism does not hesitate to rest its appre-

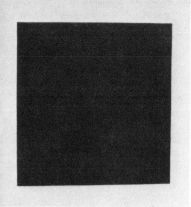

KASIMIR MALEVICH, *BLACK SQUARE,* C. 1913, OIL ON CANVAS, 42⅞ X 42⅞ IN. RUSSIAN MUSEUM, LENINGRAD

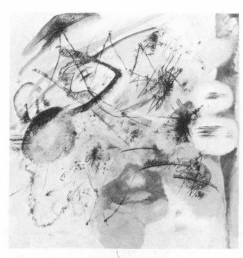

VASSILY KANDINSKY, *BLACK LINES NO.189,* 1913, OIL ON CANVAS, 51¼ X 51⅜ IN. COLLECTION THE SOLOMON R. GUGGENHEIM MUSEUM

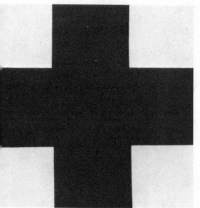

KASIMIR MALEVICH, *BLACK CROSS,* C. 1913, OIL ON CANVAS, 42⅞ X 42⅞ IN. RUSSIAN MUSEUM

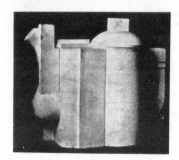

KASIMIR MALEVICH, TEAPOT DESIGNED FOR THE STATE
POTTERY, LENINGRAD, C. 1920

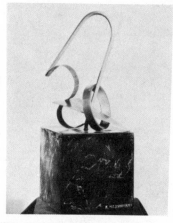

EL LISSITZKY, *PROUN 99*, OIL ON WOOD, 50¾ X 39 IN.
COLLECTION THE SOCIETE ANONYME, COURTESY THE YALE
UNIVERSITY ART GALLERY

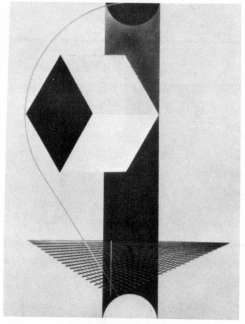

KASIMIR MEDUNIEZKY, *CONSTRUCTION NO. 557*, 1919,
TIN, BRASS, IRON, 17¾ IN. INCLUDING BASE, 7 IN. ALONE,
COLLECTION THE SOCIETE ANONYME, COURTESY THE YALE
UNIVERSITY ART GALLERY

ciation of works of art on comparisons with everyday things. Even Trotsky, despite his vision of psychological as well as social transformation, and his belief that "a work of art should, in the first place, be judged by its own law, that is, by the law of art," compared Tatlin's aesthetically significant cylindrical *Monument to the IIIrd International* to a beer bottle, and a Lipchitz Cubist sculpture to a hat rack. Abstract works, Trotsky thought, had to justify themselves by their usefulness; otherwise they were mere "exercises" which "it is better not to let . . . out of the studio."

The common-man logic of Soviet aesthetics sets it into conflict with the recurring impulse of avant-garde art to mix into reality in order to change it—an impulse that in the first decades of the Revolution deluded aesthetic radicals into regarding the Bolsheviks as their natural allies. The idea of transforming the world through art proved, however, to be anathema to the Communists. In the Marxist-Leninist philosophy, art, like ethics, law, and religion, is one of the cultural superstructures that are built upon the foundation of a society's economics and politics; it can initiate no effective social results of its own. Whatever artists imagine they are doing in their work, Communist theory holds, they are either furthering the power of the Revolutionary classes and its leadership or helping keep things as they are. The practice of the aesthetic avant-garde of putting art and reality on the same plane made it guilty, in the eyes of the Marxist-Leninists, of the heresy of "Leftism." In a more immediate sense, its notion that everybody can be a principal in the movement of social transformation was bound to appear as an abomination to the party of professional revolutionists. In her indispensable book *The Great Experiment: Russian Art 1863–1922,** Camilla Gray tells of the conflict between Bogdanov, Proletcult theoretician of an autonomous cultural road to Socialism, and Lenin, who demanded that all organizations, cultural included, be under the central Party administration.

Whatever effects the theory of superstructures may have had in politics—according to Hannah Arendt, it has prevented the setting up in Russia of a viable state—in art it amounts to a sententious formulation of the practical man's wisdom that material needs come before things of the mind, and that the latter ought to serve the former and not pursue ends of its own. "Art," wrote A. Y. Arosev, President of the All-Union Society for Cultural Relations with Foreign Countries, in 1935, "plays the role of a specific weapon [*sic*] for gaining knowledge of reality." In Russia, the conviction that "reality" stands waiting to be grasped by an educational art was prevalent long

* Harry N. Abrams, Inc., New York, 1962.

before Bolshevism; it was the basis of the populist aesthetics of the eighteen-sixties, which Chernishevsky summed up in his statement that "the true function of art is to explain life and comment on it." Setting up reality as the goal of art can lead aesthetically to almost anything: it justifies the realism of Courbet, the primitivism of Klee, the Abstract Expressionism of Kandinsky. Among the Bolsheviks, it led to a singular locking together of ideology and academicism, as the "Leftists" (Kandinsky, Malevich, Tatlin, Rodchenko, and scores of others) quit Russia or were shunted into non-controversial activities, and art became subservient to the views and tastes of Party personages empowered to decide what reality is for art at any given moment.

By 1932, the ruling bureaucracy was ready to promulgate its program of Socialist Realism as the exclusive aesthetic of Soviet society. By this step, the situation of art in the U.S.S.R. was made roughly equivalent to that in earlier authoritarian civilizations; not only was modernist experiment extinguished but also the conditions upon which modernism feeds—most centrally, the troubling historical awareness that continuing progress in new, scientifically based, socially useful skills that parallel painting and sculpture (e.g., photography, the popular arts, industrial design, light and color research) has put the future of art into question. In the Soviet Union, the artist's vocation was clearly marked off and moved into a neutralized zone. His function was to give "artistic form," with the accompanying traditional connotations of nobility and permanence, to the "content" chosen by his patron, the State. This elevation of Soviet life could be accomplished by nothing less than the "fine arts," sustained as they were by the prestige of past aristocracies and clerical cultures. No motion picture, abstract construction, no white-on-white could raise such themes as Stalin conferring with Lenin, or the first congress of workers, peasants, and soldiers, to the plane of fifteenth-century tapestries depicting the life of Alexander the Great.

The use of art to glorify Soviet fact with the aura of past greatness is implicit in a synopsis of the history of art in Russia since the Revolution recited by all the All-Union president, though Western intellectuals have been slow to recognize that communist art is deliberately backward-looking. "Instead of those currents [Mr. Arosev is referring to "Futurism, Cubism, Constructivism, etc."], which in their numerous theoretical manifestos and by their whole practice had urged the necessity of breaking with the art of past centuries, there came [a marvellous instance of the bureaucratic indefinite] other currents, which took a different attitude to the cultural heritage of the past. In

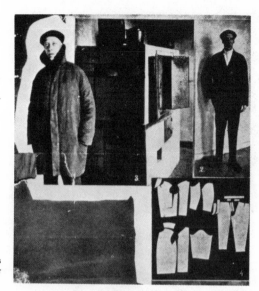

NEW WAY OF LIFE, A SET OF WORKER'S CLOTHES
MODELLED BY TATLIN AND A FUNCTIONALIST
STOVE, C. 1918

ALEXANDER RODCHENKO, *ABSTRACT PAINTING*,
1918, OIL ON CANVAS, 29⅜ X 22 IN. TRETYAKOV
GALLERY, MOSCOW

MIKHAIL LARIONOV, *SEA BEACH,* 1913-14, OIL ON CANVAS, 2?
27½ IN. COLLECTION BORIS TCHERKINSKY, PARIS

MIKHAIL LARIONOV, *SPRING 1912,* OIL ON CA?
33½ X 26½ IN. COLLECTION THE ARTIST, PARIS

spite of the movement of the 'Leftists,' the real historic development of Soviet art proceeded on the principle of *critical assimilation of the art of past centuries*." (His italics.) Cubism was, of course, also a "critical assimilation" of past art, but in the U.S.S.R. the point of the assimilation was to leave the appearance of masterpieces intact while slipping in the new Soviet themes, like faces in the cutouts of an old-time flashlight studio. These themes have remained in force decade after decade: Soviet leaders and heroes, episodes of Russian wars and uprisings, workers in heavy industry, peasants on collective farms, Russian landscapes and ethnic types, domestic and group occupations of women. Emotional qualities are also predetermined; as Soviet art is artistic, Soviet labor is happy, Soviet farming is picturesque, Soviet people are affectionate and courageous, and Soviet leaders are handsome, kindly, and far-seeing.

In dedicating himself to these "realities," the Soviet artist is restored to the pre-modern role of the craftsman who fills orders for art products, from war memorials to porcelain figurines for the mantelpiece. The relation between art and society is fixed, and the status of the official styles is guaranteed by the extinction of radical modernist "currents." The Soviets can rightly claim that they have conferred upon the artist a state of security lacking since the beginning of the Industrial Revolution. Above social and economic security he has received metaphysical security. Problems of change, both in art and in the cultural and psychological conditions of art, have been taken out of his hands; he need no longer speculate about the nature and value of this activity. While his work may fall out of favor, he need not anticipate its being rendered obsolete by sudden changes of taste, inseparable in democracies from changes in fashion. Most important, problems of creation, so disturbing to Western artists and art educators, since they involve transformations of the whole self, are eliminated in the Soviet scheme in favor of a crude concept of artistic talent as the natural capacity to respond successfully to the requirements of an accepted style. With the Party ideology as its intellectual background—in place of the clash of art movements that marks modernist creation—Russian art is serenely professional. Removed from history by the Party's monopoly on reality, and protected by decree against the erosion of its identity by the historical consciousness, Soviet art is exempt from the nervous scrutinizing of trends and possibilities that animates art elsewhere. In its stability, it has become a service industry, on a par with designing uniforms for the armed forces or restoring historic landmarks.

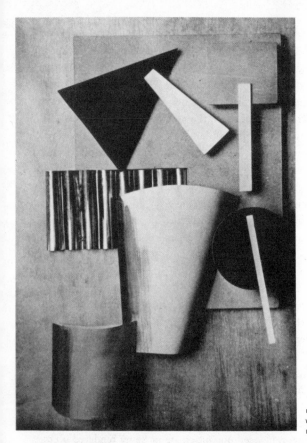

IVAN PUNI, *SUPREMATIST COMPOSITION*, C. 1915, WOOD, TIN-FOIL, CARDBOARD, OIL ON BOARD, COLLECTION ZHENIA BOGOSLAVSKAYA, PARIS

IVAN PUNI, *PLATE ON TABLE*, C. 1915, WALNUT WOOD, PAINTED CHINA PLATE, COLLECTION ZHENIA BOGOSLAVSKAYA, PARIS

Touches of "modernism" in recent semi-underground Soviet painting might lead to the belief that conditions have changed in Soviet art and that painting is now no longer required to be a "weapon" of reality. But while there seems to be no direct effort to prevent individuals from painting any way they like in the U.S.S.R. today, the public life of art is still strictly inhibited, and Socialist Realism is, by all evidence, still the art of the Soviet system.

Looked at through the Leningrad telescope, the shaky state of art in the United States appears as a highly desirable condition. Work of the official Soviet variety is produced in the United States, too—the reader will have noted resemblances between the Socialist Realist conception of high art and that of American illustration and portraiture and the techniques and values associated with the crafts—but what is called art here is largely something else. It is work that embodies the problematical nature of art in our time, that questions itself and, in so doing, also questions reality. Here, painting and sculpture are professions engaged in disengaging themselves not only from other professions but from what has been established as proper by painting and sculpture themselves. As Pollock's defiant paint-throwing captured a foothold in the tradition of painting, the artist himself abandoned his invention and sought a new path to the edge of art. At the height of its affirmation as an aesthetic mode, Action painting gives way to Happenings and to Pop, which are in turn succeeded by new borderline researches in optics and aesthetics. Under the pressure of the mass media and of industrial design, image-making and form are fused into everyday life, and the incessant activity of consciousness becomes a property of physical things. Di Suvero builds sculptures out of the beams of wrecked buildings, and Oldenburg aestheticizes bath fixtures by sewing them together out of cloth. The old idea of art as a mirror (fixed for desired distortions) held up to nature has in practice given way to the idea of art as a power of the free mind. In Leningrad, where advertising images are all but nonexistent and tables and chairs continue to be reproduced in the designs of forty years ago, things appear more solid than in New York; perhaps it is only an effect of their being old-fashioned. Enemies of modernism should be visually happier there than in Manhattan or the Loop. Leningrad itself, with its palaces, cathedrals, and broad, radiating boulevards, is a restored historic landmark, a kind of Williamsburg of the Czarist and Revolutionary past. In this worshipful atmosphere, the constant loss of identity by Western painting and sculpture becomes the paradigm of the changing identity of man in our epoch.

TIME IN THE MUSEUM

The exhibition at the Museum of Modern Art in New York entitled "The 1960s" avoided making any overt critical or philosophical assertion about the decade or the art produced in it. Possible disagreement regarding the selections was turned aside by the subtitle of the show, "Painting and Sculpture from the Museum Collections," which suggested an institution's summer inventory of its acquisitions of recent works. In contrast to such aggressive critical sorties of the past few years as the "Responsive Eye" show at the Museum of Modern Art, the "Primary Structures" show at the Jewish Museum, the "Post-Painterly Abstraction" show at the Los Angeles County Museum, the "Systemic Painting" show at the Guggenheim Museum, "The 1960s" was in the passive mood. It was offered without catalogue or preface, and all the exhibitions just mentioned, together with others that had been much discussed, were reflected in it. Two-fifths of its hundred and twenty-seven paintings and sculptures emanated from two sources—Philip Johnson and the Larry Aldrich Foundation—so the concept of the decade presented by the show seemed to owe much to their judgment; but Alfred Barr later explained to me privately that, although only a handful of the works were bought by the Museum itself, he and his staff were responsible for the choices. Faced by what seemed a built-in disclaimer, I was curious to know whether the omission of artists who seem to me of current importance—they range from Gottlieb and de Kooning through Alex Katz and Lester Johnson to Saul Steinberg and Fairfield Porter—was to be attributed to the circumstance that no works

done by them in the nineteen-sixties had been acquired by the Museum. On inquiry, I learned that paintings done in the sixties by most of these artists were available, as were sixties paintings by Rothko, Hofmann, Motherwell, and others, but that "The 1960s" exhibition was selected, as a Museum release put it, "to illustrate the contemporary movements, styles, and the forms of expression which seem most characteristic of the current decade," and that therefore these artists were all left out. Evidently some contemporary "styles and forms of expression" are (or seem) not "characteristic" of the decade, while others are. Artists like Gottlieb or de Kooning, it was explained, were typical of the nineteen-fifties rather than of the sixties, and their work was on display in another part of the building. This all seemed well intentioned, yet when I heard it I felt that all modesty had departed from the exhibition since verdicts of the utmost gravity were being delivered. That living artists were being expelled from the present and relegated to the Museum proper—that is, to the past—was hardly to be taken lightly, however lightly intended. Not so long ago these painters stood large in the sunlight, but though they continue to produce works and exhibit them, they—like spirits in Hades—no longer cast a shadow. Nor was it the relentless stream of time that brought them to this pass, for other artists, of the same age group and even older—Reinhardt, Calder, Nevelson, Fontana—were represented in the exhibition. It was their affiliation with the "styles and forms of expression" that the Museum now judged to be obsolete that deprived them of relevance to the living.

I noted, too, the names of some who, never prominent in the past, were also denied access to the present and were conveyed directly into the limbo of the Museum's general collection—artists such as Lester Johnson and Fairfield Porter who had come into the foreground only in the past few years yet had apparently failed to be characteristic of the nineteen-sixties. And what of Nakian and Saul Steinberg, who have been well known for three decades yet have not been characteristic of any? By the measure of "The 1960s" exhibition, none of these belonged in the present. A concept of time different from that of the calendar was obviously at work in the Museum, though no one there seemed to be aware of it. For all its reticence, the Museum had, by its acts of choice, proclaimed a theory about the Now in art. Inasmuch as some artists had been dropped from the decade and others denied admission, the decade itself as a living span of time had been redefined as consisting of a set of characteristic traits. As described in the Museum's release, these consist of "assemblage technique; 'stain' or 'color field' painting; systemic painting; hard-

edge abstraction and the shaped canvas; optical and kinetic art; 'primary' sculpture; and various forms of realism and 'pop.' " In sum, the decade has been stretched over a conceptual framework. When necessary it has even been pulled over the edge into the fifties; for example, two paintings and a collage by Jasper Johns, one dated 1954 and two 1955, were included, obviously to make the point that Johns' flags, targets, and objects in wooden frames assimilate themselves into the stripes and boxes prominent in optical and systemic painting and assemblage. There were also a 1959 Ellsworth Kelly, a 1957 Yves Klein, a 1958 Jean Tinguely, and 1959 paintings by Morris Louis and Frank Stella, all of whom are considered nineteen-sixties personalities. But the Museum's 1962 Hofmann, 1963 Tworkov, 1958 Sam Francis, 1959 Porter, 1962 Johnson, and similar non-conforming items had been placed outside "The 1960s" compound. Albers, Newman, and Cornell were also among the missing, and in a room where Frankenthaler, Louis, and Olitski were gathered, one missed their inevitable companion, Noland. Yet the presence of each of these was invoked in the appropriate chamber—Albers by the hard-edge, Newman and Noland by the color field, Cornell by the assemblage. They were present in their absence. But the absence of the Abstract Expressionists, and of landscape and figure painters, no matter how unorthodox, was an absolute absence. In the outdoor sculpture court a bit of air was, appropriately, let in between the categories by the inclusion of Calder and Ipousteguy. On the whole, however, "The 1960s" was as strict a survey of our ongoing history-making as one would expect to find in a freshman outline. Whatever the works started out to mean, here they were embodiments of the formulas and phrases by which the collective opinions of the art world have been shaped in this decade. Time in the Museum is a grocery list of the most actively publicized names, labels, and events.

It was precisely the collective thinking represented in "The 1960s" that made it (and its exclusions) significant as a reflection of current trends in the public life of art. Between the 1959 junk sculpture of Richard Stankiewicz or the 1960 kitchen-litter assemblage of Daniel Spoerri and the glass-and-chromium cube of Larry Bell or the painted-aluminum sections of Ronald Bladen, drastic changes have taken place in the selection and handling of materials, as well as in prevalent feeling, attitudes and ideas. Most obviously, painting has been steadily de-emphasized in favor of sculpture, craft, and technological constructions. The paintings in the exhibition were sandwiched between rooms of early-sixties assemblages and sculptures, among them a Rauschen-

HELEN FRANKENTHALER, *MAUVE DISTRICT*, 1966, SYNTHETIC
POLYMER PAINT ON CANVAS, 8 FT. 7⅛ IN. X 7 FT. 11 IN. COLLEC-
TION THE MUSEUM OF MODERN ART, NEW YORK, MR. & MRS.
DONALD B. STRAUS FUND

LARRY BELL, *SHADOWS*, 1967, GLASS AND CHROMIUM, 14¼ IN.
COLLECTION THE MUSEUM OF MODERN ART, NEW YORK, GIFT
OF THE ARTIST

RONALD BLADEN, *UNTITLED*, 1967, PAINTED ALUMINUM IN THREE
SECTIONS, EACH 108 X 48 X 21 X 120 IN. COLLECTION THE MU-
SEUM OF MODERN ART, NEW YORK, JAMES THRALL SOBY FUND

berg, an Ossorio, a Bontecou, an Arman, a Dine, and a genuine slum artifact by Ortiz—a burnt mattress—and rooms of current kinetic inventions and light displays.

Compared to the all-out associations of the assemblages with Happenings, and of the motorized and electrified constructions with science and industry, painting itself here took on a middle-of-the-road quality, which was enhanced by the fact that all canvases on display were not only familiar but thickly overlaid with art-historical justifications. In terms of number and variety, the paintings were a skimpy collection, arranged according to their ideological and technical affinities. After an overture of two blown-up silk-screened Warhol Art Nouveau Campbell Soup labels in luscious lavender, cherry, and orange, and the three Johns, came a group that might have been labelled the Bennington Acrylics—Frankenthaler, Louis, Olitski, Feeley—all of whom paint, or painted, with synthetics on unsized canvas. They were followed by painters of reiterated elements (Poons, Stella, Reinhardt, and Agnes Martin), then by Optical painters and a few assorted borderline cases (Dorazio, Kawashima); in one of the last rooms there was a swing back to some Pop and pre-Pop painters—Rivers, Lichtenstein, Wesselmann. As colored images, the canvases of Frankenthaler, Louis, and Olitski were arresting, especially when one came upon them after two or three roomfuls of assemblages. Miss Frankenthaler's abstract shapes had become more definite and emphatic than they used to be, and the Olitski and the larger Louis (I find his stripe paintings tiresome) were fairly daring, though in conventional terms. The weakness of these paintings is in the quality of their absorbed color, which they all share on a didactic basis. While the soaked in paint produces a uniform transparency, it results in a thinness that diffuses the eye instantaneously across the entire surface of the picture. As a result, the image in these paintings is all there is to them. Their quality is akin to that of the photograph or color reproduction; they could be cast on a screen without much loss. Perhaps this is what endears the work of these artists to art-historian curators, who are habituated to thinking of paintings as they appear in slides and reproductions.

Paul Jenkins, a pioneer in rolling luminous pigment on tilted canvases, was, to the credit of the Museum, given a place among the thin-paint contingent, though his metaphysical sensibility differentiates his work from their closed art-for-art's-sake dogmatism. Among the other "pure" painters, Poons and Stella were the most interesting. In completely different ways, both raise the traditional problem of the expressive scope of an art built entirely on the place-

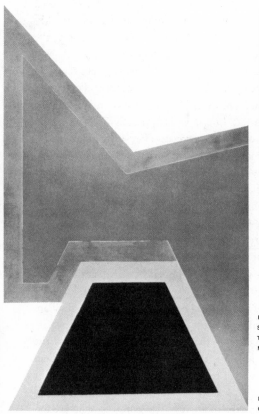

PAUL JENKINS, *PHENOMENA YELLOW STRIKE*, 1963-64, SYNTHETIC POLYMER ON CANVAS, 60⅛ X 39⅞ IN. COLLECTION THE MUSEUM OF MODERN ART, NEW YORK, GIFT OF MR. & MRS. DAVID KLUGER

FRANK STELLA, *WOLFEBORO 4*, 1966, 160½ X 100 X 4 IN. COLLECTION THE SOLOMON R. GUGGENHEIM MUSEUM

ment, reiteration, and variation of uniform elements. Musical-mathematical experimentation is a continuing strain in abstract art, and Poons is one of its most gifted younger practitioners. His two paintings in "The 1960s" exhibition were not of his eye-jumping phase, and their carefully bunched ovals, though all equal in size, brought to my mind the object-spotting on a bright one-color ground of certain Mirós. In the jutting angles of his shaped stretchers, Stella achieved a drama, essentially structural, that is lacking in his parallel-line exercises.

In all aspects of the recent art, materials assume priority in determining effects. The inherent luminosity of synthetic pigments parallels the qualities gained by the electrification and motorization of sculptural constructions. The complex mechanism of Pol Bury's slow-motion *31 Rods Each with a Ball* is an invisible element that projects the elegant aura of nineteenth-century music boxes. By contrast, the use of pencil and oil paint by Agnes Martin supplies in itself a traditionalist overtone that tempers the extremist reductionism of her graphlike compositions. That aluminum, chromium, stainless steel, and plastics are replacing older art materials, including junk and battered found objects—Louise Nevelson exemplifies the trend in her recent switch from wood to aluminum—represents an alteration in the social and psychological content of art as well as in its tonality and visual organization. The spread of new industrial products into the studios and workshops has brought with it the habits and moral outlook of the model manufacturing plant. An aesthetic of neatness, of clean edges, smooth surfaces, efficient construction, supervenes above the various styles to blend together color-field painting, hard-edge, shaped canvases, optical and minimal art—in fact, all of the modes identified with the latter part of the nineteen-sixties. From Stankiewicz's sinister 1959 *Natural History*, a package consisting of iron pipes and a boiler barely visible through a wrapping of rusty iron mesh, to the aseptic chromium-plated bronze effigies of Ernest Trova's continuing *Falling Man* series, a stride was taken much longer than the one from Rauschenberg's *First Landing Jump* to an absent de Kooning like *Gotham News*. Works of the early sixties composed of materials from the street and the junk yard participate in the city spirit of Abstract Expressionist painting; as the decade wears on, bohemia and the slums give way to the laboratory, and the measure of its span is from Oldenburg's plaster hamburgers to Flavin's fluorescent tubes.

Unfortunately, change refuses to take place in an orderly succession of

POL BURY, *31 RODS EACH WITH A BALL*, 1964, MOTORIZED CONSTRUCTION OF WOOD, CORK, AND NYLON WIRE, 29¾ X 19½ X 6½ IN. COLLECTION THE MUSEUM OF MODERN ART, NEW YORK, ELIZABETH BLISS PARKINSON FUND

TONY DE LAP, *TANGO TANGLES, II*, 1966, TWO-PART CONSTRUCTION OF SYNTHETIC POLYMER, EACH 13 X 13¼ X 13⅛ IN. COLLECTION THE MUSEUM OF MODERN ART, NEW YORK, LARRY ALDRICH FOUNDATION FUND

phases, and some artists did in 1960 what others are emphasizing now. But if decades are to be denominated in terms of qualities, the Museum of Modern Art's hunt for the currently characteristic should have led it to start the decade around 1962. By deleting from "The 1960s" all that junky stuff of Arman, Bontecou, César, Chamberlain, Latham, Gentils, Lindner, Mallary, Ortiz, Ossorio, Spoerri, Tinguely, and half a dozen "soft" (i.e., psychologically or technically tentative) paintings, those by Rivers, Copley, Kitaj, Rosenquist, Dine, Oldenburg, a much more unified—hence forceful—statement of the new taste and the values that support it could have been presented. Neatness is a physical manifestation of intellectual and social order; anarchists, bohemians, hipsters, tramps are presumed to be slovenly. The immaculate sculptures of Bell, Trova, Bladen, Morris, Flavin, Schöffer, and the equally tidy paintings of the Bennington Acrylics (Frankenthaler et al.), the Op painters, and Reinhardt, Kelly, D'Arcangelo not only immerse the spectator in a sheath of prophylaxis but reassure him of the operation in art of a rationale of conception, practice, and utility. The aesthetic of cleanliness has a political dimension; the fuss about banning thick paint, or "painterliness," from "The 1960s," derives from the wish to affirm middle-class tidiness and security represented by thin washes of color upon stretched fabric. In contrast, an artist like di Suvero, who continues to build sculptures out of stained, broken beams and twisted iron, identifies himself with social intransigence and resistance to the war in Vietnam. It is consistent with nineteen-sixties orderliness that sculptures should not be made "by hand" in the sculptor's studio but fabricated for him in a machine or carpentry shop, and that paintings should be blown up and manufactured for the artist in plastic and silk-screen. The gesture of Barnett Newman in covering with a patina of rust a sculpture made for him in a machine shop may be regarded as a protest against both the shiny surfaces and the rationalism of the kind of art with which he is usually identified. Critical catch phrases such as "color field," "hard edge," "primary," "systemic," though they are used to describe different modes of painting and sculpture, overlap to denominate a general movement in art in which sensibility is subordinated to aesthetic and technical systems. The art of the sixties is not *worked*—it is *done* according to plan.

Perceptual neatness and rationalized execution accommodate the art of the sixties to the new status of painting and sculpture as professions and as subjects of study and training in the universities. The typical smooth-surfaced, color-rationed, mechanically contrived, historically authenticated objects fa-

GENE DAVIS, *ANTHRACITE MINUET*, 1966, SYNTHETIC POLYMER PAINT ON CANVAS, 93⅛ X 91⅛ IN. COLLECTION THE MUSEUM OF MODERN ART, NEW YORK, LARRY ALDRICH FOUNDATION FUND

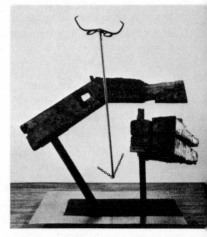

MARK DI SUVERO, *NEW YORK DAWN (FOR LORCA)*, 1965, WOOD, STEEL, IRON, 78 X 74 X 50 IN. COLLECTION THE WHITNEY MUSEUM OF AMERICAN ART, NEW YORK, GIFT OF THE HOWARD AND JEAN LIPMAN FOUNDATION, INC.

DONALD JUDD, *UNTITLED*, 1967, PAINTED GALVANIZED IRON, 15 X 76½ X 25½ IN. COLLECTION PHILIP JOHNSON

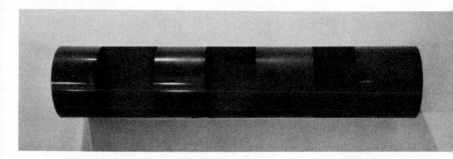

vored by dealers, museum officials, and advanced art reviewers look back to the craft-oriented procedures and house-beautiful objectives of the Bauhaus. As against the bohemian eccentric of earlier American art, the prosperous or institutionally connected personage of the new art leadership enters into direct dialogue with the middle class and its cultural programmers.

Optical and "minimal" art have introduced group formations and ideologies different in character from the older art movements. From Impressionism to Pop, the relation of the artist to his "school" consisted of a loose exchange of ideas and practices, often below the verbal level, in which each painter developed the implications suggested by his sensibility. In the new art, communication among individuals has often been superseded by individuals working together in teams. In Europe, the concept of creation was repudiated in favor of collective research by artists functioning in disciplined groups under a pledge of anonymity; the "project" was opposed to the creative act. The assumptions on which most of the art in "The 1960s" was based seem to lead inevitably to this conclusion of impersonality. The visual researches of Julio le Parc, for example, have proved astonishingly fertile, and would have gained nothing by repeating a single image in order to establish a signature.

Group exhibitions cut across personalities by their very nature, in order to present works that illustrate the ideas of their organizers. If the selection consists of masterpieces, each work also stands by itself as a summation of the artist's vision. In our time, masterpieces are no longer created; at any rate, they do not manifest themselves on the spot. Thus, for works to convey their full vitality they must be seen in the context of the artist's intellectual and emotional "system"—for example, in a retrospective. There was a depressing flavor about "The 1960s" exhibition that was in part attributable to the surface drift of art in the past few years. But the depression was also owing to the curtailment of individuals in favor of objects made in styles that had become familiar. A lesson-plan art-history survey, "The 1960s" not only excluded important figures for the sake of an ideological pattern but omitted the developmental dimension of the arists whom it did present—that is to say, their subjective time. The self-transformation of artists through their work is, however, the most interesting thing in art today. To think of the modifications during the past few years in the creations of artists of such diverse temperaments as Oldenburg, Nevelson, Liberman, Lindner, Poons, D'Arcangelo, Segal—to name a few in the show—is to shake off the enervating mood induced by the Museum exhibition. Besides the examples of home industry dis-

played as characteristic of the sixties, the actual sixties in art is constituted by the presences of artists like these—together with those disorderly presences whose Happenings and public manifestations, as by the "Provos" of Los Angeles, have gone beyond the encompassment of art by museums and perhaps past the borders of art itself.

Despite their size, the canvases in the "Large Scale American Paintings" exhibition at the Jewish Museum were not murals but, like the seventeenth-century tapestry in the Museum entrance hall, transportable pictures suitable for *any* wall large enough to accommodate them. They were essentially easel paintings—particularly today, when the "easel" is more likely to be the studio wall or floor than a piece of furniture especially designed to support a canvas. Even the largest painting in the exhibition, the mammoth "environmental" barricade by Al Held, could be dismantled and relocated with no more difficulty than a stage set.

Since these works were not made to fit a given architectural frame, the question was, Why are they so large? And why, too, not only the twenty-three paintings at the Jewish Museum but dozens of others parading through American painting of the past fifteen years, from Jackson Pollock's *Blue Poles* of 1953 through giants by Franz Kline, Barnett Newman, Clyfford Still, Mark Rothko, Adolph Gottlieb, Elaine de Kooning, Larry Rivers, Robert Motherwell, Larry Poons, Allan D'Arcangelo? By itself, bigness can produce certain psychological effects—for example, awe and the sense of being encompassed. Monumental buildings, statues, paintings convey an emotion akin to that aroused by gorges, waterfalls, mountains. Panoramic canvases by nineteenth-century Americans, such as *Niagara Falls,* by Frederick Edwin Church, and *Thunderstorm in the Rocky Mountains,* by Albert Bierstadt, attempted to translate the sublimity of size directly from nature. A similar ro-

manticism has tempted present-day observers to declare that largeness in paint-
ing is an American trait; wall-size paintings seem to go with skyscrapers and
three-thousand-mile turnpikes. "The scale of recent American painting,"
wrote a biographer of Pollock, "shows in some degree an . . . urge to attack
the vastness of the land mass as well as to echo it." Robert Motherwell, himself
a painter of giants, holds a similar view. In a recent version of his perennial
retelling of the origins of Abstract Expressionism, Motherwell credited Amer-
ican artists with introducing bigness into twentieth-century painting. "I
think," said he, "that one of the major American contributions to modern art
is sheer size." In the heat of recollection, Mr. Motherwell appears to have
forgotten that such ample works by Europeans as Monet's *Nymphéas* series,
Matisse's *The Dance*, Léger's *Le Grand Déjeuner*, Beckmann's *Departure*,
Picasso's *Guernica* got there first. It may be, however, that Motherwell meant
to accent the word "sheer" and to suggest that American artists have brought
into painting bigness for its own sake. This, with its implication of intellectual
and emotional vacancy, is a thought worth pursuing.

Size in painting (the physical measurements of the canvas) is, among artists
and critics, commonly contrasted with scale (the space generated by form,
color, rhythm, and other structural factors). The contrast is analogous to the
contrast in drama between the actual time it takes to perform a play and the
time compressed into the action of the plot (twenty-four hours, an eternity).
The problem of the artist, Klee wrote, is "how to enlarge space"; that is, how
to augment the scale of the work in relation to the size of the surface. Obvi-
ously, the larger the dimensions of the canvas the greater the difficulty in
creating a proportionate increase of scale. Thus, to undertake a big painting
has had the character of a grand risk, like a poet's decision to write an epic. In
the European paintings I have mentioned, the scale of each picture has been
made to interact with its size by means of the artist's idea: Monet's notion of
creating in his *Water Lilies* an "illusion of an endless whole, of water without
horizon or bank"; Picasso's outcry in *Guernica* against Franco's rape of Spain.
Something comparable to the metaphysical intentions of Monet and Beck-
mann is present in the large drip paintings of Pollock; as indicated in the chap-
ter on Pollock they were spurred by a ritualistic motive and the wish to pro-
duce an image with, to cite Pollock, "no beginning and no end." In *Blue Poles*
and *Lavender Mist*, size and scale are brought into a single focus by Pollock's
evoking of the transcendental creative event. The big picture has for him the
role of an absolute statement the meaning of which flows out over his lesser

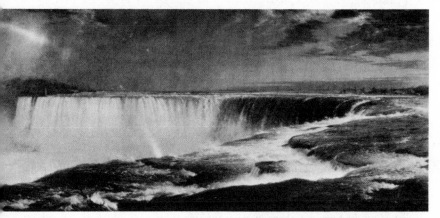

FREDERICK CHURCH, *NIAGARA FALLS*, OIL, COLLECTION THE
CORCORAN GALLERY OF ART, WASHINGTON, D.C.

JULES OLITSKI, *MAGIC NUMBER*, 1967, OIL ON CANVAS, 82 X
186 IN. ANDRE EMMERICH GALLERY, NEW YORK, COURTESY
THE JEWISH MUSEUM, NEW YORK

works. Bigness also represents finality of conception in such a painting as Newman's *Cathedra* or Gottlieb's *Coalescence*, which, like *Blue Poles,* provides the point of view from which to appreciate the artist's other works. Still and Rothko, on the other hand, presuppose an absolute statement in each canvas, so that bigness is an attribute of their subject matter and, as with painters of the Hudson River School, is present as a matter of course.

The notion of *"sheer* size" is distinct from the traditional concept of the big painting in that it eliminates the counter-concept of scale and, with it, the need to balance great expanse with an overriding idea or theme. Such a conception of size belongs, in my opinion, to an attitude in art more recent than the generation of Motherwell. It is a view in which the painting is no longer thought of as an image but has become a material object defined by its shape, dimensions, and hues. It is, one might say, nothing but itself; it has been relieved of the tension, inherited from the mind, between physical and subjective space. Such a painting is like a play whose only time dimension is the number of minutes it takes to perform it and which thus is indistinguishable from a real event—in a word, not a play but a Happening. Make the painting big enough or the Happening (or the plotless movie equivalent to a Happening) long enough and it becomes the large non-statement, an anti-*Guernica* or anti-*Water Lilies*. In the aesthetics of size, the artist's (or the spectator's) ability to maintain the psychic intensity of the creative insight is no longer relevant, and an area whose dimensions the artist may have chosen for any reason whatever (the largest wall in his studio, or the gallery where the picture will be exhibited) becomes the frame for the display of his picture-making process, be it accident, industrial craft, or some aesthetic system. The yardage of a "combine" by Rauschenberg is filled up by found objects and silk-screen reproductions, that of a composition by Warhol by printed serial images imitating the frames of motion-picture film, that of modular sculptures by sets of prefabricated units. The reduction of painting and sculpture to quantitative decisions—how big? how many?—achieves its visual essence in a bland or neutral space, a kind of bulletin board on which any marking or appendage finds itself at home. In painting, one of the first to practice art as indeterminate jotting, similar to the scrawls on a schoolyard fence or on the menu of a Bowery beanery, was Larry Rivers. At the Jewish Museum, the conception of space as a blackboard was represented by Cy Twombly's appropriately entitled *Untitled*.

With space desensitized, the difference between realistic and formal emphases in art disappears: "object" art (for example, an uncomposed presentation of a kitchen table and its random contents) becomes aesthetically identical with an art of measured areas of color or of reiterated geometrical shapes. The total effect is an ultra-naturalism in which a necktie, a plastic cube, and a sequence of parallel lines are equally "things," and which rejects as "illusionistic" even those structural aspects of painting (or drama) that represent the categories of space and time indispensable to cognition. Art and thought have never before got so far apart—by the application of reason, of course. The deletion from each of the arts of its human core of scale makes it possible to produce "mixed-media" works in which quantities of images, sounds, words, and the motions of bodies are blended into "real-life" spectaculars; in them the form of the news event has superseded all inherited forms. In speaking of sheer size, Motherwell appears to have hit on the principle of qualityless extension, which the new "environmental" art, with its various sub-classifications, from shaped canvases to process ("systemic") painting and minimal sculpture, has derived from the Abstract Expressionist background. Whether or not this art is an "American contribution" is difficult to determine, unless one is prepared to interpret sheer size in art as the accompaniment of the idolization in American political economy of the Gross National Product.

Only a fraction of the paintings at the Jewish Museum were "environmental" in the stylistic sense. In fact, the exhibition, which fell far short of covering the field of big paintings and seemed to be a summer show put together from what was handy, was distinguished by an unusual independence, in that it went outside the fashionable art modes to include figure painters and emblem- and symbol-makers, as well as second-generation Abstract Expressionists. The majority of the canvases were tableaux belonging to the pictorial order of the *Moses and Aaron Before Pharaoh* tapestry in the entrance hall. From Fairfield Porter's *Iced Coffee*, served on the porch, one could pass through Alex Katz's *Lawn Party* to Paul Georges's *Three Graces IV*, who had thrown off their clothes to dance in the field. Strictly speaking, these were not big pictures but bigger pictures; their size was not inspired by a large conception but resulted from the need for room into which to fit the chosen subject. By current standards, the canvases of Giorgio Cavallon (six by seven feet) and James Bishop (six and a half by six and a half) could not even be considered large. In the abstract compositions of Raymond Parker and Jack

CY TWOMBLY, *UNTITLED*, 1959, OIL ON CANVAS, 74 X 98 IN. SIDNEY JANIS
GALLERY, NEW YORK, COURTESY THE JEWISH MUSEUM, NEW YORK

ALEX KATZ, *LAWN PARTY*, 1965, OIL ON CANVAS, 108 X 144 IN. FISCHBACH
GALLERY, NEW YORK, COURTESY THE JEWISH MUSEUM, NEW YORK

Youngerman, the size of the whole was proportionate to the dimensions of the shapes constituting the pattern, to the same degree that the canvases of Porter and Katz were proportionate to the human figures depicted in them; none of these paintings would lose by being reduced or gain through enlargement.

The most interesting of the abstract tableaux were those of Robert Goodnough, Joan Mitchell, and Norman Bluhm. The sharp-edged, colliding shapes of Goodnough's *Vietnam III* established a direct visual reference to Picasso's *Guernica*—a rare example of a painting that makes a political statement exclusively through the means of art. In contrast, Mitchell's triptych *Chicago* provided no visible clue to its title; it was actually three related paintings in the manner that this artist has succeeded in keeping fresh. The most satisfactory pictorial handling of size in the exhibition, and in my opinion the best painting in it, was Norman Bluhm's *Santa Fe*, a composition consisting of two movements—a wide, overhead curved stroke of cherry red and a nether swing of black—confronting each other in an explosion of Action painting splatters. The tension of this inward-circling image was sufficient to compress the nine-foot height and eighteen-foot length of the canvas into a painting that is visually much more compact. Like the large Pollocks, Newmans, and Gottliebs, *Santa Fe* represents a creative synthesis of the artist's concepts that engenders new feelings about his other paintings.

Distinct from the tableau is another type of big painting, especially familiar since the nineteenth century—the panoramic segment of landscape that, lacking a compositional center, gives the impression that it could be extended indefinitely in any direction; the Rocky Mountain and Niagara Falls canvases I have mentioned fall into this classification, which Monet raised to the level of philosophy. In twentieth-century abstract art, nature as the visible scene has been transformed into nature as energy typified by the activity of the artist. Instead of the broken horizon of the Rockies, the up-and-down movement of the paint strokes forms the panorama of an inscribed landscape. The flow in Pollock's *Blue Poles* is that of writing, largely from left to right, with the poles themselves generally taking this direction, but in vertically inclined shoots that serve to "polarize" the continuous scribble of the dripped paint. Below the line of the horizon the compositions of Church and Bierstadt "read" similarly from left to right. At the Jewish Museum, panoramic abstraction was represented by Lee Krasner, Pollock's widow, by Milton Resnick, and, in a restricted sense, by the pencil-marked canvas of Cy Twombly re-

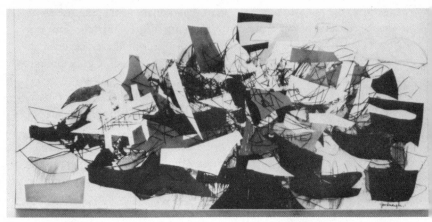

ROBERT GOODNOUGH, *VIETNAM III*, 1967, OIL ON CANV
96 X 180 IN. TIBOR DE NAGY GALLERY, NEW YORK, COURT
THE JEWISH MUSEUM, NEW YORK

NORMAN BLUHM, *SANTA FE*, 1967, OIL ON CANVAS, 108 X
IN. COLLECTION THE ARTIST, COURTESY THE JEW
MUSEUM, NEW YORK

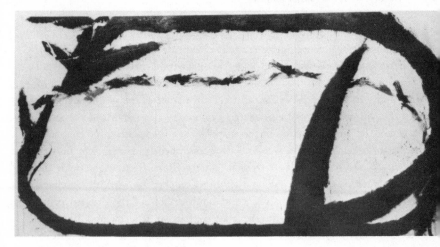

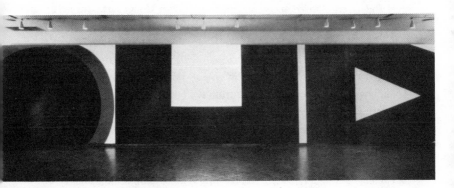

AL HELD, *GREEK GARDEN*, 1966, ACRYLIC ON CANVAS, 144 X
672 IN. ANDRE EMMERICH GALLERY, NEW YORK, COURTESY
THE JEWISH MUSEUM, NEW YORK

AD REINHARDT, *UNTITLED*, 1950, OIL ON CANVAS, 76 X 144 IN.
COURTESY THE JEWISH MUSEUM, NEW YORK

ferred to earlier. One of Resnick's most aspiring efforts, *Swan*, almost ten feet high and twenty-three feet long, swims among Monet's measureless water lilies. The movement is entirely horizontal, without a form or counter-thrust to impede it; lacking the check of the foreground tree trunks in Monet's panorama or the poles in Pollock's, *Swan* is formally closer to the Hudson River School. What makes it a painting of our time is that, following Pollock, Resnick was able to release himself from the observation of an actual outdoors in order to arrive at a continuous activity modelled on Monet's gesture.

The replacement of action by activity, or process, also manifest in Miss Krasner's *Combat*, marks the passage from Action painting to "environmental" art. Ernest Briggs made the transition the subject of his *Homage*. Within an expanse of vaguely toned, soaked-in color he composed an insert of Abstract Expressionist fragments featuring shapes derived from de Kooning's *Pink Angels* period. Another semi-environmental painting, in the sense of exploiting the quantitative idea of the one-color area but without committing itself to it, was Dzubas's *Firebird*, a narrow, twenty-foot-long streamer of red with a detailed vignette at its left end. Also approaching an "environment," but refusing to move in, was the painting of Knox Martin, who for years has followed the strategy of never getting on a bandwagon but running alongside it. The true "spatialists" in the show included Gene Davis (ten-foot-high colored stripes of even width forming a stockade just short of nineteen feet in length), Ellsworth Kelly (three sixty-five-inch-square panels, one red, one yellow, one blue), and David Budd (a seven-by-fourteen-foot black painting bisected by a white curving line that near one end breaks into dots and dashes of color).

The most intellectually expressive "environments," however, were those of Jules Olitski and Al Held. Olitski's *Magic Number* (despite its coolness, quantitative thinking tends to be hospitable to magic) is a wide yellow curtain whose single hue descends to a thin edge of blue and orange and a corner of white, as if the yellow concealed an outdoors. Perhaps *Magic Number* intends to represent a quantity that excludes the disorder of the daylight world. Thomas Hess has remarked that the light of this painting comes from the inside, like the light of TV, instead of from a point behind the spectator, as in Renaissance paintings. In calling his colossus (twelve by fifty-six feet) *Greek Garden,* Held may have wished to associate the ancients with Madison Square Garden in a side wink at Pop; certainly there is nothing vegetational about his painting. More likely, though, the Greek reference pertains to the basic geo-

metrical forms that constitute the layout of *Greek Garden:* a circle, a square, and a triangle. Held's primary shapes appear to constitute a rebuttal of the primary colors of Ellsworth Kelly; as against the latter's red, yellow, and blue, the color in *Greek Garden* is purposely dampened into disagreeable combinations of brown on brown, white on black, yellow on green, in order to deprive the huge surface of any effect but that of size. In this painting, the dimensional aesthetic reaches its strictest statement. Unlike color-field painting, which drowns the consciousness in rainbow translucences, *Greek Garden* forces the mind to work by making emptiness unpleasant. Held seems to have realized that the exaltation induced by sheer size does not last; the vast paintings of the vast spaces of America became fashionable as quickly as a new tourist site and for about as long. In the United States, there is a correlation between the gigantic and the transitory. People turn their backs on the Grand Canyon and take to reading magazines in airplanes above the clouds. Held's circle, square, and triangle assert that in the midst of magnitude the most elementary forms of the intellect take over. This may prove to be the major discovery of "environmental" art about the American environment.

HYPOTHESIS FOR CRITICISM

In his article, "In Praise of Hands," written thirty years ago, Henri Focillon extols the hand as an organ of thought. "The most delicate harmonies," he writes, "evoking the secret springs of our imagination and sensibility, take form by the hand's action as it works in matter." It is the hand, he holds, not the eye, that discovers and investigates surface, volume, density and weight. Thus Focillon is enraptured with Hokusai, in whose compositions "you can see the hand move about . . . nervous and rapid, with a surprising economy of gesture. . . . The violent mark it deposits on this delicate substance, this paper made of scraps of silk . . . dots, blots, accents, and those long crisp lines . . . all convey to us the world's delights and something not of this world but of man himself." Considering Focillon's enthusiasm, one would expect him to judge paintings by the range and quality of the evidences of the hand shown in them. The kind of cool, preconceived, immaculate, "non-painterly," in sum, bodiless, abstractions currently prominent in American art would seem to illustrate the kind of painting that would fall under his ban. Focillon, however, though with apparent reluctance, rejects the impulse to rank paintings according to the artists' modes of handling their surfaces. The issue, he realizes, is one of substance not manner. Thus his essay tells of a young artist who boasted that in the landscape he had painted every touch of the artist's hand had been extinguished. Focillon is not perturbed. If the painter wished to reject manual virtuosity, if his hand chose to negate its visible traces, that too constitutes a manual statement; it affirms a taste for order

and permanence, for a rational conquest of the accidental, and for an "austere desire to eliminate his personality and to plunge with all modesty into a great contemplative wisdom, an ascetic frugality." In art, personality turned against itself results in another kind of personality. By cleansing his work of the imprint of the organic, by purging it of "expression," the artist causes it to become expressive of his passion for self-transcendence. The late Ad Reinhardt, whose satin surfaces constituted a polemic against Expressionism, was an Expressionist in this sense.

Both poles of the behavior of the hand in art—as alive on the canvas and as rendering itself invisible—were from the start prominent in Abstract Expressionism. The decisive role of manual tracks, including accidental slips, runs, blots, fingerprints, in the paintings of Pollock, de Kooning or Kline did not prevent an intellectual and aesthetic exchange between these works and the relatively impassive tablets and veils of such contemporaries as Tobey, Rothko, Newman, Gottlieb and Still. What distinguished the Action painting wing of Abstract Expressionism from their fellow image makers was the coalescence in the act of painting of undifferentiated movements of the body and mind. In a manner akin to certain dances of the East, or to an industrial skill like diamond cutting, all the physical and intellectual energies of the artist were concentrated in heightened pitch in the digital extremities. At the same time, this concentration was entirely exploratory—one might almost say, explosive. Its function was total creation on the spot, not, as in the relaxed, freely associative state of the Surrealists, the formation of an image in the mind to be transferred to the canvas. Never before had the action of the artist taken place in so extreme a liberation from external direction—for example, that oppressive sense of the layman's demand for an identifiable subject or message in a painting which inhibited Klee. It is this freedom of manual movement, extending to the farther side of virtuosity, that, reflecting the social isolation of American art in the decade after the war, is the link between the formal characteristics of Action painting and the historical circumstances (the "cultural crisis") out of which it emerged.

That a meaningful image could be realized through the spontaneous "thinking" of the hand was a radical idea, if not an altogether new one—an idea which is still misunderstood by people trained to believe that all forms originate in, or are inherited by, the mind, and that consequently the absence of mental planning can only result in formlessness. The reductive (or "ascetic") symbolism developed conceptually by the contemplative Abstract Expres-

sionists was intellectually more accessible, by association with earlier visionary painting, for example, that of Redon, than the calligraphy of the Action painters. Yet with both groups of Abstract Expressionists what counts is the tension focussed in the image by the handling—the impact of a Rothko, Newman or Gottlieb lies not in the metaphysical connotations of its oblongs, rectangles or ovals but in the expansion and compression of the surface by which the artist's psychic state is conveyed. The notion of antagonistic aesthetic directions within Abstract Expressionism is an ideological superimposition of later critical writing rather than a fact of the actual historical development. In many of the later paintings of Hans Hofmann, a remarkable range of spontaneously instigated gesticulations of the brush—wherein, as Focillon says of Hokusai, "the hand seems to gambol in utter freedom, and to delight in its own skill"—is combined with carefully premeditated rectangular, even-surfaced slabs of unruffled yellow, red or blue. In emphasizing the autonomy of the hand while negating that autonomy in the same picture, Hofmann seems to insist on the futility of a dogmatic approach to handling—which did not save him, however, from being presented as a painter of "flat" color areas in an ideologically contrived posthumous exhibition.

In art, the hand represents the boundary between human action and mechanical or chemical process. In breaking contact with his pigment by throwing it off the end of a stick or pouring it from the can, Pollock brought the painter's act to an extreme of physical release; one step more was sufficient to carry it out of the artist's control into automatism and chance. After Pollock's paintings had become popularly familiar, machines appeared with which by inserting a coin one could make an "Action painting" through regulating spurts of color upon a whirling sheet of paper. Since then, it has become the rule among artists of the avant garde to execute paintings with paint rollers, silk-screen printing and other touch-eliminating devices and to have sculptures produced in factories or to assemble them from ready-made elements. To this type of art Focillon in 1936 raised prophetic objections. Though he had come to terms with art in which the hand conceals itself, the possibility of paintings from which the manual touch would be entirely absent filled him with disquiet. In art made by machines, he declared, "the cruel inertia of the photograph will be attained by a handless eye," resulting in an absence of physical responsiveness attractive and yet repellant, "like the art of another planet, where music might be a mere graph of sonorities, and ideas might be

exchanged without words, by wave lengths." The ultimate quality of such an art, Focillon contended, would be loneliness and estrangement.

The nub of Focillon's position is its resistance to attempts of twentieth-century vanguardism to sever the ancient connection between art and the crafts. Twenty-five years before the publication of "In Praise of Hands" the issue of ending the identification of art with handwork had been given ultimate formulation by the act of Marcel Duchamp in exhibiting factory-made objects as works of art signed by him. Today, this act has taken on the authority of a sacrament. As noted earlier, Duchamp's deed was a decisive event in art history. Yet Duchamp himself contributed nothing to the expansion of consciousness in the art act. Keeping in mind the effect of Duchamp on art as making, it is tempting to define art as that form of thinking that arrives at its conclusions through the physical handling of materials. This definition offers practical advantages that are worth considering. With art thus defined no aesthetic premise is accepted as valid that does not anticipate that it will undergo alteration by the artist's engrossment in the sensuousness of his medium. In short, a wholly brain-generated art is rejected on principle. Paintings illustrating aesthetic verities, whether Abstract Expressionist, Pop or Minimal, are classified as blackboard demonstrations rather than as works of art. Eliminating the unique manual impress, or, by contrast, duplicating its appearance for the sake of effect, is recognized as furthering, under present conditions of mass production in the arts, the assimilation of painting and sculpture into the system of directed creation dominated by Hollywood and Madison Avenue. A picture or object worked out mentally and realized in paint, plastics or metal by mechanical means is considered to belong to the practical arts—fabric design, perhaps, or architectural ornament. Blowups, like the Picasso monument in Chicago, escape falling into the category of reproductions only when their final form represents a collaboration between the artist's sketch or model and the free exercise of skill by artisans responsible for the enlargement.

The concept of art as thinking fused with doing offers a point of resistance to the present trend toward incorporating the arts into the mass media, on the one hand, and subjecting them to ideological manipulation by an avant-garde academy, on the other. The hand, that primitive instrument on which each of us still depends, wishes to conserve its limited powers against the overwhelming forces let loose upon the imagination by the deluge of technological innovations, from synthetics to transistors. The hand, it is safe to say, has a natural

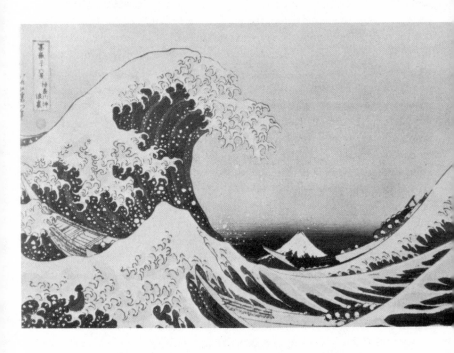

KATSUSHIKA HOKUSAI, *THE GREAT WAVE OFF KANAGAWA*
1823-1829, THE METROPOLITAN MUSEUM OF ART, TH
HOWARD MANSFIELD COLLECTION, ROGERS FUND, 1936

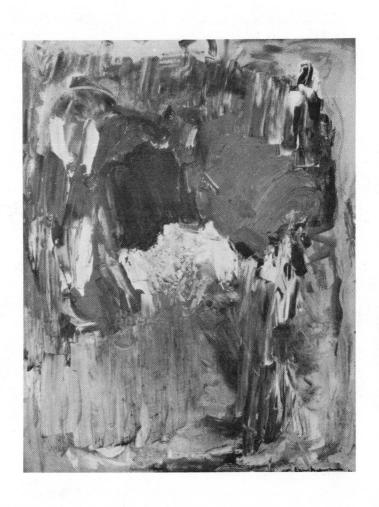

HANS HOFMANN, *CHEERFUL REVERIE*, 1961, OIL ON CANVAS,
50 X 40 IN. COLLECTION MR. & MRS. HAROLD ROSENBERG

preference for a pencil over an instrument panel. As far as it is concerned, the medium is never the message, if for no other reason than that the hand knows that what an instrument produces depends on how it is used. The reduction of the spectator to passivity through chemical or electronic stimulation of reflexes is irreconcilable with art conceived as a manual activity. Whatever the value of environmental art and audience-participation, passivity is not a value of art. Poe envisioned the poet as systematically pulling the strings of his reader's sensibility; his author-sorcerer, however, confined himself to the apparatus of sound, rhythm, imagery provided by *language*, a direct relationship of power within a shared human situation. In contrast, the present-day "artist-technologist," as one observer recently named the manipulator of mass responses, draws increasingly on the laboratory and its products, whether acids or strobe lights, and his operations have not necessarily more to do with art than has the third degree. To attach the title "art" to the application of instrumentalities of physical and mental breakdown is simply a way of demanding the privilege of unlimited experiment on human beings. In self defense, we ought to assert that there is no such thing as an artist-technologist. Though the artist and the engineer are both capable of affecting the human organism, the difference in their reasons for doing so prevent them from having anything in common.

One should like to post these thoughts, and the notion of the centrality of the hand associated with them, on kiosks prominently placed throughout the art world. They might on occasion interrupt the rush toward the old-new and even create a distraction from paradoxes that have grown tiresome—for one, that the most advanced art is art that has gotten farthest away from art through the logic of historical evolution. Creation needs to limit the role of the head, and in painting and sculpture the hand would seem to be best fitted to provide this limit.

What is troubling, however, is that the hand is a symbol of the craft outlook. When Focillon conceives art as "struggling with the hardness of things" he seems to find the ultimate meaning of art in the experience of the handicraftsman, though, as we have seen in his appreciation of Hokusai, his thought goes beyond craft to the free movement of the responsive self. The relation of art to craft can never be dissolved; but it is not an absolute relation—it is subject to the historical transformation in the practices, social functions and materials of both. The misunderstanding of these changes, and the impatience of artists with attitudes inherited from the tradition of art as "making," is in

large part responsible for the prominence of anti-art ideas and works in the art of this century. Art that continues to consist of "struggling with the hardness of things" represents a stubborn reluctance to grasp the meaning of the age. In regard to the craft view, anti-art is liberating.

But anti-art can be stifling, too. Half a century ago, Duchamp's act in *declaring* art instead of fabricating it, was part of the vanguard effort to draw painting out of the salon into the realities of the city; the same act today is strictly of the salon. To cure the anonymity of factory-made objects by the signature of the artist presupposes that he possesses an individual identity—an assumption that might have been viable fifty years ago but which today, with the conditions of mass society advanced by half a century, is highly questionable. Indeed, the deliberate negation of individuality has become the project of much machine-inspired art. The end result would be a featureless object authenticated as art by the signature of nobody. Expanding the dimensions of the individual, or contracting them, continues to be the ultimate preoccupation of art in our time, and it is in the light of this preoccupation that the role of the hand in art should now be seen.

LIGHTS! LIGHTS!

Among the first offerings of the new art season was, not unexpectedly, an Environment; that is (to attempt a definition), a work that encompasses the spectator, or gives him the feeling of being encompassed, instead of confronting him with an object or image to look at. A collaboration between an architect and a sculptor brought into being a labyrinth of tall panels painted red on one side, yellow on the other, and set in slanting rows of L-shaped pairs; as the spectators passed through the corridors thus formed, their movements turned sounds on and off. What these sounds, composed by the sculptor, were like, how they related to the colors and dimensions of the painted slats, and how they affected one's sense of being surrounded by and made part of the operating mechanism of the construction, I am unfortunately unable to report, for when I visited the exhibit the sound apparatus was out of order. This, too, was not completely surprising. Environments in art, as in actuality, have a way of breaking down, and people who have been frequenting such combinations of stage setting and mechanical activity have learned to take partial, and even total, collapse in their stride. Since the early Happenings, one of the chief sources of Environmental art, foul-ups have been accepted as aspects of the production. Robert Whitman, an old Happenings hand, is described in Michael Kirby's *Happenings* as considering accidents to be "an integral element of the Happening." Complacency about nonfunctioning and malfunctioning was encouraged by the Buddhist-derived aesthetics of resignation that was promoted by John Cage, who in planning his concerts welcomed street

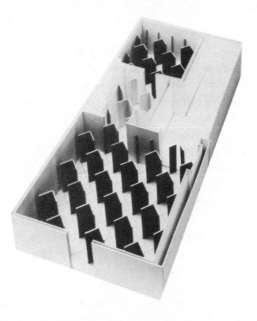

JOHN LOBELL AND MICHAEL STEINER, *ENVIRON-MENT IV: CORRIDORS,* COURTESY THE ARCHITEC-TURAL LEAGUE OF NEW YORK

LOUISE NEVELSON, *ATMOSPHERE AND ENVIRON-MENT I,* 1966, ENAMELED ALUMINUM, 78¼ X 144⅜ X 48½ IN. ON FORMICA-COVERED PLYWOOD BASE IN EIGHT SECTIONS, EACH 14 X 18 X 15⅛ IN. COL-LECTION THE MUSEUM OF MODERN ART, NEW YORK, MRS. SIMON GUGGENHEIM FUND

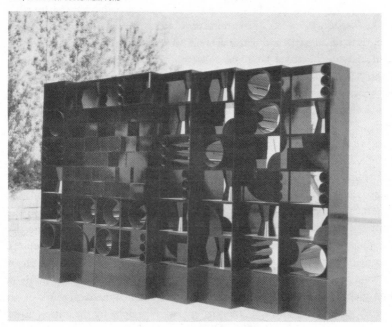

noises, radio static, and the errors of instrumentalists as contributions (divine?) to the total musical occurrence. Another legitimation of mishap comes from the practice of the Action painters of leaving drips, blots, and fingerprints in evidence on the canvas and inducing accidents as a way of stimulating compositional ideas. Art history aside, however, an Environment, even when it stops "working," is an Environment still; its temporary impotence may even evoke a new sensation—that of relief. It has also been argued that mechanical failure adds creative authenticity to the event; after all, the outstanding feature of the conveyor-belt products of the entertainment business is that they do work.

In any case, Environments, whatever happens in them or fails to happen, have made people aware that one is always somewhere and in a state of more or less conscious sensitivity to what is around. This insight seems sufficient to have made "Environment" the most pervasive word in the art world today; to label a project an Environment qualifies it as significant and avant-garde. Pop Art novelties designed for the mass market—such as inflated plastic chairs, slogan-bearing buttons, comical dishes—command notice in art sections of the press as Environmental creations that embody the style of our surroundings (which, of course, they in fact do not). The American exhibit at the 1967 São Paulo *Bienal* was called "Environment U.S.A. 1957–1967," and the large sculptures set in parks and plazas around New York City as part of the Cultural Showcase Festival bore the collective title of "Sculpture in Environment." "Environment" has translated that recondite term "space," which aesthetics shares with physics and mathematics, into the homey, everyday idea of place; in its present use, "Environment" is a Pop word. To praise a work, a critic will now speak of "the power of its presence on the environment," whether that power is exercised by a gray box silently posed in an empty hall or by a blinking, squawking contraption as hard to evade as a nagging nerve. According to a catalogue statement by a young museum director, a wedge-shaped construction of sheets of plastic makes the room "lose its boundaries. The lines of the room . . . find a symbolic end-point in the sculpture; this turns the room in on the sculpture and makes it part of the sculpture. By absorbing the lines of the room, the sculpture becomes a tension-filled object, energizing the whole room." Apparently, the sculpture swallows the room, blowing itself up like Aesop's bullfrog and making the room jump inside it. This may be difficult to grasp, but it indicates the new need to think of art Environmentally, even if the "energizing" has to be done by the critic's prose.

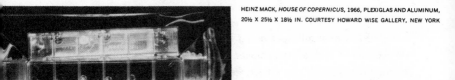
HEINZ MACK, *HOUSE OF COPERNICUS*, 1966, PLEXIGLAS AND ALUMINUM, 20½ X 25½ X 18½ IN. COURTESY HOWARD WISE GALLERY, NEW YORK

KATZEN, *ENVIRONMENT VI: LIGHT FLOORS*, COURTESY THE
ARCHITECTURAL LEAGUE OF NEW YORK

NICOLAS SCHOFFER, *MICROTEMPS 11*, 1965, MOTORIZED
CONSTRUCTION OF STEEL, DURALUMINUM, AND PLEXI-
GLAS, IN BLACK WOOD BOX, 24⅛ X 35¼ X 23¾ IN. COLLEC-
TION THE MUSEUM OF MODERN ART, NEW YORK, FRANK
CROWNINSHIELD FUND

Anything, naturally, put down in a given area changes that area. How an object transforms its environment and turns it into a work of art was thoroughly investigated by Wallace Stevens in his "Anecdote of the Jar":

> I placed a jar in Tennessee,
> And round it was, upon a hill.
> It made the slovenly wilderness
> Surround that hill.
>
> The wilderness rose up to it,
> And sprawled around, no longer wild.
> The jar was round upon the ground,
> And tall and of a port in air.
>
> It took dominion everywhere.
> The jar was gray and bare. . . .

In teaching drawing and composition, Hans Hofmann urged his students to see the model as situated in an all-active space. Objects, no matter how immobile, can also be conceived of as quivering with an inner *élan;* I think of Arshile Gorky discovering that rocks were "in motion" inside, and of Jules Romains' descriptions of the currents of vitality streaming through the streets of Paris in *Death of a Nobody* and the bursting colors of vegetables in a grocer's bin in *The Body's Rapture.* The notion of an active universe extends across a wide range of sensibilities, from the mystical to the scientific; it is on this basis that writers have found resemblances between the spottings and errant lines of Pollock's paintings and the diagrams of electronic phenomena in physics manuals.

Still, there is an enormous qualitative difference between an intuition of all living things having a living envelope and the conception of an Environment designed to shoot stimuli into those who enter it. In the main, current Environmental art leans toward an "energizing" of enclosures that immerses the spectator in a Turkish bath of sensations. A statement issued by the Architectural League for an exhibit entitled "Environment II: Prisms, Lenses, Water, Light" declares, "Here the spectator actually becomes a part of the environment, seeing and being seen through lenses, unable to avoid the effects of pulsing lights, falling water, and colors and forms reflected onto the walls." The key phrase in this is "unable to avoid"; the capture of the spectator by

the work and his subjection by it to controlled effects is the radical principle introduced by Environmental art. This subjection fundamentally alters the relation between the artist's creation and its intended public. On this ground alone, Environmental art is without doubt the most avant-garde art mode of the nineteen-sixties—if we take avant-garde to mean the type of art that, regardless of art values, makes all other kinds of art seem a thing of the past. The Environmental concept spontaneously associates itself with the all-out wherever it appears—whether as the be-ins of the hippies or Artaud's audience-enveloping "theatre of cruelty." The unavoidable reflex controlled by a "programmer" is recognized to be the condition indicated by McLuhan's unavoidable slogan, "The medium is the message." An amusing version of the overpowered spectator playing his part in Environmental art was presented in a photograph taken at the exhibition in the Paris Museum of Modern Art entitled "Light and Movement." It showed the Israeli Op artist Agam and an unidentified companion gazing upward in awe at a spot of light on the ceiling, and the caption was "Light Responding to Verbal Commands." The scene had an overtone of Moses and the Burning Bush.

In Europe, the art of lights and movement has for several years taken the lead in pointing toward a future beyond painting and sculpture. The novelty lies less in illuminated entertainment and mechanized art as such than in the motives and outlook of the artists. Historians like to recall fireworks displays in the royal court of medieval China and mobiles in festivals at Versailles; at Mexican folk fiestas, pinwheel fireworks constructions called *castillos*, some of them thirty feet in height, howl and whistle as they burn themselves up. In more recent art history, Environments look back to geometric abstraction in painting and sculpture and to the functionalist aesthetics of the Bauhaus and the Constructivists, but they draw also on Happenings and mixed-media performances. Fun-house props and new-design products belong to the Pop element in the Environmental scheme. More important, however, is the relation, for better or worse, between environments and new social and psychological conditions. Bauhaus constructions were a new way of stylizing our physical surroundings, but they did not change the nature of architecture or house furnishings. Environments by contrast appear in a period when managed, or programmed, living space, from dwellings to metropolitan "cores," is envisaged by architects, engineers, and community planners as dominating the movements, the sensations, and, ultimately, the decisions of human masses. Space travel, too, has brought the necessity for a completely controlled en-

OTTO PIENE, *BONN OPERA HOUSE LIGHT INSTALLATION*, COURTESY HOWARD WISE GALLERY, NEW YORK

DAN FLAVIN, *PINK OUT OF CORNER — TO JASPER JOHNS*, 1963, PINK FLUORESCENT TUBE IN HOLDER, 8 FT. X 6 IN. X 5⅜ IN. COURTESY THE MUSEUM OF MODERN ART, NEW YORK

CHRYSSA, *FIVE VARIATIONS ON THE AMPERSAND*, 1966, CONSTRUCTIONS NEON LIGHT IN TINTED PLEXIGLAS VITRINES, COLLECTION THE MUSEUM MODERN ART, NEW YORK, GIFT OF DOMINIQUE AND JOHN DE MENIL

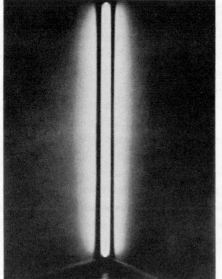

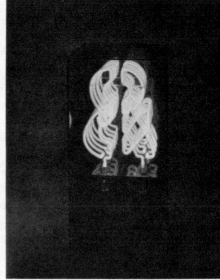

vironment, both within the vehicle of transportation and at the point of arrival. To Buckminster Fuller, the living conditions of the astronaut are the first instance in human history of totally regulated space occupancy, and to him the astronaut's cabin provides the ultimate model for planned utilization of the world's resources. (Fuller seems to neglect the dungeon as an earlier organization of space to control living.)

Responding to phenomena of this order, Environmental painters and sculptors carry their medium into the domain of architects and engineers by conceiving within the general environment another, more intimate physical context to which the human being must respond—one that underlines, for example, what light, noise, and motion can do to his nervous system. European Environmentalists especially have engaged in renewed questioning of the viability of art and of the position of the artist as creator in the technological epoch; hope has been revived that art will fade into activities more consonant with the structure and pace of the modern city. Vasarely, the outstanding practitioner of Op painting, is now quoted as wishing the art object to disappear entirely and to be revealed only in its effects. Throughout the Continent, artists have formed groups, many calling themselves anonymous, that approach art as "research." One such group, the Centre for Advanced Creative Study, with headquarters in London, a few years ago quoted Mondrian's call for "the end of art as a thing separate from our surrounding environment, which is the actual plastic reality," together with his prophecy that "by the unification of architecture, sculpture, and painting . . . a new plastic reality will be created. Painting and sculpture will not manifest themselves as separate objects . . . but . . . will aid the creation of a surrounding environment not merely utilitarian and rational, but also pure and complete in its beauty."

The impulse to get rid of the art object is supported by several lines of argument, some deriving from traditional avant-garde attitudes, others newly discovered in the apparent incompatibility of the art "thing" with the dynamics of industrial mass society. Artists of the Catholic nations of Europe and from Latin America demand the "desacralization" of art and condemn the worship of the art object by museums, collectors, dealers, and art lovers. A related antipathy is to the continued restriction of art to a cultural and financial élite and its denial to the population as a whole. There is impatience, too, with the art object, on the ground that it tends to overstress the significance of the unique personality, and with the romantic egotism of the artist as creative genius. All these objections, essentially well founded, contain echoes of the

avant-garde of the twenties, but the criticism is pointed at concrete conditions of today.

Some alternatives to the accepted ideals of the art world were proposed in a statement of principle by the French *Groupe de Recherche d'Art Visuel*, printed in the catalogue of an exhibition by the Argentine Optical and light-movement artist Julio le Parc, a cofounder of the *Groupe*. The primary concern of the *Groupe*, said the statement, is "the divorce between art and the general public." To overcome this "contradiction," the *Groupe* has developed audience-participation activities through works installed in labyrinths (obviously a surefire Environment), in game rooms, and on the street. LeParc's catalogue contained photographs of people, including the young, having a good time looking at themselves in ingeniously distorted hand mirrors, wearing eye-tricking spectacles, trying to sit on springs, and watching forms twisting about on screens, all of which, obviously, dispenses with the requirement of an élite culture for art appreciation; as simple entertainment, however, it is quite cold compared to conventional clowns, animal acts, or puppets. Like other functionalists, the *Groupe* dissociates itself from the self-engrossed individualist artist, with his mystique of the inspired creative act; it looks forward to seeing him replaced by "seekers, imaginers of elements, assemblers and animators" working together. ("Seekers" and "imaginers" sound romantic, too, but perhaps they are cured by working together.) To "desanctify" the art object, the statement advocates the production of art in editions of a hundred copies, to reduce the obsession with ownership. But increasing the number of art objects, the *Groupe* concedes, is not an ultimate solution; what is needed is to change the basic relationship between the artist and the public, and this requires completely doing away with the art object. Instead of making and acquiring (or looking), artist and audience would meet in "activity centers" in which "participation would become collective and temporary." Thus the program of the *Groupe* draws the theoretical line that connects opposition to the art object and to subjectivist aesthetics with optical experimentation, the use of new devices and new materials, wide popular appeal, and Environmental constructions and group performances.

Symbolic of the anti-object feeling are inventions in the kind of art that destroys itself. A manifesto by Gustav Metzger relates auto-destructive sculptures to auto-destructive tendencies in contemporary society: "Auto-destructive art is the transformation of technology into public art." Tinguely has associated art that blows itself up with suicide and the end of the world—a

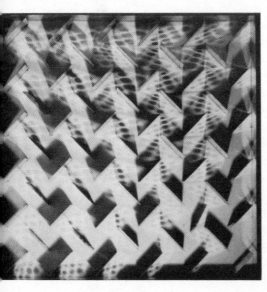

JULIO LE PARC, *CONTINUEL LUMIERE NO. 5,* 1964, ALUMI-
NUM, WOOD, PROJECTION BOX, 48¾ X 48¾ IN. COURTESY
HOWARD WISE GALLERY, NEW YORK

GUNTHER UECKER, *INSTALLATION,* 1966, COURTESY
HOWARD WISE GALLERY, NEW YORK

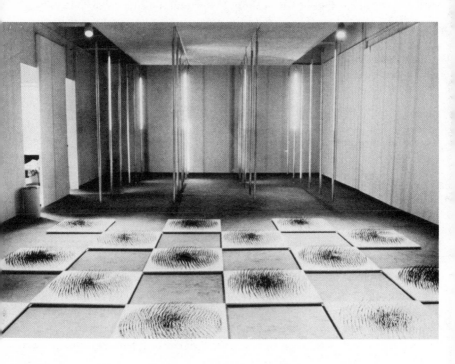

logical step, one might say, from the elimination of the artist's ego and the art object. The strobe lights at the Architectural League exhibit and at other light performances have the effect of disintegrating the contours of individual bodies and dissolving their identities in a stream of visual stutters. At a theatre on Second Avenue, Yayoi Kusama wrapped up the whole Environmental obliteration inventory—artist, art object, audience, the world—in a single package entitled "Self-Obliteration, an Audio-Visual-Light Performance," the handbill for which invited ticket buyers to "Become one with eternity. Obliterate your personality. Become part of your environment. . . . Self-destruction is the only way out! On your trip, take along one of our live bikini models." To help out with the lighting effects, spectators were urged to wear polka dots. To what extent Kusama was being satirical, or about what, it is hard to say, as it was about her "food reliefs" and "aggregation furniture" of a few years ago. Art that proclaims the end of art always has something comical about it, as well as a suspicion of bad faith, and if the world is ending, too, that is too much for one person to take advantage of to put on a show. Yet for all one knows, Kusama may have meant something else. One value of Environmental performances lies in their testing how far the public can be enlisted in mocking itself. Environments have revived the long-cherished ideal of art for everyone. Under present conditions, this raises the spectre of audiences willingly making themselves "part of the Environment" by reacting to its dictation.

Controlled stimulation of mass reflexes is expected by some to become the basis of grand fiestas in the "global village" of tomorrow. It can lead also to an intolerable passivity. Environments are of our time—not a very reassuring time. The audience-encompassing idea confronts art with real issues, but there are issues that this idea itself has not confronted. A painter is a product of painting; supply him with prisms, transistors, projectors and he becomes not a sense-expanded painter but something else—a technician, with the outlook of a technician, perhaps a showman of Obliteration. The Environmental artist today is more than halfway inside films, electronics, plastics, amateur theatricals; his advantage over the professionals is that he is in them with ideas derived from an art—painting, sculpture, theatre, the dance. But where will the distinctive and transforming ideas come from when painting and the drama have disappeared into the multiple-media picnic? Mondrian had no basis for assuming that without the separate arts there would still be the artist, or that the term "art" would still signify what it signified to him—something "pure

and complete in its beauty." It is one thing to "defetishize" the art object and to visualize it in terms of the processes, mental and physical, that brought it into being. It is a quite different thing to eliminate art itself and yet continue to count on the presence of artists. The "seekers and imaginers of elements" invoked by the *Groupe de Recherche* can come into being only through the experience of a more profound reality than that conceived by current technology and the mass public. Their orientation would have to be toward the actual living environment rather than toward a décor constructed of lights, double images, goofy sounds, and other twentieth-century artifacts.

MUSEUM OF THE NEW

It requires a certain daring for a new art museum to start off with an exhibition by artists who proclaim the end of art and demand the elimination of museums. Suppose the customers—sponsors, the public—take them seriously? It is probably safe to rely on the levity of the art world in regard to anti-art pronouncements; after all, people who have been against art have kept art going for more than fifty years. Inspired by their tradition, the Chicago Museum of Contemporary Art, which opened in October, 1967, has gone to the limit in proposing that an art museum should not be an art museum. Its director, Jan van der Marck, formerly curator of the Walker Art Center, in Minneapolis, is convinced that "the arts have exploded all over the place" and that painting and sculpture as such no longer, in the second half of the twentieth century, represent vital forms of creation. The art he shows will reflect this attitude, and he is prepared to place his institution behind experiments in music, the underground film, and poetry readings "perhaps accompanied by electronic effects with tapes and lighting." The new Museum is strictly avant-garde—a space platform on which advanced art, wherever it is produced, may alight in its orbit around the globe. Van der Marck has made it plain that he is interested neither in regional art ("There is no Chicago art") nor in accepted reputations. "I'm not concerned," he says, using Calder as an illustration, "with art that has already proved its point." A museum that rejects the dimension of time, which museums are supposed to embody, appears to be in a state of contradiction, but being contradictory fits into the general scheme of the new institution.

One of the stars of its inaugural exhibition is Allan Kaprow, plotter of Happenings and fabricator of sites for them to happen on, or in. In an article entitled "Death in the Museum," which appeared in *Arts Magazine* in February, 1967, Kaprow denounced museums as "a fuddy-duddy remnant from another era" and suggested that "modern museums should be turned into swimming pools and night clubs . . . or . . . emptied and left as environmental sculpture." Strong words, especially since the museums that Kaprow was thinking of were not the nineteenth-century marble-columned temples of the arts or the converted mansions of millionaires but exactly the kind of super-modern art emporium—with screen-projection systems, control panels, "jazzy lighting effects and piped-in lectures . . . entertainment and baby-sitting facilities"—that has been unveiled in Chicago. In Kaprow's view, it is futile to modernize any museum, because it is a place in which pictures and sculptures are set apart "from the rest of nature" and this setting apart is antagonistic to the modern creative temper. Art ought to be out in the street, the second-hand-car lot, the garbage dump. "The spirit and body of our art," affirmed Kaprow, bravely, "is on our TV screens and in our vitamin pills."

The Museum of Contemporary Art goes all the way with Kaprow, stopping just short of not existing. It is passionately opposed to enveloping art in an aura of "high culture" and it has no intention of setting anything apart from anything. Its stress is on informality; "art should grab you by the shoulder and shake you," says van der Marck, who would probably not be too disturbed if it also led people by the nose. He wishes to "take the eternal out of art" and make it "expendable." He concludes his catalogue for the first exhibition at the Museum by lauding an "event" piece by Alison Knowles for representing a "radical dissolution of the barriers that separate art from life." In keeping with this outlook, the Museum's program for its inaugural year contemplates much instant and evanescent art—Happenings, "light objects," paper art, art ordered by telephone to be made in Chicago workshops. The opening of the Museum was celebrated by a discothèque dance with strobe lights and an "evening" involving John Cage (who was prevented from cooking mushrooms onstage, with sound effects, only by a last-minute lack of mushrooms), Dick Higgins, who is the proprietor of the Something Else Press, of New York, and Alison Knowles, who is Mrs. Higgins.

The first exhibition, "Pictures to Be Read/Poetry to Be Seen," aimed at dissolving the boundaries of painting and poetry. Putting words into pictures, and shaping poems to resemble objects, is of course nothing new. Inscriptions appear on Egyptian statuary and on Renaissance portraits; George Herbert

wrote poems in the shape of—among other things—a tombstone; Dadaist, Surrealist, and Bauhaus articles made words "work" as compositional elements in paintings, collages, and posters; the late Frank O'Hara collaborated in "poem-paintings" with such painters as Bluhm, Rivers, and Hartigan; and de Kooning, Kline, Vicente, and others incorporated poems in etchings done in William Hayter's studio in the fifties. What distinguished these creations from those in the Contemporary Museum was the ideological intention of the latter. Of the twelve artists in the "Pictures to Be Read" exhibition, half were identified with the "intermedia" movement promoted by the Something Else Press, which, as its name implies, is out to replace the arts with a new species of entity—the aesthetic hybrid. The other artists in the exhibition, with the exception of Mary Bauermeister, were also working in forms borrowed directly from activities outside of art—blueprints, scratch pads, maps, instruction sheets, photographs, comic books. All this is familiar. The unusual thing is that the program of melting down forms and fusing them together was not only being presented by the Museum but had been adopted by it as its own. Chicago had thus produced the interesting phenomenon of a museum with an aesthetic ideology. The effect could be the opposite of a "dissolution of the barriers" between art and life. It could lead, instead, to splitting art institutionally into theoretical compartments, in a manner analogous to the divisions among the avant-garde movements of the early part of the twentieth century. Such a development, if it were continued, in defiance of momentary shifts in art-world tastes (it won't be*), could be a force for intellectual clarity, and thus provide a highly desirable antidote to the present practice among museums of extending an equal art-historical welcome to all modes that have succeeded in becoming fashionable.

In its present phase, the Contemporary Museum is explicitly dedicated to the Duchamp-Cage tradition of reaching away from art toward things and symbols that happen to fall within the artist's field of vision.

The "Poetry to Be Seen" among the pictures in the exhibition was devoid of the attributes of poetic composition and consisted mainly of "found" words—of the same order as the found objects of collage and assemblage. In the background of the show was Duchamp's 1965 exhibition, "Not Seen

* This prediction was soon fulfilled. Though Happenings, light shows and films were featured in the first year of the Museum, they were interspersed with such normal museum fare as a Fantastic Art exhibition (Redon, Picabia, Dali, Delvaux, and so on) culled from Chicago collections, and exhibitions of sculptures by George Segal, drawings by Pollock, paintings by Wesselmann.

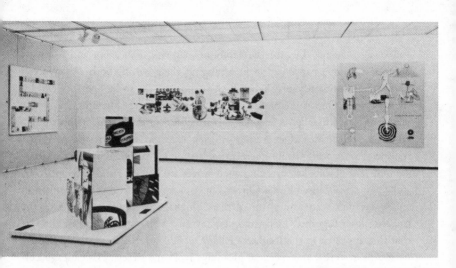

OYVIND FAHLSTROM, *INSTALLATION*, "PICTURES TO BE READ/POETRY TO BE SEEN," COURTESY THE MUSEUM OF CONTEMPORARY ART, CHICAGO

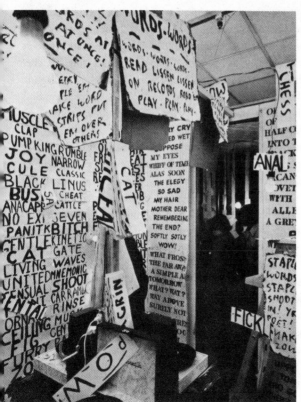

ALLAN KAPROW, *WORDS*, COURTESY THE MUSEUM OF CONTEMPORARY ART, CHICAGO

and/or Less Seen." Two of the exhibitors, Oyvind Fahlström and Kaprow, induced audience participation in arranging their words; both are involved with the games theory of Cage, which permits works to be "performed" by the spectator. One Something Else broadside quotes the thought that "canvases and sculptures have become performable"—a development, on the literal plane, of the idea of an Action painting as an enactment by the artist that the spectator repeats within himself. Fahlström had designed a group of Pop-painted "sitting blocks" carrying such words as "Breath" and "Stripped." A story about the Museum in a Chicago newspaper showed a young matron in an Op costume seated on a pair of these blocks; art and life could hardly be pressed closer together. Fahlström also favors a Pop-style politics of the sort that first appeared in the Reuben Gallery several years ago; it attacks society by means of verbal and pictorial gleanings from the streets. His Chicago collages contained such items as "Here Lies Chuck Executed for Cowardice," in which the words are put together as in a jigsaw puzzle; a hand reaching out to write, on a paper blackboard, "My Secret Identity Is"; picture cutouts of General Walker and of a naked burlesque queen; two paper match folders with the motto "New Hope for School Dropouts"; and this clincher (scrawled in the center of his "Life-Curve, No. 2—Snow Field," a collage in white fur): "Bomb Hanoi Now. . . . Why? . . . 'Cause Silva Say So." While it is true that these data associate art with life, they do so as mere reminders of both and without arousing the feelings of either.

Kaprow's contribution was a hut bearing a large sign, "WORDS," built into a corner of the gallery. The inside of this Environment, a version of which had been presented earlier in New York, is divided into two square rooms, one of which is plastered with dissociated words on strips of paper. Words, barely audible, are played on phonographs, and the spectator is supplied with a stack of bits of paper and with a stapling gun, so that he can write words and tack them wherever he likes. The other room is a forest of paper streamers—suspended from the ceiling—on which one may fasten messages with paper clips. The public as a collective collaborator in works of art is notoriously lacking in talent, and it was unlikely that Kaprow's booth would be any more interesting at the end of its engagement than it was at the start. The usual reply to this criticism is that the aim of modern art is not to fabricate an object but to instigate an event. Judged on this score, the major event in *Words* is Kaprow's own performance in making the setting; for the spectator, less "happens" than in a birthday-party game.

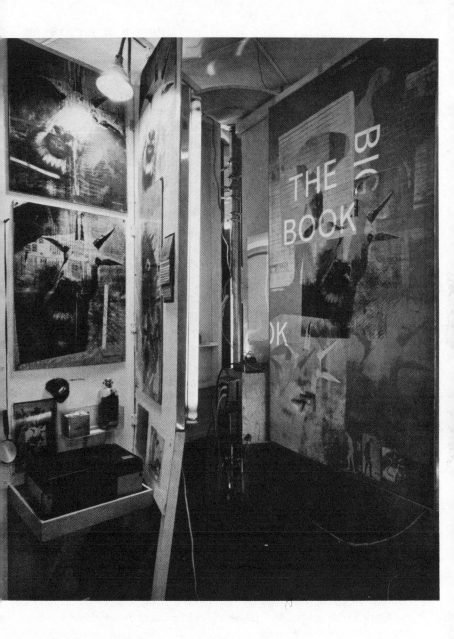

The other major audience-activating Environment in the exhibition was *The Big Book*, by Alison Knowles, who, like Kaprow, is a veteran Happenings-maker. Through this Environment the spectator was invited to crawl; "no two people," asserts Miss Knowles incontrovertibly, "enjoy a hole in the same way." *The Big Book* is a physical metaphor that literally contains everything. It is the story of the artist's life presented through copious samples of her domestic and cultural surroundings. It is both individual and collective; seventeen artists, including several in the Contemporary exhibition, contributed to it. Eight feet high and weighing one ton, it has eight movable "pages," each several feet wide, into which are set doorways, ladders, tunnels, murals, prints, signs, furniture, cooking facilities, a toilet, medicine, coffee, a guestbook, and an art gallery. It is practical: to make sure that art does not cut one off from life, there is a telephone in it on which one can call the office or the babysitter. No medium has been left out of this "Book"; it is audio-visual, kinetic, electrified, mobile. It makes use of painting, sculpture, film, silk screen, mirrors, colored lights, double images, carpentry, welding. Sounds of building *The Big Book* are played back to visitors, together with talk originating in the Higgins ménage. Here art has become so thoroughly intertwined with life that one wonders whether life has anything left for itself. And, too, whether a work so personally *lived* is to any real degree accessible to strangers, even if one should move in. "Maybe," Miss Knowles ponders, with admirable awareness, "having done *The Big Book* is better than going through it."

Whether or not the "overlapping of the media" hailed by the Contemporary Museum has brought art closer to life, it has undoubtedly made it easier for people to live almost entirely in an arts complex. The ultimate Museum of the Now, toward which the Museum of Contemporary Art strives, is any city street seen through an aesthetic screen. Several of the "Pictures to Be Read" exhibitors—Ray Johnson, Kitaj, George Brecht—give the impression of being so totally immersed in art that it doesn't matter whether they make it or find it. A box by Johnson, known in New York for the charming paper cutouts he sends through the mails, contained Chinese lettering on blocks, a family photograph, and a sign saying, "His Art Looks Old-Timey Eccentric and Chinese Modern to Me." Another work relates to the steel comb exhibited by Duchamp half a century ago. Kitaj's silk-screen posters contain pseudo-recipes for painters ("How Many Times the Same Color May Be Applied") and include a negative of the well-known photograph of Rothko,

RAY JOHNSON, *MASSAGE BALL*, 1967, COLLAGE AND PAINTING, 14⅝ X 16⅝ IN. RICHARD FEIGEN GALLERY, COURTESY THE MUSEUM OF CONTEMPORARY ART, CHICAGO

MARY BAUERMEISTER, *PICTIONARY*, 1966, 21 X 40 IN. COURTESY THE MUSEUM OF CONTEMPORARY ART, CHICAGO

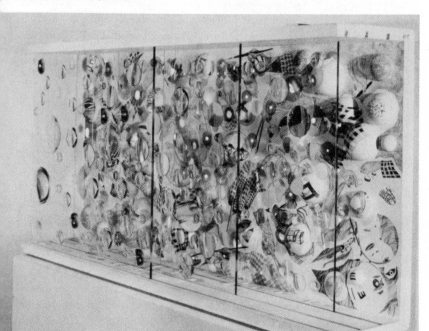

Newman, de Kooning, Tomlin, Baziotes, and other artists who were protest-
ing a choice of jury by the Metropolitan Museum of Art in the fifties. Brecht,
a box-maker in the Joseph Cornell manner (the vogue among art historians,
which van der Marck followed, is to explain why Brecht's boxes are *not* like
Cornell's), uses images relating to dance recitals at the Judson Memorial
Church and to the biographies of friends (e.g., another Something Else artist,
Joe Jones, is commemorated by a birth certificate of one Joseph Jones, accom-
panied by the statement that "Joe Jones Is Not Jo Jones").

Though she was somewhat out of key with the exhibition, and, visually,
was the best artist in it, Mary Bauermeister, a young German Post-Surrealist,
is also art-conscious in the most aggravated degree. *V.I.P. Very Important
Picture* is an irregularly diamond-shaped structure made of her characteristic
layers of glass crammed with discs and painted balls, in the center of which an
empty frame advertises the absence of a painting. Bauermeister's "words to be
seen," done in meticulous handwriting or in old-fashioned lettering in English
and German and worked in among her tiers of small stones or inscribed in her
crowded jewel cases, enunciated problems of creating art and gave instruc-
tions, at times ironic, to the spectator: "These Damned Tools Hands In-
cluded," "This Is a Reproduction of a Reproduction Glued to the Bottom of
the Box Piece at the Left," and this ultimate confession of aestheticism: "I'm a
Pacifist but War Pictures Are Too Beautiful."

Two Italians and a Japanese in the exhibition had been known to me only
through publications, including the catalogue of an exhibition in Milan of a
group of artist-theoreticians under the title "Towards a Cold Poetic Image."
Something Else and the Cold Poetic Image proved capable of getting along
without strain. Gianfranco Baruchello meditates in symbols, words, and small,
analytical drawings a bit reminiscent of Matta. His images, at times executed
on Plexiglas and on photographic paper, are pseudo-functional—arrows,
maps, plans—with words written or printed in a tiny hand, like notes on the
back of an envelope of thoughts and reminders about a projected undertak-
ing. His exhibits in the Chicago show mentioned Heidegger and quoted (erro-
neously) from Eliot's "Prufrock": "I Am Not Prince Hamlet Nor Am I Sup-
posed to Be." Baruchello has a convincing intellectual quality. Gianni-Emilio
Simonetti, also a contributor to the Cold Image, employs miniature pasted-on
figures and decalcomania, together with small painted geometric shapes, dots,
and arrows scattered on a vast gray-white ground. His work, like Baruchel-
lo's, evokes the functional chart or the memorandum of an event. Another

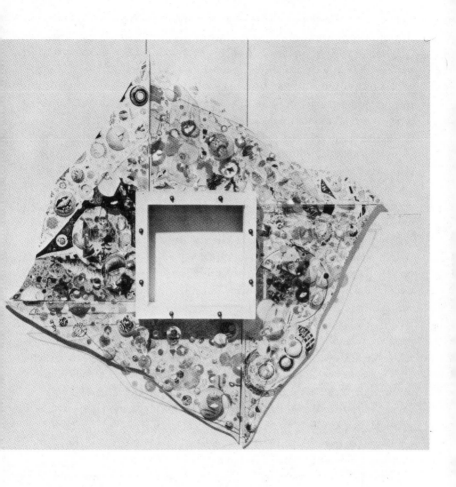

MARY BAUERMEISTER, *V.I.P. VERY IMPORTANT PICTURE,*
1966-67, 64 X 64 IN. COURTESY GALERIA BONINO, LTD.

Cold Imagist, Shusaku Arakawa, adds instructions on diagrams, like the paintings of Rivers that label the parts of the body—but without the body. His language, in print or typescript, favors Surrealist dissociation. He likes to label his works at the bottom with a box presenting information: "Title: A Couple. —Name: Arakawa.—Date: 1966–1967." This matter-of-factness symbolizes the professional aspect of the mixed-media movement and the degree to which it is concentrated on the art-market package.

Another use of the note-pad format is represented by the drawings of Wolf Vostell, a German collaborator of Something Else and Kaprow. Vostell's sketches of plans for Happenings have an Expressionist dash and softness at odds with the tight handling of the Cold Imagists. These works are in effect doodles, and the notion of exhibiting them may have been stimulated by the worship-of-personal-relics by the Something Else group. In a sense, Vostell's drawings genuinely break down the barrier between art and life, since they were produced for some other purpose than to be art—as if one framed one's breakfast (this has actually been done by Daniel Spoerri, an artist who was not in the show but is associated with Something Else and greatly admired by van der Marck). Vostell's sketches belong to an action that will occur elsewhere—not in the Museum—whereas Arakawa adapts the form of the diagram or ground plan in behalf of an aesthetic objective. The words in Vostell's sketches, since they relate to a performance not available in the gallery, are meaningless; while they are "to be seen," they are in no sense poetry.

The only "new" artist in the exhibition was a young Chicago Pop painter, James Nutt, a member of the South Side Hairy Who group. He specializes in gruesome comics neatly executed in garish colors on Plexiglas, with added bits of flat metal (e.g., heel plates) and plastic. Of the "poetry" in his work I remember only the title of one example—*Snooper Trooper*.

In general, the "Pictures to Be Read/Poetry to Be Seen" show lived up to its title. Most of the exhibits were highly intelligent but not much to look at. The works were projections of ideas, and, apart from their verbal equivalents (i.e., without being approached as something to "read"), they were (again with the exception of Mary Bauermeister and of the Environments) finicky designs without scale, sensuous appeal, or passion. They were thus signs of intellectual activity, while the words in them, being largely either reminders or nonsense, were merely there to be "seen," i.e., as aesthetic elements. As for the media-mixing program of the Museum, it is a fact of art history that the art object has been increasingly giving way to the art event; the active nature

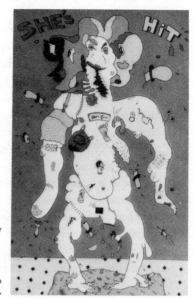

JAMES NUTT, *SHE'S HIT*, 1967, ACRYLIC, PLEXIGLAS, AND MIXED MEDIA, COURTESY THE MUSEUM OF CONTEMPORARY ART, CHICAGO

DANIEL SPOERRI, *MARCEL DUCHAMP'S DINNER*, 1964, CUTLERY, DISHES, AND NAPKINS MOUNTED ON WOOD, 24⅞ X 21⅛ X 8¼ IN. COLLECTION ARMAN, NICE, COURTESY THE MUSEUM OF MODERN ART, NEW YORK

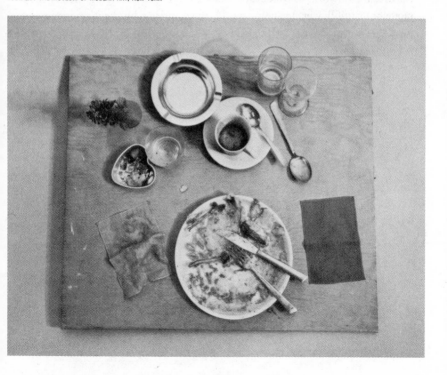

of painting and drawing was pointed out half a century ago by Paul Klee, for example. Removing art from the context of the treasure house of artifacts into an environment of "life" takes, however, more than incorporating everyday objects into mixtures of color or light and sound, or converting painting into theatre, or denouncing museums or transforming them into community recreation centers. Today, as indicated earlier, the art museum is already a mass medium no more separated in essence from popular life than is a movie theatre or bowling alley. That is why, despite his objections, Kaprow was in the Museum of Contemporary Art. Art, nevertheless, does not overcome its distance from the real world by passing from the realm of art history that is embodied in the traditional museum to the realm of the mass media, whose products, philosophers never tire of telling us, are a major factor in the alienation of man in contemporary society. Moreover, the Chicago exhibition made it clear that, whatever be their ideological convictions, the museum conception of art as a privileged form of work prevails in artists and so cannot be driven out of art. To dissolve "the barriers that separate art from life" is an impossible ideal— the dream of a world in which all actions are intended to be forgotten at their moment of fulfillment. In such a world, ruled entirely by the Now, museums would, of course, have ceased to exist.

ART OF BAD CONSCIENCE

Politics haunts the art of our time as Nature haunted the paintings of the nineteenth century and myths and sacred episodes those of earlier epochs. Since the thirties everyone has been aware that as a political weapon art is all but useless. Despite its earnestness, Social Realist art, like the paintings and demonstrations of the Futurists, Dadaists and Surrealists, proved futile in affecting the trend of events. The most celebrated political painting of the century, Picasso's *Guernica*, has been of doubtful political consequence; its basic context is not the Spanish Civil War but Picasso and his imagery. In aiming at public objectives modern art succeeds only in underlining the privateness of the artist's idiom—also that this idiom is charged with references to the history of art, not the history of nations. On the other hand, art works coordinated into political programs, as in totalitarian countries, have been futile as art. By all evidence art history is at odds with history. And the relative helplessness of art when it crosses over into the political arena keeps increasing year by year with the expansion of the mass media—the more advanced the communications system the less the impact of the unique aesthetic statement. To challenge the version of events disseminated by contemporary propaganda machines with a painting or sculpture is equivalent to battling a tank division with a broomstick. A picture that takes sides in a conflict may produce the satisfaction of a ritual act, but for practical results artists had better turn to other professions than painting. Nor can painting and sculpture augment their powers by appropriating the style of the popular arts, for the power of the

media lies not in their style—they absorb all styles: the eye-dazzles of Op as readily as the photographic close-up—but in their mechanisms of production and distribution.

The practical course would therefore be for painting to renounce politics as a field of professional interest, regardless of the political passions of individual artists. To a large degree this is exactly what art has been doing since the War, except in certain Communist countries. None of the postwar art movements has had social aims. Action painting, closest in time and in spirit to the Dadaist-Surrealist tradition of social revolt, was a deliberate repudiation of politics in art; it arose from the conviction, based on direct experience with the ideological pressure of the Left, that art and politics are incompatible. To quiet its still-quivering political nerve ends, it conceived a dramatic simulation of action in the artist's struggle with the data of the canvas, whether this data consisted of arbitrary marks placed on it to instigate beginnings, as in Pollock, Hofmann and de Kooning, or of the tension induced by the shape and size of the canvas itself, as with Newman and Rothko. Of the movements following Action painting, Pop Art has come closest to laying hold of the social substance, and Happenings, an emanation from the idea of Action painting and from Pop, are potentially adaptable as a medium for disseminating political ideas in the manner of the Living Newspaper of the thirties or the portable theatre of the Chinese Communists. So far, however, the mood of disengagement from politics has, especially in the United States, prevailed with these modes, too—Kaprow said the other day that Happenings are difficult to put on in Europe because people there expect them to carry a political message and become irritated when they find that they are getting art instead. Optical and kinetic art and light displays have built bridges to a larger public, but while they have succeeded in publicizing themselves they have not asserted any attitude toward society, and have had about as much political influence as the Ferris wheel.

As for minimal art and so-called color-field painting, they arise from the classroom in art history and remain enclosed in it on principle. In their strict banning of social and psychological content, they carry to its logical conclusion the truism that art, whatever else it may be concerned with, is, ultimately, concerned mainly with itself. Still, a language whose basic function is to render its users speechless can hardly gain much intelligent respect. Acceptance of the rule that painting necessarily locks out the mind from the drama of history threatens to put art on the level of weaving or furniture design. Mind-

ing its own business, art has been forced increasingly to question what its business is. After the experience of the thirties, disengagement from politics came as a liberation. But twenty-five years of this freedom have encompassed art with a broad margin of uneasiness about its role in human life.

Willem de Kooning, America's leading post-war painter, has been the most consistent of the Action painters in replying with a firm nay to political dogmas; to his credit he has repudiated equally dogmas of art history. In his paintings and drawings of the 1960's, he has continued his experiments, begun in the thirties, in expanding spontaneity in the act of creation. To this master of visual evocation the notion of a predetermined content in painting, to say nothing of a "message," has been as repugnant as the notion of a predetermined absence of content—for instance, the conviction that art in our time must be "abstract" or that certain subjects are disallowed by avant-garde aesthetics. De Kooning's new paintings, in high-keyed reds, pinks and whites, celebrate the theme of "women" which, except for brief intervals, the artist has been elaborating for the past twenty years, but they are also landscapes and abstractions. Formally, they are linear compositions of actions of the brush (and of brush, pencil and charcoal in the drawings) and at the same time experiments in relations of mass, surface, color and light. The physically diffused girlies of the 1960's creations are products of de Kooning's latest devices for getting around his willful mind and trained hand, which are bound to assert themselves in any case—indeed, within the very process by which they are being circumvented. To extract unanticipated figurations from his canvases de Kooning has bred one image out of another (by plastering newspaper on a wet painting, he produces, when the sheet is removed, two decontrolled compositions); he has drawn the figure with his left hand, with two or more pencils simultaneously, with both hands at once, with his eyes closed, and while watching TV. Compared with his earlier paintings, the work of the 1960's shows gains in rhythm and surface vibration through the quiver of his line and the chromatics of his reds, pinks and whites. In the large paintings he has, as in the past, gambled with the possible destruction of each work-in-progress by submitting it to associations of ideas and feelings that appeared during the course of its creation. No art is more immediately engaged with the organic life of its creator. Several of the paintings are among the most lyrical creations of the century, but de Kooning has not excluded images arising from currents of spite, disgust and vindictiveness. His

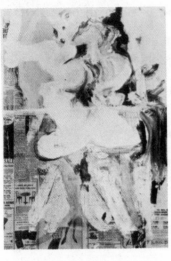

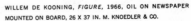
WILLEM DE KOONING, *FIGURE*, 1966, OIL ON NEWSPAPER
MOUNTED ON BOARD, 26 X 37 IN. M. KNOEDLER & CO.

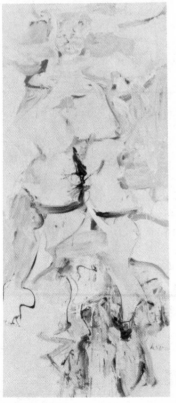

WILLEM DE KOONING, *WOMAN ACABONIC*, 1966, OIL ON
PAPER MOUNTED ON CANVAS, 80½ x 36 IN. COLLECTION
THE WHITNEY MUSEUM OF AMERICAN ART, NEW YORK,
GIFT OF MRS. BERNARD GIMBEL

WILLEM DE KOONING, *WOMAN SAG HARBOR*, 1964, OIL ON WOOD,
80 X 36 IN. COLLECTION JOSEPH HIRSHHORN, COURTESY M.
KNOEDLER & CO.

paintings come into being on the edge of dissolution. For them to exist has required a heroic endurance of uncertainty, as well as a reasonable rate of good luck or favors from the unknown. In his concentration on the creative process de Kooning frees himself from coercion by art history conceived as an evolution of forms; instead of seeing works of predecessors or contemporaries as representing an "advance" over an earlier stage, he looks past the art object to its mode of creation. Thus a work thoroughly familiar, whether it be a painting or a musical instrument, can be "invented" again by re-activating its creative principle. Conceived as creation the art of the past becomes an inexhaustible source, while the meaning of present-day work extends far beyond the objectives of art as a profession. Consistent with his principle of constant renewal, de Kooning's primary aesthetic quality is freshness, the freshness of things as they appear in the immediacy of a dream. Compared to his "women," most of the painting and sculptures produced out of the rationalist aesthetics of the past few years look as if they were aged at birth.

In all this there is not, of course, a trace of overt politics, nor has de Kooning ever attempted to attribute political meaning to his work, as have contemporaries from Matta to le Parc. In practicing art as action on the canvas he decisively turned his back upon public issues. He was alone among the Action painters in introducing into painting elements of popular culture, such as imprintings of news columns and cuttings from ads, but in his work this material carries no implications about the society in which it originated. Yet under the conditions of ideological pressure characteristic of the past forty years, spontaneity itself is a quasi-political attitude—one condemned by Lenin, outlawed in totalitarian countries, and repugnant to conformists and programmers. De Kooning's expansion of the resources of painting for opening up the sensibility to interaction with chance, impulse, the arbitrary and the unknown presupposes that the individual as he is pits himself against all systems, while the temperament expressed in this artist's canvases affirms, like that of Pollock or Bacon, the disorder of the epoch. If politics haunts postwar painting, de Kooning haunts the ghost. He is the nuisance of the individual "I am" in an ideological age. His improvised unities represent a reminder that modern social philosophies, while they justify their conflicts as fought in behalf of the individual, consistently shove him aside in the course of their endless battles. De Kooning's art is a refusal to be either recruited or pushed aside.

Separated from politics art has turned its political passions inward upon itself. The notion of a revolutionary avant-garde perennially thrusting art upward to new heights has established itself as an *idée fixe*. Outworn formulas of radical politics have been patched up for reuse as imperatives of art criticism; for instance, the notion—borrowed, often unconsciously, from Bolshevism—of the "rubbish heap of history" into which artists of no matter what rank are thrust by the triumph of the latest art movement. Conveniently enough, live-dangerously aesthetics can be combined with the most conformist social attitudes. Thus Hilton Kramer, in the *New York Times*, echoes, with a spleen normally directed against party traitors or subverters of regimes, the verdict of the avant-garde of color stains, that de Kooning's paintings are relics of a fashion of the forties related to the "Existentialist" pose of living in an epoch of crisis. In short, de Kooning's experiments and anxieties are disturbers of the peace of artists (and critics) who wish to enjoy a normal artistic career. That no crisis ever existed except as a pose or fashion, or if it did exist it is now past, is a momentous political conclusion—one in which the art page of the *Times* seems to be at odds (perhaps in order to provide a Sunday sanctuary for cultured readers) with its news and editorial sections. To clinch the doom of de Kooning as a hangover from a past (non-) crisis, Mr. Kramer also applies to him the dustbin-of-history theory by which Kramer has in his few years of *Times* tenure relegated to the shadows such transients as Pollock, Giacometti, Moore, Klee, Beckmann and other makers of twentieth-century art: they violate what is apparently Mr. Kramer's cardinal criterion in that their influence "has," as he says about de Kooning, "long ceased to have any relevance to living artistic problems."

What these "artistic" problems are, if the matter is not to be decided by the poll, taken by Mr. Kramer among the newest reputations, was the subject of a five-day discussion at a large conference of artists and intellectuals held in Caracas in the Fall of 1967 under the sponsorship of the Inter-American Foundation for the Arts. The exchange of views there quickly made it evident that the definition of "living artistic problems" often depends on where you live. For some speakers from the New York art world, the issue for painting today is universal recognition of the revolutionary heights scaled by artists to whom the essential significance of painting lies in the shape (square, vertical or horizontal) of the canvas. For the Latin Americans, the issue was "Yankee imperialism"—an artist, they felt, was obliged to indicate his resistance to existing conditions as a matter of professional honor. The aesthetics of this resistance

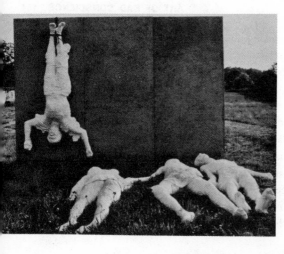

GEORGE SEGAL, *THE EXECUTION*, 1967, COURTESY THE NEW SCHOOL ART CENTER

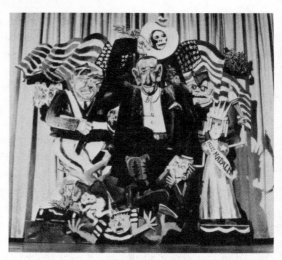

RED GROOMS, *PATRIOTS' PARADE NO. 2*, 1967, WOOD CONSTRUCTION AND ENAMEL, 8 FT. X 10 FT. X 33 IN. COURTESY THE NEW SCHOOL ART CENTER

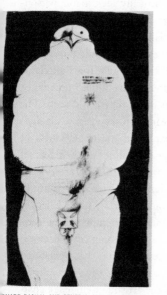

ONARD BASKIN, *OUR GENERAL*, 1967, INK DRAWING, X 32 IN. COURTESY THE NEW SCHOOL ART CENTER

ranged from art forms involving audience participation (designed to awaken the masses) to the Dada-related belief that in "post-modern" art the artist's "manifestation" counted for more than the art object—a circumspect way of saying that art could go to the devil. In response, a New York painter asseverated that for him painting was bounded by the piece of material he was working on, and his companions, an art critic and a curator, nodded in assent and murmured the word "quality." Discussion in this sector came to an abrupt end. The Latin Americans got the point that in New York artists feel themselves exempt from human history—a state of mind which confirmed their feelings about the "Yankees" and which several confessed to envying. Perhaps the mistake of the New York aesthetes lay in going to a conference, since in the world of "quality" there are no problems, "living" or otherwise, to be debated.

That same Fall, forty-three artists, most of them well known, and covering an art-world time span from Shahn to Warhol, braved the issue of aesthetic quality versus politics by contributing sculptures, paintings, drawings and prints to an exhibition at the New School Art Center entitled "Protest and Hope." Thirteen of the artists, including such stylistically identifiable personalities as George Segal, Robert Rauschenberg, Elaine de Kooning, Red Grooms and James Wines, executed works especially for the show. The vital question was to what extent they and their fellow exhibitors could apply their styles to such themes as the war in Vietnam and the struggle for civil rights (there were not, so far as I recall, any items devoted to the "hope" portion of the show's title), or, failing in this, to what modes of art they could turn. The "Angry Arts" exhibition on Washington Square earlier in the year, while dedicated to protest on the same issues, actually expressed the hopelessness of artists in regard to political art and their contempt for politics or their fear of it in that almost all the works were dashed off without regard for style or standards, as if in a rush to return to the serious business of making paintings and sculptures. In contrast, "Protest [I keep automatically writing "Chaos"] and Hope" was in the great majority of its exhibits an attempt to deal seriously with grave issues. The artists' struggle for a broadening of consciousness, sensibility and technique lent a pathos to the exhibition that demanded respect and gave it an importance beyond the assembling of a few dozen works by familiar figures. It was an adventure of the artistic intelligence analogous, in a way, to the opposite movement by abstract artists of the 1940's in

cutting loose from politics after their discovery that what they had been try-
ing to do under the goading of the left was in conflict with basic processes of
the creative imagination.

The pathos of "Protest and Hope" was underlined by the irony of its set-
ting: the show was sequestered in a room on the fifth floor. In addition, each
of the art modes in the exhibition, new and less new (most of the avant-garde
styles, with the exception of Op, color-field painting and minimal sculpture,
were represented), offered its particular degree of resistance to being im-
pressed into the service of political feeling. Derivations from Pop Art, by this
time a term which has become far too inclusive, proved most available for re-
tooling. The best works in the show were by Segal and Grooms. Elaine de
Kooning, long an experimenter with the social possibilities of Abstract Ex-
pressionism, wisely shifted toward Pop for her *Countdown*, a booth resem-
bling those in which election leaflets and buttons are distributed. Some artists
turned to news photos or photo effects, and painters more or less close to Pop
simply replaced their customary images with politically suggestive ones.

The showpiece of "Protest" was Segal's *The Execution*, an imaginative dra-
matic tableau in the style developed by this artist through life-size plaster casts
placed in realistic settings. It consisted of a figure hanging head down by a
rope around its ankles from a bullet-scarred wall, before which lay in appeal-
ingly casual poses, like girls who had flung themselves on a lawn, the bodies of
three other victims. The whiteness of Segal's casts lends to his figures an eerie
effect and a sense of quiet and timelessness, as if each work surrounded itself
with a museum of its own. These qualities of *The Execution* induced a mood
of reflection—precisely the mood belonging to art and dissipated by the mass
media. In this sense, the work was a contribution to political consciousness,
despite the conventionality of the concept of people stood against the wall.
Charles Cajori's drawing, *Pax Americana*, also represented bodies of the
slain, but although it pointed to the slayer in its title it lacked the dramatic im-
pact drawn by Segal from the art-life interchange of Pop; as in the older real-
ism the effect of Cajori's motif was dissolved in appreciation of a good drawing
nicely composed. Jack Levine's *Invasion*, Leonard Baskin's *Our General*, Ben
Shahn's *Goyesca* #2 and Jacob Landau's *Songs in the Night* were all artistic
in the sense that Cajori's *Pax* was: they communicated skill of handling more
strongly then indignation. This meant that their subject matter had been
forced into adjustment with traditional concepts of style, at times, as in
Shahn's *Goyesca*, with the aid of overtones from particular works. In con-

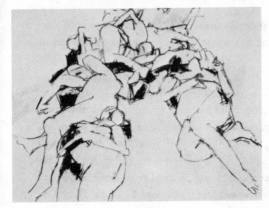

CHARLES CAJORI, *PAX AMERICANA*, 1967, CHARCOAL, 27 X 34¼ IN. COURTESY THE NEW SCHOOL ART CENTER

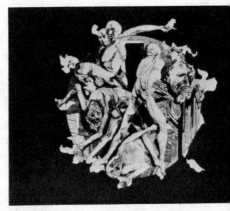

JACOB LANDAU, *SONGS IN THE NIGHT*, 1967, 22¼ X 29⅞ IN. COURTESY THE NEW SCHOOL ART CENTER.

JACK LEVINE, *INVASION*, 1967, OIL ON CANVAS, 32 X 28 IN. COURTESY THE NEW SCHOOL ART CENTER

trast, Red Grooms' ferociously juvenile *Patriots' Parade #2,* a wood construction in blatant colors, which caricatured a fanatical flag-bearer, a death's head and a symbolic Miss Napalm surrounding a reflective President Johnson advancing upon victims resembling broken dolls, hammered out an antagonism unchecked by dissonant considerations of form—no jingoist could look at it without turning purple.

In Caracas, Latin American artists singled out Pop as the style most apt for political expression, yet, except for the group around the Reuben Gallery some years ago, Pop paintings and sculptures seen in New York have rarely had political intentions. Exceptions that might have been included in the "Protest" exhibition are Oyvind Fahlström, Wolf Vostell and Peter Saul. Pop, too, in a tangential way is Juan Genovés, a Spanish painter, whose exhibition in New York in 1967 aroused unusual excitement—an indication, perhaps, of a new public and critical appetite for a politically expressive art. Genovés's paintings draw on the cinema as Segal draws on the *tableau vivant.* (A Segal could be paraded through the streets on a float.) Genovés composes in the rectangular frame of motion-picture film, and he favors the newsreel image of crowds shot from above as in panics, riots or massacres. Within the rectangle, hordes of tiny figures are usually on the run, and at times are caught in the circle of a spotlight that picks out individuals and freezes them in position. *Escalation* is divided into four oblongs of equal size: in the top one the shadow of a bomber covers part of a fleeing crowd; in the one below two shadows hover over a denser crowd; in the two lowest the shadows and fugitives continue to thicken. *Escalation, The Prisoner, Face to the Wall* deal with victims of history, but Genovés's art is not so much political as a presentation of the metaphysical terror of the anonymous person caught in the stampedes of modern mass society. Some of his paintings reminded me of scenes in escape movies, especially one of unsuccessful flight from a Nazi concentration camp, *The Seventh Cross.* Made out of images half-familiar through photography, Genovés's art gains force through formal innovation, in contrast to the muffling of the theme that occurs in traditional drawing.

Returning to "Protest and Hope," Elaine de Kooning's *Countdown* collected verbal and pictorial residues of matters that had been much in the public eye in the past few years: rockets, the atom bomb, the Chessman Case, JFK, Johnson and Humphrey. Her use of luminous papers under fluorescent light might have been intended, like Genovés's spotlight, as a device of visual emphasis, but its impression on me was one of excessive neatness (perhaps she

had laboratories in mind). Like Segal's *The Execution*, Goodman's painting *Examination* is composed of four figures—three nude men standing at attention in a receding row and a fourth seated on a stool in the foreground. Borrowing from photography in a manner different from Genovés, Goodman managed to generate a sense of undefined menace.

The attempt by some artists to use color as a symbol generally failed. Red has no difficulty representing blood or fire, but its effect tends to be melodramatic, hence short-lived. D'Arcangelo's adaptation of his favorite highway-markers motif by splashing red on a U.S. 80 sign to commemorate the road on which Mrs. Liuzzo, a civil rights worker, was murdered by segregationists was almost too pat. A principle related to the over-effect of blood also vitiates the use of photos of children burned by napalm: the fact is too shocking to be grasped emotionally, and the artist, in simply presenting the picture, fails to communicate a judgment. Awareness of the insufficiency of their means prompted several artists to accompany their works with verbal political statements. Robert Mallary posted a carefully worded summary of his position on Vietnam atop his construction featuring a napalm victim. Saul Steinberg, as usual, presented a picture to be read—a variation on his Uncle Sam as Sphinx in a landscape with Indians on horseback and with pyramids surmounted by the all-seeing eye—but this time he took the radical step of supplying an explanation of his symbols. Robert Indiana had only to insert the words "YIELD BROTHER" into one of his customary emblems for it to take on a political connotation. Some of the explanations—e.g., that of Arne Wolf—were as impenetrable as the images.

It may be that the end is in sight of the Thirty Years' War of art against the political conscience. If so, the problem is how art can avoid turning back to the kind of mental forcing out of which can come only lifeless illustrations of ready-made ideas. On the whole, the attempts at statement in "Protest and Hope" were emotionally inadequate, aesthetically unexciting, often intellectually irrelevant and marred by cheap irony or abuse. These weaknesses in no wise detract from the importance of the exhibition as an indication that the imagination of a significant group of artists has begun playing upon the conflicts and catastrophes of the times. Art cannot do much for politics. (In the opinion of such a seasoned observer as Wyndham Lewis, it cannot do much about anything. "It is quite impossible," he wrote in *The Demon of Progress in the Arts*, "for his [Cézanne's] canvases to have any effect outside of the technique of painting.") But responding to political struggles can do much

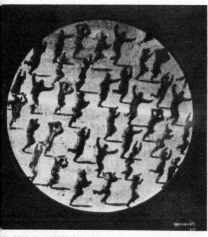

AN GENOVES, *MICROGRAPHY*, 1966, OIL ON CANVAS, 10⅛ X 9⅜ IN. COL-
CTION THE MUSEUM OF MODERN ART, NEW YORK

NEY GOODMAN, *THE EXAMINATION*, 1966, OIL ON CANVAS, 73 X 49 IN.
URTESY THE NEW SCHOOL ART CENTER

AINE DE KOONING, *COUNTDOWN*, 1967, COLLAGE, 2 PANELS 8 X 5 FT.
URTESY THE NEW SCHOOL ART CENTER

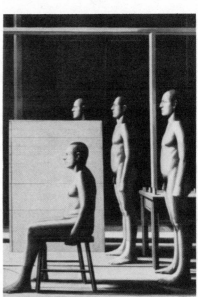

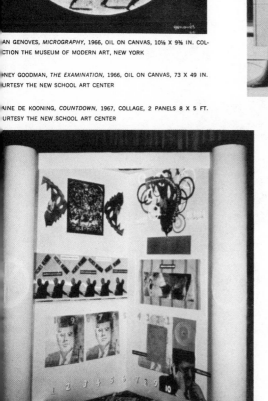

for art. Art always borrows its seriousness from values—religious, romantic, scientific—to which it fails to live up. The formal interests of the artist and his delight in his craft set him apart from genuine holiness, love or research. Yet when logic induces the artist to discard these concerns and try to renew art by its own means, he finds himself in a blind alley. Art today needs political consciousness in order to free itself from the frivolity of continual insurrections confined to art galleries and museums. The actions of society present a resistance against which modes of art can test their powers and reinstate the creation of images as a vocation of adult minds.

DISCOVERING THE PRESENT

In January, 1968, a four-day conference was held in Paris to commemorate the one hundredth anniversary of the death of Charles Baudelaire (he actually died on August 31, 1867). Organized by Pierre Schneider, a Paris-American writer on art, the meeting, attended by some thirty writers, cultural historians, philosophers, museum directors, Baudelaire specialists, poets, artists and art critics from eighteen countries, paid homage to Baudelaire as an art critic. It was the author of *Les Fleurs du Mal* who introduced the concept of the modern as an aesthetic value. He bestowed upon art an adjective which it has been unable to shake off: "There is," he wrote in 1846, "a new element —*modern* beauty." What the conference wished to study was the modernism of Baudelaire in its possible application to the situation in art today. Under the general title of "La Découverte du Présent," the observance was directed by its preliminary statement toward Baudelaire's "poetic criticism," in terms leaving little doubt that this approach was being proposed as an alternative to the servility and computer mentality prevalent in current writing on art. In stressing Baudelaire's conception of the artist and the critic as "discoverers of the present," the title of the conference set it, at least nominally, in opposition to the kind of criticism that deals with art objects as belonging to a realm sealed off from the space-time of the human condition. Nor did discovering the present leave room for the critic who thinks of painting in terms of techniques and the handling of aesthetic "elements"—the kind of critic who, Baudelaire jeeringly noted, "will always recommend drawing to colorists, and color to

draughtsmen." For his own part, Baudelaire announced, "Regarding the technical means and processes taken from the works themselves, the public and the artists will find nothing to learn here. Things like that are learnt in the studio . . . The best criticism is that which is amusing and poetic: not a cold, mathematical criticism which, on the pretext of explaining everything . . . voluntarily strips itself of every shred of temperament . . . The criticism which I approve will be [the] picture reflected by an intelligent and sensitive mind. Thus the best account of a picture may well be a sonnet or an elegy."

Obviously, poetic criticism is not a program that can be attractive to ideologists, system builders, curators or art departments. By its nature it invites abuse, in that it seems to substitute colorful phrases for a serious analysis of paintings and sculptures—though as Thomas Hess, one of the Paris conferees, pointed out in his paper, all writing on painting, even the dullest, is compelled to resort to metaphors and symbols in order to translate visual data into words. Even more seriously objectionable to professionals, however, is Baudelaire's notion of the obligation of the critic in regard to the present, which compels him to gamble his judgments of works of art on a general intuition of his time, a factor about which it is impossible to be certain. There is not available any course of study through which he can prepare himself to know the destiny contained in current history. He is thrown into the arena of conflicting interests and philosophies, and in order to make its way his criticism will have to become, in Baudelaire's now famous definition, "partial, passionate and political." If he is mistaken in his choice of partisanship, his criticism, regardless of his connoisseurship, will be a succession of errors. Poetic criticism puts the critic in the same boat as the artist; it forces him to choose among the possible directions offered by the present, and to choose wrongly in regard to history is fatal, though to be wrong about paintings is not. To Baudelaire, it is essential to the vocation of critic that he run the risk of losing everything. To wish to be always right is fatuous. The eclectic critic, the one capable of supporting all aesthetic doctrines, like the contemporary who has run from Abstract Expressionism to Pop and Op and ended with Minimalism, was to Baudelaire the personification of a moral disease, especially virulent in modern times—the disease of doubt. Such a critic failed to understand that art derives its intensity through restricting its field of observation, that creating is a procedure analogous to believing: If the poetic critic is liable to fall into error, the eclectic critic is guaranteed extinction.

Emanating from this passionate search for the new, everything Baudelairean

is bound to act as a red flag to conventional criticism. Not only was the poet opposed to "studio jargon" but he spoke slightingly of the careful examination of canvases, and even claimed to have written about the Salon of 1859 without having seen it. "The duty of criticism," he declares, "should be to seek to penetrate deep into the temperament and activating motives of each artist, rather than to attempt to analyze each work minutely." Thus his interest is bent toward studying the time through its creative minds, a kind of dramatic project which reaches its fulfillment in his figure of the Dandy as the personage in whom the style of the period is fused with its spiritual condition. Paintings are taken as clues by which the imagination of the spectator can situate itself in the unknown world of the present. Baudelaire resolutely denies the existence of an absolute or eternal beauty to which art values can refer; such a conception, he insists, is only an abstraction "creamed from the general surface of different beauties" (a perfect description of academic aesthetics, traditional or avant-garde). Values in art are relative to contemporary modes of seeing, feeling and behaving. The present is the hot moment in history—the moment of action, hence of passion and style. All great art is art of the present; the classics are great because "ancient life was a great parade." In seeking to peer through the painting to its creator, and his motives and methods, Baudelaire bases values in art upon living men rather than upon an order of objects representing aesthetic essences.

Judging paintings by their poetic "correspondences" in the modern world, Baudelaire did not escape damage as a critic. In the opinion of succeeding generations he lost most of his critical bets; he tied his modernism too tightly to Delacroix and withheld it from Courbet and Manet, missed poetic qualities in Ingres, praised painters no longer remembered and dramatized Guys as the artist of the age. To these errors, Baudelaire could have had only one reply: "A critic does not cease to be a man . . . so there is never a moment when criticism is not in contact with metaphysics"—a statement which is less a justification than a defiance.

It is his insights into contemporary life and his capacity to relate those insights to concrete aesthetic thinking that distinguish Baudelaire's criticism and identifies him as a founder of the tradition of the new. ("It is true that the great tradition has got lost," he writes, "and that the new one is not yet established.") For him the novelty of the present is twofold: it is, on the one hand, the new décor of the streets, the costumes of the men and women of the city, the "floating existences" of the underworld, the reign of chance in human

relations, the intermittences of feeling. But the modern is also a unique state of consciousness, a new moral condition and a metaphysical predicament. In the "painter of modern life," for whom he sought never altogether successfully, new surfaces are combined with new passions; the devotee of "*la modernité*" takes it as his task "to disengage from fashion that which is poetic within the historical, to draw the eternal out of the transitory." Modern art is synonymous with romanticism—"that is, intimacy, spirituality, color, aspiration toward the infinite." But Baudelaire is opposed to the "old romanticism," in which inspiration takes the place of observation, analysis and method, and he regrets the absence of new everyday objects and scenes in the paintings of his idol Delacroix.

Yet an art that is modern only in its reflection of the latest décor of city life or industry is an incomplete art, a dull copying of visual data; "the result," says Baudelaire, conveying what would be his verdict upon much of the art of the 1960's, "is a great vice, the vice of banality, to which those painters are especially prone [who] consider it a triumph if they can contrive not to show their personalities." Baudelaire's attack on Courbet on the ground that he sacrificed the imagination in behalf of external fact contains the ingredients of a Baudelairean judgment of Pop, Op, electronic and kinetic art. Its equivalent on the social plane is his celebrated hostility to progress—actually, to the idea of progress—because it projects the fantasy of a world moved from the outside and capable of improvement without the intervention of the will or genius of individuals. Neither art nor society advances of itself; it only passes through more profound or more superficial phases. "The artist," says Baudelaire, in a challenge to all determinisms, "stems only from himself." (Elsewhere, he contradicts this by deploring the glorification of the individual and the decline of schools in art.) For all the marvels of the modern scene, modernism is, subjectively, an ordeal. No one can leap over his own time, and to seek the present is to plunge "into the depths of the Unknown to find the new," an enterprise which is not only aesthetic but heroic. Thus Baudelaire concludes one of his Salon reviews with a section "On The Heroism of Modern Life."

Generalizations of this sort, though often stimulating to artists, are ordinarily of little value in art criticism. The strongest feature of Baudelaire's writing on art is his ability to translate his socio-historical intuitions into concrete conceptions of the function of color, line, surface. His criticism restores the connection between art and social life without sacrificing the autonomy of the

aesthetic. His insight into painting is cultivated by his enthusiasm for the new
:n phenomena outside of art. His modernism lies not in the paintings he chooses
to admire or vilify but in his appreciation of the visual attributes of things
newly conceived or coming into being and still unassimilated. With him their
strangeness, animation, ambiguity, even uncouthness are converted into posi-
tive values of painting; "Delacroix is sometimes clumsy but he is essentially
creative" is a dictum that sounds as if it had been delivered yesterday about a
contemporary. Inspired by Delacroix, Baudelaire elevates color to a primary
place in modern art, and speaks of the "delicious pain" aroused in him by a
café striped red and green. But he adds subtlety to his discussion of color by
his admiration for contemporary clothes, discerning that "great colorists
know how to create color with a black coat, a white tie and a grey back-
ground." Strangeness in a work he takes to be indispensable, yet he is careful
to distinguish between the simple, unpremeditated strangeness that is the inev-
itable accompaniment of individuality, and strangeness coldly calculated for
effect. Praising Delacroix as an artist "whose chief preoccupations are move-
ment, color and atmosphere," he explains that these elements call for an im-
precise contour, light and floating lines and boldness of touch. "Delacroix," he
adds as if with a wink at the American critics at the Paris conference, "is the
only artist today whose originality has not been invaded by the tyrannical
system of straight lines." Consistently, he attacks the linearity of Ingres,
whom he accuses of drawing like "a man with a system." He is sensitive to the
distinction, which has come to be widely noted only in our century, between
a work that is complete (i.e., which contains all that the artist has seen and
felt) and a work that is finished (i.e., which has a surface handled à la mode),
and to induce the spectator to feel his way into a painting he stresses that what
is complete need not be finished and that what is finished may not be com-
plete. This notion of the creatively complete is carried forward in another
intuition, absolutely modern—that a good painting is brought into being
through a succession of fulfilled images superimposed upon one another, so
that the final picture is the result of many complete acts of creation, each new
layer carrying the picture closer to its ultimate idea. In contrast, he recalls
paintings executed in finished sections, with the rest of the composition
blocked out in outline; paintings so produced, he concludes, are a form of
manual labor.

Baudelaire's antagonism to contrived art is the negative aspect of his exalta-
tion of freshness in its dual manifestations in new physical objects and in the

clarity of vision which he associates with convalescence, childhood and the ecstasies of hashish. It is the holiday of the senses he finds most frequently in Delacroix that accounts for his continuing reverence for the master. Baudelaire's critical method is, above all, a procedure for apprehending the new. Its essential premise is the encounter between a critic as an adventurer of the imagination—"a dreamer whose mind is given to generalization as well as to the study of details"—and a unique and unfamiliar image. To this encounter the critic brings not knowledge but a self, a self with a readiness for transformation. In confronting the work he appropriates it for his own time, regardless of the period in which it was created. This transfer of the work into presentness and into a living intelligence is the primary objective of "poetic criticism."

Baudelaire illustrates his process of criticism-as-renovation in a section entitled "Critical Method," which opens his review of the Universal Exhibition of 1855. His theme is a confrontation with a "product of China" by a spectator who knows nothing about Chinese art and to whom the work is "something weird, strange, distorted in form, intense in color, and sometimes delicate to the point of evanescence." For practical purposes, "Chinese" here means "new"; Baudelaire might have been speaking of a Matisse as it is perceived by an academic sensibility. Despite its "weirdness," however, Baudelaire tells us (though he does not explain why), the work is "a specimen of universal beauty" and deserves to be appreciated. How will the critic go about understanding it? Baudelaire's reply to this question goes to the root of his radical outlook and implies a definition of the function of art in the modern world. The spectator, the critic, he asserts, will understand the Chinese art object not through acquiring information about it but through working "a transformation in himself that partakes of the nature of a mystery; it is necessary for him, by means of a phenomenon of the will acting upon the imagination, to learn of himself to participate in the surroundings that have given birth to this singular flowering." Through the work, the spectator is transported to China and perhaps into another century. "Few men," Baudelaire goes on, "have the divine grace of cosmopolitanism in its entirety, but all can acquire it in different degrees." In its effect on the mind, a work of art can be a species of travel as well as an agent of metamorphosis. The spectator appreciates it through his capacity for change, and the change wrought in him is the meaning of the work. In a subsequent passage, too long to quote, Baudelaire details, with an eloquence exceptional even for him, the slow absorption by the spectator of strange sensations from the imagined China—"all that world of new harmo-

nies [that] . . . patiently penetrate him, like the vapors of a perfumed Turkish bath"—which results finally in his conversion to the new. In the end, invigorated and enriched by new perceptions, his entire outlook may undergo a reversal. Thus art also has a moral effect. In its emphasis upon an encounter by which the spectator is transformed, Baudelaire's poetic criticism rests upon a dramatic experience that contains but transcends the aesthetic.

The condition for this approach to art is, Baudelaire makes clear, naïveté, one of his major standards for evaluating both artists and critics—it means in his scheme being dominated by one's own temperament even within the framework of artifice or manner; in short, following the drive of a self. Baudelaire's exposition of his critical method is accompanied by a continual attack on pedagogues, pundits and system makers. He contrasts his uneducated confrontation of an art work with that of Winckelmann, the celebrated eighteenth-century historian of ancient art. Let the reader imagine, he suggests, "a modern Winckelmann (we are full of them; the nation overflows with them; they are the idols of the lazy). What would *he* say if faced with a product of China?" This question, Baudelaire adds, is "almost equivalent to a formula." Whatever the scholar cannot fit into his system he will cast out as worthless. With the modern Winckelmann, the Chinese (new) work will be rejected as a barbarism, then incorporated into an aesthetic doctrine that falsifies it. Baudelaire confesses that he, too, has been tempted at times to concoct a critical system into which he could retire and relax. His efforts always came to naught through the appearance in art of something spontaneous and unexpected. To accommodate the new, the system, no matter how spacious, had to be revised. Fed up with the humiliation of being forced to re-do his ideas, the poet sought refuge in naïveté, and instead of discoursing authoritatively on composition, balance, tone and other aesthetic elements, he decided to respond to paintings in terms of pleasure, feeling and morality. One requirement alone is left for the critic to meet: he must possess a talent for moving with agility across "the immense keyboard of the universal correspondences"—in sum, the essence of art criticism is an imagination cultivated in metaphor and the ability to write well.

The two decades in which Baudelaire wrote his critical pieces were not a great period in art; even the earliest waves of the modernist movements did not reach their crest until after his death. Not the least of Baudelaire's contributions to the discovery of the present is his anatomy of the intellectual foundations of mediocrity. Imagination, he charges, is systematically assaulted in the name of tradition (Ingres), on the one hand, and of nature (Courbet), on

the other. Refusing to draw on their own minds, the majority of painters, "sad specialists, old and young," are thrown back upon the acquisition of technical skill. "Everyone is painting better and better—which seems to us a lamentable thing." Baudelaire is appalled by the ignorance of painters. With three or four exceptions, artists, he notes, are spoiled children unfit for the company of a poet or philosopher. To demonstrate the merit of Delacroix he recalls that there were more writers than painters at his funeral. A combination of skill and stupidity is sufficient to earn for artists the acclaim of a public nurtured on photography, that embodiment of the "gloomy beacon" progress. In regard to quality, Baudelaire's present seems no different from ours, and one hearkens uneasily to his words about the mysterious shifts of vitality by which centers of creation in art have been suddenly left barren.

The Paris conference obviously contained the seeds of warfare. The battle, however, never took place. The irony of the occasion was that the enemy of scholars and technicians was being honored by a few artists but mostly by scholars and technicians. In the opening paper the painter Masson acclaimed Baudelaire as too wise to speak of paintings that did not speak to him—a faithfully Baudelairean caution that would seem to put at a distance critics and historians whose profession obliges them to "cover" the art of a given artist, place or period regardless of how they feel about the works. Papers of the United States participants were dutifully directed toward the present day. Barnett Newman spoke on "Passionate Criticism," Thomas Hess on "The Poet in the Studio," and I on a theme wistfully entitled "Toward the End of Art History." The Mexican poet and essayist Octavio Paz raised the interesting point that the idea of the modern may have reached its end and ought now to be subjected to the same kind of rigorous analysis that Baudelaire had applied to the concept of tradition. In the main, however, the conference dissipated itself, as might have been expected, in arguments over texts, usually the same ones, and the question—to my mind irrelevant to Baudelaire's enlightenment of the present—of whether in his later years the poet turned away from the modern world toward the Church and the past. Despite the knowledge and moments of brilliance displayed at the conference, the present still remains to be discovered. It may be that the Now is not a subject for conferences. Perhaps the message of Baudelaire is that, like a work of art, the present can only be discovered through oneself.

VICISSITUDES OF THE SQUARE

At least a third of the paintings in the 1968 Whitney Annual fall within the scope of Constructivism as it is conceived by George Rickey in his new book of that title.* A similar, if not larger, proportion of the works shown in the previous year's Annual, devoted to American sculpture, also belonged to this mode. Constructivism, with its aura of mathematics and engineering, and its implication of impersonality (one branch of it is called *Kalte Kunst,* or Cold Art), is, among a large segment of young Americans, the strongest alternative so far to the emotionality and self-centeredness of Abstract Expressionism. Until a few years ago, Rickey complains, this fifty-year-old movement was largely ignored. Today, however, from Albers to Zox, the walls of museums are covered with squares, circles, diamond shapes, vertical lines, horizontal lines, grids, emblems, color chromatics, shaped canvases, inlaid cutouts, one-color paintings, all sharing the precise look of works produced through rationally controlled processes. As for the galleries, seven announcements of openings arrived on my desk the morning after New Year's Day, every one for an exhibition of constructions on canvas or in three dimensions. Contemporary critical jargon tends to separate works such as these into several categories, examples of which are hard-edge and color-field. Rickey, in contrast, has chosen to extend the term Constructivism, inherited from Russian abstract art of 1914, to cover all types and deviations of rationalist art, including his own kinetic creations. The subject of his book is those non-representational,

* George Braziller, Inc., New York, 1968.

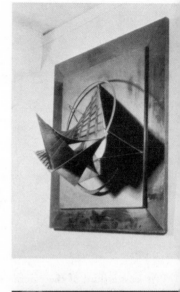

ANTOINE PEVSNER, *LINES AND TANGENTS*, PRIVATE
COLLECTION

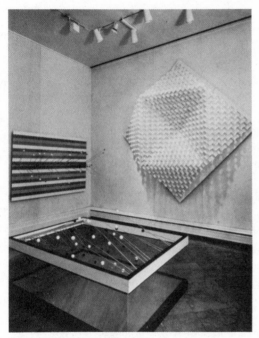

IVAN PICELJ, *TOPOS, IRA, IDES*, 1967, COURTESY
ALBRIGHT-KNOX ART GALLERY, BUFFALO

GEORGE RICKEY, *TWO LINES — TEMPORAL I*, 1964,
TWO STAINLESS STEEL MOBILE BLADES ON PAINTED
STEEL BASE, 35 FT. 2⅜ IN. HIGH, COLLECTION THE
MUSEUM OF MODERN ART, NEW YORK, MRS. SIMON
GUGGENHEIM FUND

non-mimetic, pre-planned twentieth-century paintings, sculptures, and "constructions" that pass in a direct line from Russian Constructivism and Suprematism (Malevich, Gabo, Pevsner, Tatlin, Rodchenko, Lissitzky) through the Dutch De Stijl (Mondrian, Van Doesburg) and the German Bauhaus to such present-day derivations and hybrids as optical painting, minimal sculpture, "post-painterly abstraction," "art of the real." Rickey's use of a single name to denote the entire development has, in my opinion, the advantage of emphasizing the unity of the intellectual assumptions present in all phases of Constructivism, and, in addition, of calling attention to common visual qualities, as against the current practice of label-mongering and aesthetic logic-chopping by which artists and their promoters endeavor to establish the originality of every petty difference in the handling of a line or a hue. The specialized technical dogmas that have at intervals emerged in Constructivism, such as the rejection of color as "superficial" and the glorification of the vertical versus the diagonal, have tended to operate within the context of a broader set of attitudes that are in general characteristic of mathematical abstraction; for instance, the demand for an art founded on objective laws (including, in recent years, laws of chance) and the passionate wish to strip painting and sculpture of "inessentials."

In its enthusiasm for the rigorously defined, Constructivist art has gravitated toward the simplest geometrical shapes—the square, the circle, and the triangle; for Kandinsky, Rickey tells us, the triangle had "its particular spiritual perfume." Historically, the formal elements of this mode are derived, as Rickey points out, from the decorative patterns of applied art—the chevrons, diamond shapes, swastikas, waves that appear in mosaics, rugs, heraldic devices—and it is no wonder that the public reaction to Constructivist abstractions has been to compare them to things seen in department stores. But while Constructivism reaches back to the most primitive ornamentation, it is also the art most directly responsive—one might almost say obedient—to what is most modern in the modern world. Insofar as it is an art of Reason, Constructivism is a revival of classicism in twentieth-century form; it echoes Plato's pleasure in the contemplation of geometrical images "in and of themselves," Poussin's belief in a rational order underlying appearances, Cézanne's formula of treating nature "by the cylinder, the sphere, the cone." But Constructivism differs from classicism in that it is neither humanist in outlook nor serene nor static in sensibility. Motion was inherent in it from the start, and a rectangle of Mondrian, a space pattern of Gabo, quiver in nervous suspension. Constructivism

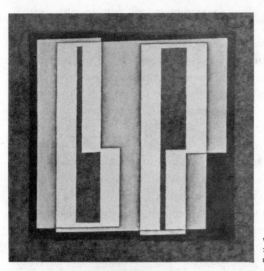

JOSEF ALBERS, *b AND p*, 1937, OIL ON PRESSED WOOD, 23¾ X 23¾ IN. THE SOLOMON R. GUGGENHEIM MUSEUM

VICTOR VASARELY, *ONDHO,* 1956-60, OIL ON CANVAS, 86⅝ X 71 IN. COLLECTION THE MUSEUM OF MODERN ART, NEW YORK, GIFT OF DAVID THOMPSON

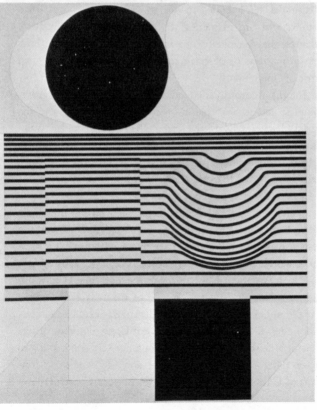

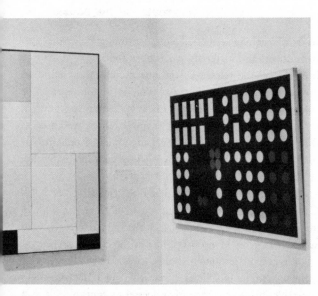

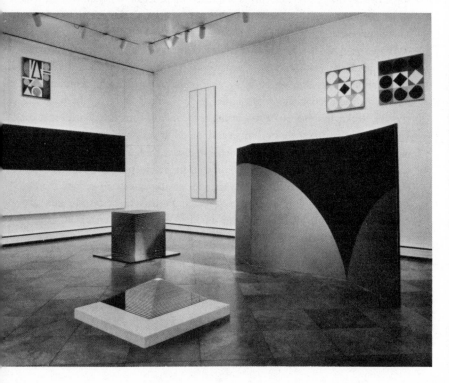

early identified itself as a "machine aesthetic," and, continuing to absorb into art new industrial instruments and materials, it has been the formal mirror of phenomena brought forth by the telescope, the microscope, the computer, film, kinetics, electronics, water and air pressure, studies in the tensions of metals. The square of Malevich and the circle of Lissitzky keep reappearing in thousands of new arrangements—in such otherwise unrelated compositions as those of Albers and Frank Stella or the targets of Tadasky and Kenneth Noland, or else multiplied into the serial rhythms revealed by microphotography, the oscilloscope, or banks of illuminated mirrors.

From its relation to the crafts, on the one hand, and to science and technology, on the other, Constructivist art derives important advantages as a force in contemporary culture. It is a mode of art, probably the only mode, that can be taught with measurable degrees of progress, like arithmetic or carpentry. The objectivity of Constructivist insights makes possible an accumulation of knowledge that can be shared, as in scholarly research, while its workshop spirit breaks down creation into a sequence of processes as transmissible as a recipe, even allowing the production of works through directions given over the telephone. In the confusion of the arts in the twentieth century, the clarity and self-limitation of Constructivism in respect to both means and ends recommend it as a program for mass education in studio practice, as well as for critics and educators in search of a stable point of departure. Recounting the arrival of leading Bauhaus personalities in the United States in the nineteen-thirties, Rickey notes that "it was in the *academies* of the New World that the welcome was warmest for both men and ideas." It is significant that American painters and sculptors were not much impressed by Constructivist concepts; the American Abstract Artists group of the late nineteen-thirties had more the character of a holding operation for the idea of abstract art in general than of a creative movement linked to Constructivism. Perhaps the anti-individual disciplines of the Bauhaus repelled artists who had noted their resemblance to the conditions of creation in the commercial-art studios. To reach major status in America, Constructivism had to wait until the nineteen-sixties, when Pop Art had overcome the distaste of artists for the procedures of the mass media and a generation trained in the art departments of large universities had emerged.

In Rickey's opinion, the real force of Constructivism, however, lay not in its style, technique, or materials but in its basic revision of the traditional concept of the artist. The characteristic images of Constructivism demanded, he asserts, "a radical shift from ideas held for thousands of years." Its "vocab-

ulary [square, circle, checkerboard, and so on] had been handed down quite separately from the ebb and flow of schools in 'fine' art. . . . It was not until our epoch that the very neutrality, the self-effacement, of such craftsmanship was to become an aesthetic principle characteristic of a significant group of artists." Self-effacement, it appears, or depersonalization, goes with elementary shapes as an essential "aesthetic principle" of Constructivism. It is in its handling of this question of individuality, basic to creation of art in our time, that I find Rickey's *Constructivism* unsatisfactory and the movement itself laden with ambiguity.

Since the beginning of the movement, the depersonalization affirmed by Constructivists has been of two kinds—utilitarian and metaphysical (or mystical). In Russia during and after the Revolution, self-effacement meant art in the service of the masses (the anonymity of utilitarian design favored by Rodchenko, Tatlin, and Lissitzky) or it meant an art of essences (the metaphysical entities dealt with by Malevich and embodied in Gabo's theory of replacing mass and contour in sculpture by living "forces"). Subsequent Constructivist ideologies have continued to vacillate between the anonymity of the artisan and mystical self-annihilation. Often the two motives have been united in one artist. Here is Rickey's summation of one of Mondrian's "essentials of the image": "A social implication; equilibrium, through a contrasting and neutralizing opposition, annihilates individuals as particular personalities and thus creates the future society as a real unity." Here an aesthetic principle—equilibrium—acts to produce by negation a selfless brotherhood that reconstructs society.

That geometrical shapes can carry such grand implications as those attributed to them by Malevich, Gabo, and Mondrian, or be seen as designs for packaging or floor coverings (as was the case with Mondrian almost to the year of his death), makes Constructivist art the most difficult to apprehend visually and the most fruitful in critical and theoretical polemics. Philosophically, its concept of anonymity may be read as either transcendence or suppression, as glorious unself-conscious artisanship or as externally directed drudgery. For Rickey, however, self-effacement is simply the opposite of Expressionist or Romantic egotism.

In Europe, Constructivism has brought into being numerous self-declared "anonymous" groups working and exhibiting collectively. In these, too, apart from the fact that their members soon emerge with signatures of their own, it is not always possible to separate the anonymity of craft production from that

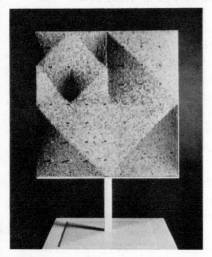

VJENCESLAV RICHTER, *RHYTHM 7*, 1968, STEEL FRAME PLUS ALUMINUM, 15¾ X 15¾ IN. ALBRIGHT-KNOX GALLERY, BUFFALO

GEORGE ORTMAN, *TRIANGLE*, 1959, COLLAGE OF PAINTED CANVAS ON MASONITE WITH 9 PLASTER INSERTS, 49⅝ X 49⅞ X 3¾ IN. COLLECTION THE MUSEUM OF MODERN ART, NEW YORK, LARRY ALDRICH FOUNDATION FUND

GEORGES VANTONGERLOO, *CONSTRUCTION C VOLUME RELATIONS*, 1921, MAHOGANY, 16⅛ IN HIGH, COLLECTION THE MUSEUM OF MODERN ART, NEW YORK, GIFT OF MISS SILVIA PIZITZ

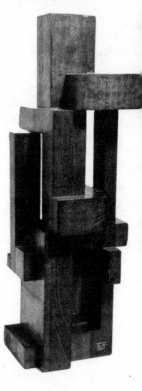

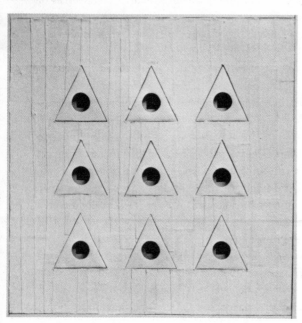

of mystical conceptions of creation. The anti-individualism of the German Zero group takes on a quasi-religious aura with their explanation that "Zero" means "a zone of silence" for a new beginning. It is evident that a rational methodology and clearly formulated objectives do not preclude a mystical sensibility. "I felt only night within me," Rickey quotes Malevich as testifying, "and it was then that I conceived the new art." To Malevich, as to Melville, "the white field" represents the "void" beyond feeling. "The square of the Suprematists," Malevich wrote, "can be compared to the symbols of primitive men. It was not their intent to produce ornaments but to express the feelings of rhythm." This version of the square corresponds to Barnett Newman's experience of "the living rectangle"—a concept usually abandoned by Neo-Constructivist color-field craftsmen who have picked up Newman's "image." The logic of Malevich was directed not toward achieving a system of rational formal relations but to advancing into "the 'desert' where nothing is real but feeling." In his symbolic reasoning, Constructivism comes close to Abstract Expressionism conceived not in the vulgar sense of an artist "expressing his personality" but as bringing into view the shapings of a unique mind. In Kandinsky, the Constructivist and Expressionist currents actually converged; Rickey quotes with apparent approval the statement that for Kandinsky "the impact of the acute angle of a triangle on a circle produces an effect no less powerful than the finger of God touching the finger of Adam in Michelangelo," but he regrets that Kandinsky's "poetic nature" turned him toward "symbolism" (of which Malevich's white-as-void is apparently absolved), and his final verdict on Kandinsky is "He was a Romantic."

What Rickey fails to see is that there persists within Constructivism a continuing conflict, corresponding to the conflict between utilitarian and "pure" art that emerged in Moscow at the very origins of the movement and split the Russian abstractionists into two camps. The circle or the swastika serves equally as an element of design and as a magical sign invoking hidden powers. Yet it is one thing to summon up the invisible, another to paint arcs or stripes. To be consistent in his attempt to exclude "symbolism" from the Constructivist creed, Rickey would have to rule out all the great figures of the movement, including Gabo, whom he admires above all the others and to whom his book is dedicated. Constructivism, says Gabo, "has accepted the fact that what we perceive with our five senses is not the only aspect of life and nature to be sung about; that life and nature conceal an infinite variety of forces, depths, and aspects never seen and only faintly felt which have not less but more

importance to be expressed and to be made more concretely felt through some kind of an image communicable not only to our reason but to our immediate everyday perceptions and feelings of life and nature." Rickey extols Gabo for being "less metaphysical" than Malevich, but after this description of Gabo's traffic with "forces never seen" I'm not sure I know what Rickey means by "metaphysical." Jackson Pollock could have subscribed to much of the passage quoted, and by its principle Action painters such as Hofmann and Kline have more in common with Constructivism than have many of the pattern-makers who fill much of Rickey's survey. The chapter "Tangents and Pressures," which discusses visual tensions created by abstract means and which quotes Klee's *Pedagogical Sketchbook*, could have been included in a study of characteristic effects of Abstract Expressionist paintings; for instance, "close cropping of the format so that the picture seems squeezed in a tight fit" describes a device often used by de Kooning in his *Women*.

In sum, the weakness in Rickey's otherwise excellent family roll call of Constructivism in its present-day manifestations lies in its overschematized opposition between the anonymity and non-subjectivity of the geometrical painters and sculptors and the presumed egocentricity of the Abstract Expressionists. (Rickey demonstrates self-effacement by modestly excluding his own work, except for one small illustration, though he is among the most interesting of contemporary kinetic sculptors.) All art, even the "coolest" and most objective, is "hot" to some degree or it is lifeless, and all art is "cool" to some degree or it is mere formless matter. And modern art movements, whether they begin in devotion to reason or to feeling, soon enter a craft phase in which paintings are turned out by workshop methods that place primary stress on techniques for producing effects; it was the cool manufacture of hot Abstract Expressionist canvases that brought this movement into disfavor. Rickey is impressed by Gabo's rejection of Romantic individualism, but he pays too little attention to the nature of the insight that for Gabo replaced mood as a creative principle. In the United States, the metaphysical heritage of Constructivism has been strongest in artists close to Abstract Expressionism, such as Newman, Rothko, and Reinhardt.

As for the craft aspect of Constructivism, it has in this country separated itself from social aims and seeks acceptance on a purely aesthetic basis; in short, it lacks both practical usefulness and philosophical meaning. In the heyday of Russian Constructivism and the Bauhaus, many of the mathematical and emblematic compositions now appearing in museums and galleries might

have been fashioned for practical purposes. The useful has its aesthetic, too, but it is related to what pleases the eye rather than to theories of the evolution of styles. The only justification for current "pure" abstraction is that it is historically correct. It is neither good for anything, expressive of anything, or much to look at.

In the United States in the nineteen-sixties, Constructivism as it is interpreted by various new aesthetics has had a more radical effect on art criticism than on painting and sculpture. It is one of the merits of Rickey's book that he ignores most of this polemical material in order to set the works themselves in appropriate descriptive categories. Still, in his eagerness to eliminate "metaphysics" he passes over an artist like Newman but features descendants of Newman like Noland, Morris Louis, and Stella. In thus qualifying art negatively by its absence of philosophical sensibility, Rickey's *Constructivism*, like much current art criticism, is, in effect, left with nothing but motif to distinguish between one work and another, as if one considered them as pictures of squares or boats. But the square has been a theme in art for half a century, and painting squares is now no different from painting trees or clowns; the question of the feeling they convey becomes all-important. To Rickey, feeling is by definition a weakness, so that Albers, to whom the square is a neutral setting in which colors perform as "actors," is dubbed a Romantic, like Kandinsky. The fact that Jasper Johns chose the image of the American flag as a transition from Abstract Expressionism to a more calculated art makes his work neither more nor less self-effacing than that of, say, Lester Johnson, who uses the human figure for a comparable purpose, yet Rickey includes the first artist and, of course, omits the second. Artists who have shaken off the grip of aesthetic dogma often pass easily from abstract construction to abstract "expression" and back again; like Kandinsky, Alexander Liberman has worked in both modes, and in his recent sculpture he combines them by traversing geometrical planes with wandering linear shapes. The basic difference in abstract art is not between individualism and self-effacement but between the artist as a philosopher of scale, placement, number as revelations of unseen "depths and aspects" and the artist as a designer laying claim to a new aesthetic status —a difference not always readily visible at first sight.

SIGNS

Of major interest in the recent Adolph Gottlieb retrospective works done between 1941 and 1966 is the degree to which this artist's paintings, no matter how abstract and "reduced" they become, retain an unmistakable content of symbolism and poetic suggestion. One of the most alert of the war generation of American artists to the issues of abstract art, Gottlieb has consistently refused to confine his work to the aesthetics of abstraction. In his earlier canvases subject matter, although never literal, is explicit. The primitive "pictographs"—with their crudely outlined hieroglyphs and signs (the fish, the eye, the circle, the spiral); their division into boxes, like the boxes children chalk on sidewalks; their scrawls of war paint and their thick borders of black; their unmodulated contrasts; their yellow, blue, and purple hues—simulate markings on bark or on fabrics woven of grass. They call up an imaginary jungle, as the Gottliebs of the middle fifties evoke unlocated countrysides.

The later paintings, however, go so far toward simplification and abstraction as to raise the question of whether they refer to anything outside themselves. In recent years, Gottlieb has arrived at compositions consisting of two or three abstract shapes on a one-colored field. These emblems could readily function, like the square, the circle, and the chevron of current Constructivist paintings, as formal quantities with which to demonstrate advanced concepts in space and color theory. Gottlieb today works on the edge of pure abstraction; to slip entirely into this current he has only to purge his paintings of symbolic mystery by asserting the physical mystery of color or shape. A few

of the paintings actually do this. *Units II, Units III, Focal,* and *Sign* arrest the mind in the blankness of sheer looking. In general, however, Gottlieb has refused to restrain his painting from visionary probings. Signmaking is too deeply grounded in the psychological and cultural imperatives of his art to be renounced in favor of formal exercises.

His aesthetics originates in the conviction, shared by the American vanguard of the war years, that Western art forms are played out—the conviction that was reached by the Dadaists and the Surrealists, and by Klee and Kandinsky, out of the experiences of the First World War. If art was to continue, it had to begin again at some point outside the European tradition. In the forties, Gottlieb was one of the most vociferous of the New York artists in favoring an end to American artistic dependence upon Paris; the American Indian element in his symbolism, from the early pictographs to his present-day sun discs, was undoubtedly precipitated by his fervor for an art tradition alien to Western painting. Earlier New York artists had sought an identity for their art through the unique local color of the metropolis. Realism, however, remained trapped in the old styles. To achieve the new, Gottlieb saw, it was necessary to open out the present myth. A leader in shaping the strategies of the renewal of art in America, he turned, as did Gorky, Pollock, Rothko, Newman, Baziotes, David Smith, toward the inscriptions of the aborigines and the jottings of the unconscious. Gottlieb's joint communiqué with Rothko in 1943 presented the Baudelairean concept, less familiar then than it is today, that modern art must be "an adventure into an unknown world." From his earliest abstract paintings (e.g., the 1941 *Eyes of Oedipus,* with its childlike profiles of the King) to late oils bearing cryptic mathematical formulas, Gottlieb has held to his perspective of a beyond-art structure, whether in images of the primitive-archaic or of the outer space of modern physics.

The "unknown world" of the Gottlieb-Rothko manifesto was, as might have been anticipated, a *distant* world. Gottlieb's signs are insignia of remoteness, an Africa or cosmos of the mind, as far away as possible from the sign systems of New York. Such detached symbols, comparable to those of mathematics, liberate the intellect, but they also run the risk of emptying it. The trend among the American emblem painters has been toward compressing experience into a closed set of visual terms, as few as possible in number, and then reiterating those terms as totems in a tight order of variations. Emblematic art tends toward the official seal. There is in these design-signatures a semi-

comic assumption of authority. You are not permitted to question X's rectangle, Y's stripe, Z's splash. Gottlieb has gone part of the way toward this ultimate. It is to his credit, as it is to the credit of such early colleagues as Newman and Rothko, that he has stopped short of the image-in-itself, or, as current art talk has it, of the art work as a pure (that is, non-signifying) object. This stopping short has to do with his way of handling his materials—in a word, with his style. *Style is the irreducible plus that separates a work of art from the universe of things.*

The situation of the postwar Americans was complicated by their awareness that African masks and the hybrids of dream had already been incorporated into avant-garde European art. As visual matter, primitive motifs merely augmented the burden of the past. To rid itself of dead forms, the mind needed the aid of some other organ. Hence, in the new American primitivism the hand of the artist reached past the intellect and its own acquired skill toward contact with the hidden structure of reality. Gottlieb's link with the Action painters lies in the augmented role of the hand in visual discovery. His approach is more studied and deliberate than that of de Kooning or Pollock. His temperament is not of the kind that seeks truth through provoking a state of disorder. Instead of enacting the unknown on the canvas, he has sought contact with it through the magical idiom of medicine men and astronomers. With him, symbols, whether animal shapes or plus and minus marks, not only serve as points of departure but remain intact in the finished work. Yet the signs he selects are not in themselves the substance of his statement, nor are selection and adaptation the sum of his creative process. The meaning of Gottlieb's symbols is in his experimental activation of them in the formal vocabulary of twentieth-century painting. Emblematic Expressionism is painting carried on at the intersection of metaphysical sensibility and aesthetic sophistication. Its objective is an intuition built out of color, texture, shape, and scale. Or it is color, texture, shape, and scale that take on the lure of an intuition.

What is constantly surprising in a large exhibition of Gottlieb's paintings is their variety—a variety that subsists in their handling and that will be missed by the spectator who sees only the pictorial profile of his pictographs or his "bursts." Though Gottlieb has continued for years to exploit a single format (he has developed only three or four in his career), his work has in each phase incorporated an extraordinarily wide spectrum of the expressive devices of modern painting, including the gestural effects introduced by Action painting —scratchings, smearings, splashes, blots, washes, thick strokes, random lines,

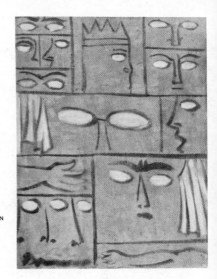

ADOLPH GOTTLIEB, *EYES OF OEDIPUS*, 1941, OIL ON CANVAS, 32 X 25 IN. COLLECTION MRS. ADOLPH GOTTLIEB, NEW YORK

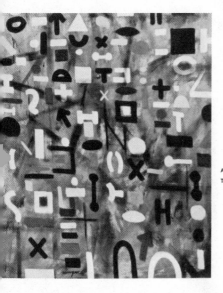

ADOLPH GOTTLIEB, *COMPOSITION*, 1955, OIL ON CANVAS, 72 X 60 IN. COLLECTION WILLIAM S. RUBIN

ADOLPH GOTTLIEB, *UNSTILL LIFE #3*, 1954-56, OIL ON CANVAS, 84 X 192 IN. COLLECTION THE MUSEUM OF MODERN ART, NEW YORK

ADOLPH GOTTLIEB, *UNA*, 1959, OIL ON CANVAS, 108 X 90 IN. COLLECTION THE ARTIST

ADOLPH GOTTLIEB, *CREST*, 1959, OIL ON CANVAS, 108 X 90 IN. COLLECTION THE WHITNEY MUSEUM OF AMERICAN ART, NEW YORK, GIFT OF THE CHASE MANHATTAN BANK

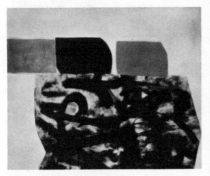

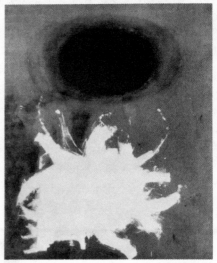

ADOLPH GOTTLIEB, *SIDE PULL*, 1956, OIL ON CANVAS, 50 X 60 IN. COLLECTION MR. CLEMENT GREENBERG

absorbed tones, hard and soft contours. This variety has not diminished with the simplification of motif in his paintings of the fifties and sixties. A composition whose ostensible image consists of two or three rudimentary shapes carefully placed in relation to each other and to their distance from the borders of the canvas (the paintings through the middle fifties were "wall-to-wall" in design) is actually a surface alive with complex and unique manifestations of feeling, which conflict with and modify the static image. Sometimes the ground is worked in a manner that is almost imperceptible, yet the "action" is quietly there, and the unique effects occur. One becomes aware of monotony when unworked areas are too extensive—*Icon* and *Trinity* are examples. Gottlieb's serigraphs and lithos are inescapably posterish. But works in every period illustrate the range of his manual inventiveness. *Figure* (1951) has the rough, stuccolike texture and warm tones of a wall in the tropics. *Labyrinth III* (1954) and *Blue at Noon* (1955) come close to Action paintings stabilized by a grilled understructure, in what was for Gottlieb an interval of transition. In the same period, *Composition* (1955) reaches toward the rhythmic effects of Mondrian's *Broadway Boogie Woogie*, though by different pictorial means. *Descending Arrow* (1956) experiments with the directional tensions studied by Klee, which Gottlieb had tried out in *Man and Arrow II* (1950). *Side Pull* (1956), with its calligraphy and opposing movements, is a true Action painting, exploring independently a path traversed by Hofmann. In the present decade, *Black Black* (1961), which consists of tones and thicknesses of black around a crimson core, is a romantic landscape made of two well-defined signs coupled with an amazing display of evocative paint application.

"Nature," for Gottlieb, is in the laying on of the paint; a format identical with that of *Black Black* presents an entirely different *paysage* in *Mist*, and still another in *Orb*. One of the difficulties of Gottlieb's paintings, given the conditions of contemporary art appreciation, is that reproduction reduces them to their iconic ingredients and affiliates them with trademarks; the Gottlieb "burst" featured on a car-card that advertised his exhibition came to suggest Gottlieb Products, Inc. (Museum personnel ought to be aware of these problems.)

On first seeing Gottlieb's paintings in the forties, I found his work too programmatic. My view was changed when I came across two or three paintings exciting because of their color. Those pungent, almost sinister hues could not have been figured out—they emanated from feeling and imagination. Color has continued to be Gottlieb's chief means of transporting himself into un-

known worlds. It is his instrument for enlarging consciousness; at the same time, it is a quality weighed exclusively as a visual element of the work in progress. This ambiguous use of color as simultaneously connotative and formal is basic to abstract art—it is the principle by which non-representational painting distinguishes itself from decoration. With an imaginative artist, the balancing of formal elements will inevitably evoke content, summoning up qualities associated with objects and experiences outside of art. Nature and psychology inhere in the most abstractly related visual data, unless they are trimmed out of the work by training or by doctrinal taboo. The unbidden springing up of an external or subjective physiognomy in a painting is what artists have in mind when they speak of inventing or re-creating "reality" on the canvas. A work like *Orb* carries resonances equivalent to the presence of treetops and waves. "When I work, I'm thinking in terms of purely visual effects and relations," Gottlieb said in a recent affirmation of faith. "But it's inconceivable to me that I could experience things and not have them enter into my painting." It is by this belief that Gottlieb has resisted the aesthetic dogmas and ritualized boredom of the "colorists." When his color fails (and, since its success depends on its expressiveness, it can fail), it is usually through being too readily enticing.

A sense of distance is attainable through size, as by the Pyramids or skyscrapers. As Gottlieb's imagery has contracted, his paintings have grown larger. His early canvases are all of modest dimensions; the first big picture is *Labyrinth III* (1954), a transitional work in which the gridiron of the pictograph is disassembled into linear "action" visually related to Pollock. Another big one is *Unstill Life III* (1954–56), also a foray, as its title suggests, into Action painting. In these pictures, size is offered as a substitute for the imaginative "otherness" of the primitive signs, as if Gottlieb were testing his ability —as did many of his contemporaries in their later years—to achieve statement by means of aesthetic elements alone, without straining after content through myth. Later, the large size becomes frequent, but with a return of assurance in his new iconography. His playing with the possibilities of scale in the disc-and-blot format extends from huge canvases down to the charming paintings on museum postcards of Old Masters, three by five inches, done in 1962–63. Despite the current fashion for the mammoth, *Icon* and *Trinity* are, in my opinion, much too big. Most of Gottlieb's new giants, however, achieve a remarkable retention of wholeness; this is true even of *Una*, which consists of an isolated circle of color about eighteen inches in diameter on a field of more

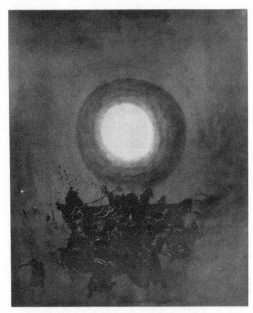

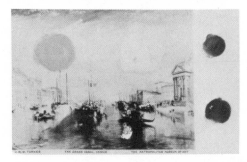

than sixty-five square feet. With their activation of color and the harmony established between the scale of the figures and the outer dimensions of the canvas, the largeness of these paintings defines the proportions of the artist's concept, instead of being a blown-up version of it.

Gottlieb's art is not of the extremist sort that attracts disciples and enemies. It has responded to its intellectual environment without attemping to overwhelm it. His paintings are not an ideological call to arms but, rather, a disciplined poetry of atmosphere, comparable in its evocation of rare climatic states to that of the later Symbolists. With Gottlieb, the search for cultural distance that is a basic project of contemporary vanguardism possesses a quieter, more mental cast than does the emotional self-alienation of de Kooning or Pollock. His is an intelligence intelligently aware of the limitations of intelligence in an epoch when all assumptions are in question. His work demonstrates that abstract art can be sufficiently charged with expressive power to prevent it from ending as mere wall decoration.

MOMA DADA

The history of Dada and Surrealism zigzags between contradictory attitudes toward art. Professing absolute radicalism, Dada split on the issue that its anti-cultural manifestations had become merely the format of another art movement. Surrealism was fragmented by its refusal to renounce its own disciplines in favor of political action against Fascism. In the forty years since these movements were at their height, the art-negating spirit of Dada-Surrealism has come to dominate the art values of the West in increasingly complex mental intrigues. A likely explanation would be that in societies of advanced industrialization and mass media the arts tend to lead a parasitic existence, and that this was first divined by the shocked generation of World War I. Under these conditions art can overcome its intellectual debasement only through an expressed hostility to art, or, at least, a show of indifference to it. In the process of re-orienting itself on this negative axis, art has lost its traditional public of devoted art lovers and has acquired a new one defined as an avant-garde by its habit of seeing art in a self-defeating context—from paintings splashed with pigment or consisting of a sheet of single-colored fabric to blinding light exhibitions or the inaudible poetry readings of original Dada. Like other revolutionary movements, Dada and Surrealism did not remake the world in their image, but they did point out that it was being remade. In any case, Dada-Surrealism has succeeded in transforming art and reconditioning the public to the arbitrary and the strange. Even modes of art most alien to Dada-Surrealist stylistic concepts, such as the "pure" art of geometrical forms or color

bands, have depended for their development on the general absorption of the Dada message that anything can be art, and the Surrealist one that poetry is the substance of painting whether represented by a nude or a curling string of lines and letters. A square within a square can exist as art today (and not as mere design as in Mondrian's lifetime) because of a public trained in acknowledging its ignorance in the face of the artist's will. The victory of Dada-Surrealist thinking has been so nearly complete as to project its values in reverse; its anti-art philosophies have turned into an aesthetic and its repugnance to the pious worship of masterpieces has brought into being Dada-Surrealist icons and holy men—for example, Man Ray's nail-studded flatiron and Duchamp, the anti-art master.

Since all advanced art in our time carries some mark of Dada-Surrealist influence, dozens of different kinds of historical exhibitions could be organized around the theme of Dada, Surrealism and their heritage. One might begin with "Dada, Surrealism and The Passionate Machine—from Picabia and Rube Goldberg to Tinguely and Psychedelic Light Shows." Another exhibition could be "Dada, Surrealism and The Mentally Extended Landscape—from Duchamp's 'Tu m'' to the Maps of Baruchello and the Pebble Beaches of Bauermeister." Or "Dada, Surrealism and Parody Paintings—from Magritte to Lichtenstein." Or "Icons of Dada and Surrealism—from Melted Watches to Stuffed Goats." A comprehensive exhibition at Knoedler's in December, 1967, entitled "Space and Dream," commemorated by a book of the same title by Professor Robert Goldwater,* marked off a large area of Surrealist poetic interest and, by playing on the ambiguity of the word "space," was able to include Mondrian, Lipchitz, Gabo, Moholy-Nagy, Pevsner and Moore alongside such heroes of Surrealism as Miró, Ernst, Magritte, Arp, Dali, de Chirico and Tanguy.

What would make an exhibition specifically Dada-Surrealist, as distinguished from the packaging of artifacts by artists allied at some time or in some respect with Dada and Surrealism, would be the retention of the spirit of cultural estrangement and/or collective hostility of the movements themselves. The aesthetics of formal adulteration and metaphorical reality (actual objects in painted surfaces, paintings that fool the eye or deny painting, erotic machines, impossible combinations of images), which Dada-Surrealism developed in opposition both to "pure" art and to paintings based on nature, is founded upon an ethical antagonism to the tranquil enjoyment of art in this

* Walker & Company, New York, 1968.

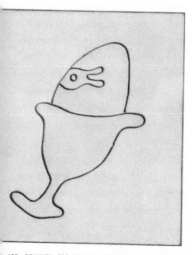

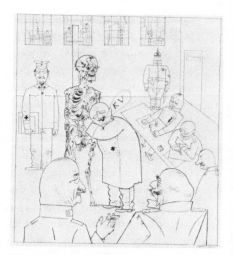

GEORGE GROSZ, *FIT FOR ACTIVE SERVICE*, 1918, PEN, BRUSH, INDIA INK,
14⅝ X 13⅜ IN. COLLECTION THE MUSEUM OF MODERN ART, NEW YORK

ARP, *DRUNKEN EGG HOLDER,* 1928, STRING AND OIL ON
WAS, 26 X 21⅝ IN. COLLECTION MME. M. ARP-HAGENBACH,
L, COURTESY THE MUSEUM OF MODERN ART, NEW YORK

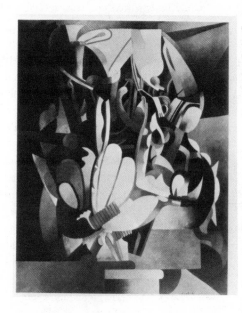

CIS PICABIA, *I SEE AGAIN IN MEMORY MY DEAR UDNIE,* 1913,
N CANVAS, 8 FT. 2½ IN. X 6 FT. 6¼ IN. COLLECTION THE MU-
OF MODERN ART, NEW YORK, HILLMAN PERIODICALS FUND

epoch of upheaval. Dada and Surrealist stylistic mixing serves this ethical purpose and is justified by it as a new aesthetic program; for instance, to produce a sadistic effect, a headless female dummy is modelled in volume and flesh tones within a serene composition of plane surfaces; "I wanted to put painting once again at the service of the mind," wrote Duchamp, invoking by "again" the traditional relation between art and philosophy. "I was endeavoring to establish myself as far as possible from 'pleasing' and 'attractive' physical paintings." Space amalgamated with dream, when space is considered as a formal problem in painting, but not also as intellectual, emotional and cultural distance, becomes merely another professorial or exhibitor's category.

The exhibition entitled "Dada, Surrealism and Their Heritage," at the Museum of Modern Art, was not an exhibition of Dada and Surrealism but a selection of works by Dadaist and Surrealist artists, plus works related to them by style or method; not a trace of tension was generated between the exhibition and its spectators. Indeed, the show created exactly the opposite effect, and all evidence indicates that this was intentional. The exhibition was designed to salvage the art residues of Dada and Surrealism while laying once and for all the radical ghost introduced by these movements into the art of our time. If this could be accomplished, the creations of the past fifty years could be regarded as retrospectively tamed and ready for peaceful consumption.

Consisting of more than three hundred items, including small, tastefully chosen exhibits of Duchamp, Arp, Miró, Dali, Magritte, Ernst, Giacometti, Masson, Man Ray, Matta, Picabia, Schwitters, Picasso, Cornell, Tanguy and Gorky, the show was a paean to established avant-garde painting and sculpture, accompanied by a careful, systematic bleaching of their philosophical, psychological and cultural content. Paintings, prints, collages, constructions, assemblages historically identified with nihilism, provocative demonstrations, scandal and insolence took on a presence not different in kind from that of other works generally on display in the Museum. In a season marked by a succession of political and social crises, including arson in the cities and students battling the police, "Dada, Surrealism and Their Heritage" was a springtime oasis of lyricism, fantasy, orderliness and good taste. Apparently, time had relegated the tumult of the studios and cafés to the noiseless realm of the history of forms; Dada and Surrealist works had ceased to work, and the "heritage" of these movements had become the company they keep in the Museum —that is, the heritage of Dali's limp watches is Oldenburg's soft typewriter,

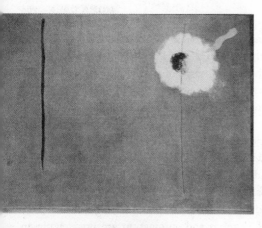

JOAN MIRO, *PAINTING*, 1927, OIL ON CANVAS, 38¼ X 51¼ IN. PRIVATE COLLECTION, COURTESY THE MUSEUM OF MODERN ART, NEW YORK

MAX ERNST, *THE ELEPHANT CELEBES*, 1921, OIL ON CANVAS, 49¼ X 42 IN. PENROSE COLLECTION, LONDON, COURTESY THE MUSEUM OF MODERN ART, NEW YORK

ARSHILE GORKY, *AGONY*, 1947, OIL ON CANVAS, 40 X 50½ IN. COLLECTION THE MUSEUM OF MODERN ART, NEW YORK, A. CONGER GOODYEAR FUND

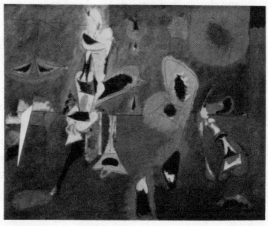

that of Schwitters' junk building the "combines" of Rauschenberg. This paci-
fication of the two most unruly areas in the entire history of art carries the
implicit promise—and this is the basic message of the exhibition's catalogue—
that modern art has at last been restored to order and will henceforth confine
itself to its own affairs and leave "life" to politicians and philosophers.

A museum director with a veneration for Dada and Surrealism, or for his-
torical fact, might have attempted to produce some kind of equivalent to the
events or environments into which Dada and Surrealist exhibitions incorpo-
rated paintings and objects, and for which numerous models exist in the texts;
conventional as it was, the "Fantastic Art, Dada, Surrealism" exhibition pre-
sented by the Museum of Modern Art in 1936, besides having the advantage
of novelty (the techniques of paste-up and automatism are now taught in
kindergartens), made at least the token gesture of framing a front page of the
New York *Evening Graphic* that illustrated a choice episode in the Peaches
Browning case. Dr. William S. Rubin, the new curator of the Museum of
Modern Art, who organized "Dada, Surrealism and Their Heritage," took,
however, a strict position against any horseplay with films, noise, disorder or
surprises that might have placed Dada and Surrealist art works in their histori-
cal setting; the closest his exhibition came to it was a reconstruction of Dali's
rainy taxi in the Museum's garden. While eager to cull from Dada and Sur-
realism paintings acceptable to the taste of the sixties, he wanted nothing to do
with the actuality of those movements. His aim was not to restore the social
and psychological context of the works but, on the contrary, to dissolve it and
to shift the works themselves into other categories of appreciation. In his opin-
ion the philosophical, political and poetic insights of the Dadaists and Surreal-
ists, when not irrelevant to painting, were positively detrimental to it, and for
the sake of the paintings themselves these early associations had best be for-
gotten, as if they came from a bad neighborhood.

Dada and Surrealism, Rubin found, were guilty of the essential flaw that
they considered paintings to be vehicles of thought and imagination "but not
worthy of delectation in themselves." To Rubin this repudiation of aestheti-
cism is equivalent to voluntary abdication from art itself, and he cites the anti-
art pronouncements of Dadaist and Surrealist artists as evidence that the
movements themselves had cleaned the slate of any aesthetically significant
notions, as if their negative outlook had not inspired the original works that
had fallen into his hands. In regard to art, Rubin believes, history had con-
demned Dada and Surrealism in advance. "The . . . concern of these

movements with philosophy, psychology, poetry and politics," he writes in the catalogue, "stamped the art they encouraged with a character much in contrast to that of prevailing avant-garde ideals." By these "ideals" Rubin means something he calls "modernist abstraction," in which the rule is for each art to confine itself to a preoccupation with those elements peculiar to it—painting with color and space, poetry with words. This is a notion conceived by the Symbolists and considered radical in the 1890's; both Gide and Valéry have explained the collapse of Symbolism by its "purity," that is, its detachment of aesthetics from ethics. Denying the ideals of art for art's sake, the Dadaists and Surrealists were, by Dr. Rubin's logic, left without aesthetic direction: "They fostered activities in the plastic arts so variegated as almost to preclude the use of the terms as definitions of style." To Rubin, the result approaches chaos, since none of the Dada-Surrealist modes of creation, from parody to biomorphic sculpture, has, in his opinion, any genuine relevance to modern art, i.e., "modernist abstraction." He praises Arp, for instance, as the last sculptor in a tradition that goes back to the Greeks, while instructing the reader that the "best sculpture of recent generations has derived from another tradition," one having to do with "space-enclosure." (By this measure, Dali's water-soaked taxi becomes a formal masterpiece.)

Obviously, Rubin would have preferred that Dada and Surrealism had never existed, but since the works were there he was prepared to take them in charge and arrange them according to their merits. Art values, he is convinced, were embodied in Cubism at the time Dada and Surrealism arose, and the creations of Duchamp, Ernst, Magritte and the others are aesthetically valid to the extent that they conform to Cubist principles. For instance, Ernst conceived of *frottage* (rubbing) as a device for releasing images of the unconscious, and succeeded in bringing to light fabulous birds, monsters and landscapes. Rubin, however, is not interested in divination, and though Ernst, like other Surrealists, repudiated Cubism, what saved him as an artist, in Rubin's eyes, was his absorption, willy-nilly, of Cubist concepts. His magical pictures, Rubin explains, were an echo of "the late Analytic Cubism which that same year was undergoing a not unrelated metamorphosis in the hands of Masson." This amounts to subjecting Ernst himself to art-historical *frottage*—rub him and you get Cubism.

Practicing a kind of post-Freudian art history, Rubin discovers in the Dadaists and Surrealists qualities which they did not intend, or which they intended to shun: " 'Anti-art' depended from the first on the very presence of the 'pure

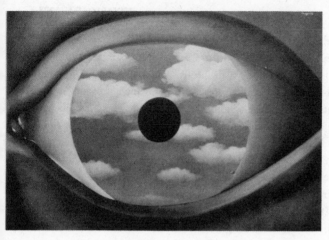

RENE MAGRITTE, *THE FALSE MIRROR*, 192[
OIL ON CANVAS, 21¼ X 31⅞ IN. COLLECTIO
THE MUSEUM OF MODERN ART, NEW YOR[

YVES TANGUY, *NOMBRES IMAGINAIRES*, 195[
39 X 32 IN. PIERRE MATISSE GALLERY
NEW YORK

ALBERTO GIACOMETTI, *THE PALACE AT 4 A.M.*, 1932-33, CONSTRUCTION IN WOOD, GLASS, WIRE, STRING, 25 X 28¼ X 15¾ IN. COLLECTION THE MUSEUM OF MODERN ART, NEW YORK

O PICASSO, *AT THE END OF THE JETTY*, 1937, AND INK, 11¼ X 8¼ IN. COLLECTION MR. & MRS. V. EASTMAN, NEW YORK, COURTESY THE MUSEUM MODERN ART, NEW YORK

KURT SCHWITTERS, *FEC. 1920*, COLLAGE, 9¾ X 7⅛ IN. COLLECTION THE MUSEUM OF MODERN ART, NEW YORK, COURTESY MARLBOROUGH-GERSON GALLERY

painting' against which it reacted, and it incorporated more of that 'art-art' than its authors knew." These artists-in-spite-of-themselves could provide a rich subject for a contemporary Molière. Rubin goes a long way toward the comic realization of the aesthetically rehabilitated Dadaist in his formal analysis of Duchamp's painting on glass, *The Bride Stripped Bare by Her Bachelors, Even*. Passing beyond the "love machine" subject of Duchamp, Rubin considers the glass itself as a transparent "field" through which objects on the other side can be seen as in a realistic painting, so that the images on the glass are suspended in "the illusion of the space of the room." Obviously, the same disposition of the "picture plane" and deep space transforms every store window with a sign-painter's figures on it into an equivalent of *The Bride*—in the end it is Duchamp who has been stripped bare by Rubin's formalist appreciation.

In isolating the art in Dada and Surrealist works from their imaginative and theoretical context, the Museum of Modern Art presentation does not hesitate to tear the works apart in order to extract the "art-art" and transfer it, by situating the works in a preconceived scheme, to a hypothetical realm of "delectation," undisturbed by the artists' ideas. A similar dissection of art since the Second World War establishes the "heritage" of Dada-Surrealism as works in which an evolved "modernist-abstract" groundwork is magnified and the superfluous poetic roots are shrunk or sterilized. "Today," Rubin writes, "we are able to see how much originality these [Abstract Expressionist] pictures contain despite debts to Surrealism." In Rubin's vision of twentieth-century painting, Dada-Surrealism was an interruption in the steady evolution of abstract art toward purified self-consciousness. For some thirty-five years, this aberration confused the true issues of art by its political and mythmaking chatter. In the fifties, at last, after the frenzies of Action painting (a "heritage," in Rubin's view, of the Dadaist gratuitous act) had subsided, the authentic avant-garde was able to reassert itself. Dada and Surrealism are dead, and the verdict of history, delivered through Dr. Rubin, is that "it appeared by 1955 as if the entire Dada-Surrealist adventure was a kind of anti-modernist reaction situated parenthetically between the great abstract movements prior to World War I and after World War II." Rubin is, however, willing to register the dissent represented by the emergence of some younger neo-Dadaists, such as Rauschenberg and Johns, who anyway have freed themselves of anti-art ideas and are dedicated to good painting. In sum, the "Dada, Surrealism and Their Heritage" exhibition is a funeral celebration, ac-

companied by a call to order under the banner of classroom aestheticism. That the Museum comes forward in this pageant as the militant representative of the genuine vanguard of the twentieth century, lecturing reactionaries such as Picabia, Duchamp and Breton about avant-garde ideals, is not without its Dadaist flavor. As Tzara pointed out in 1922, "the true Dadaists were against Dada."

Armed with his anti-anti-art interpretation of art since the Great War, Rubin organized a pleasant show reflecting two principles of choice. One is the "modernist abstraction" aesthetics we have described, which weighs relations of figure and ground, placement, color, handling of edges, and so on—in sum, the principles of modernist good design. From this point of view, the exhibition was thoroughly successful. Most of the items in it passed the test of good design. In the interests of historical accuracy one is compelled to observe that there was too much good design. The quality of junkiness and what Kenneth Burke called "organized bad taste" courted by Dadaism and Surrealism was played down to the degree of achieving an exhibition that was a model of gentility. With very few exceptions, notably the *"poupées"* of Hans Bellmer and Dali's *Le Grand Masturbateur*, the selections were, if not delectable, at least discreet and respectful. The exhibition was loaded with icons of avant-garde playfulness, from word-image games to Oppenheim's fur-lined teacup. Duchamp's *Bicycle Wheel* was included (what is a purer form than a wheel?) but not his celebrated urinal (pretty enough but perhaps embarrassing as an object "worthy of delectation in itself").

The other standard of selection, which contradicts the aesthetic one, but which saves Rubin from the charge of narrow formalism, is that of the influence of the works chosen on the art of today. A favorite term of the catalogue —a rather odd one in view of Rubin's abhorrence of mysteries—is "prophetic": "Duchamp emerges as a prophet of the concerns of recent artists"; "Schwitters proved to be a prophetic artist" vis-à-vis Rauschenberg. The exhibition juxtaposed art born out of art—for example, a wrapped object by Man Ray with a package by Christo, a target by Picabia with a target by Johns. The effect, perhaps justified, was to depreciate the originality and, in some instances, even the authenticity, of a type of contemporary art that depends on originality for its claims. Technical innovations stemming from Dadaist-Surrealist investigations of the unknown (automatism, scraping, decalcomania) were described on wall labels in such a way as to turn them into

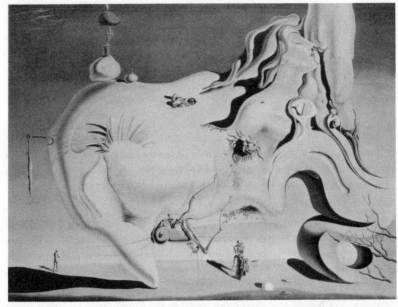

SALVADOR DALI, *THE GREAT MASTURBATOR*, 1929, OIL ON
CANVAS, 43⅜ X 59¼ IN. PRIVATE COLLECTION, COURTESY THE
MUSEUM OF MODERN ART, NEW YORK

CHRISTO, *L'EMBALLAGE DU NEO-DADA EN BOIS DE PALISSADE*, 1963, COL-
LECTION MR. & MRS. JAN VAN DER MARCK, CHICAGO, COURTESY THE MU-
SEUM OF CONTEMPORARY ART, CHICAGO

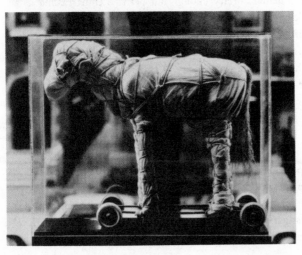

recipes for producing pictures; by following them anyone could be an artist, though readers were dutifully warned that "pure automatism, like pure accident, is inimical to art."

Determined by the dual standard of Rubin's aesthetics and his art history, the choices in the "heritage" section added up to an excursion into aimlessness. Is not the post-Surrealist Giacometti of the knife-edge portraits and walking men part of the heritage of Giacometti of the Surrealist "cages"? To Rubin, however, cages are sculptures of today, "space enclosures," but heads and men are monolithic, hence not modern, so there were no late Giacomettis in the heritage. But if Surrealism was reactionary, why should not its heritage be reactionary? On the other hand, a Dada-Surrealism show that included paintings as remote from Surrealism as the two Newmans could have included anything. If history was taken into account, how explain the total absence of America's leading Surrealist of the thirties, Peter Blume? Probably he failed to meet either the test of the Cubist "ground" or of influencing art now. Nor was notice taken of the politically left Surrealist painters of the West Coast before the war. Rubin's historical yardstick proved, in the last analysis, to be current fashion.

An item in the exhibition was an assemblage by Man Ray entitled *The Enigma of Isidore Ducasse*. It consists of a cloth package tied with rope, and is said to contain a sewing machine, an object sacred to Surrealism because of Ducasse's (the Count of Lautréamont) disjunctive metaphor about the encounter of a sewing machine and an umbrella on a dissecting table. But Man Ray's *Enigma* no longer exists, and the piece on display was a reproduction belonging to the Museum's Study Collection. For me this ersatz contrivance symbolizes the exhibition as a whole. The "enigma" of Dada-Surrealism—the endlessly negative processes it has introduced into modern art—had been replaced with a didactic equivalent, an intellectual package, mislabelled Dada-Surrealism.

No museum can be expected to welcome the thought, which often occurs to strong-minded artists, that art under certain circumstances can be odious, and that at almost any time it is what Breton called an "alibi." Nor is it the obligation of a museum to resurrect history but only to collect and display its relics. There is no more reason for an art museum to strive to restore the life of an art movement than for a natural-history museum to put artificial flesh on a dinosaur. To present art as dead is appropriate to museums, though this may

lead to questioning whether museums are appropriate to the art of this century.

But if Dada-Surrealist rancor, shock, magic, politics and black humor are put aside, why designate the exhibition as Dada-Surrealism? If Schwitters, who was never a Dadaist or a Surrealist but obviously a constructor of Cubist-inspired compositions, was to be featured but not Klee, if "spontaneity" was to be the basis for the inclusion of Gorky but not of de Kooning (exhibited with Klee in the "Space and Dream" exhibition) or Hofmann, why speak of Surrealism at all, let alone of its "heritage?" In strict, pragmatic fact, works of art are produced by individuals not movements. Unless one is prepared to acknowledge the intrinsic creative force of Dada and Surrealism in the paintings of Miró, Magritte, Giacometti, Dali, et al., why not simply present shows of their work, plus that of contemporaries whose creations are copies or variations of it. The exhibition of "Destruction Art," presented at the same time as "Dada Surrealism" at the Finch College Museum of Art, which included work by such contemporaries as Arman, Yves Klein, Les Levine, Ortiz and Tinguely, was unquestionably closer to the reality of Dada than was the ambitious academic hijacking adventure at the Modern, yet it appeared, properly, under a descriptive, rather than an art-historical, label. I can think of only one purpose for the "Dada, Surrealism and Their Heritage" exhibition—to knock out the philosophical underpinnings of modern art. The show is a remarkable, if not epoch-making, instance of a museum openly intruding into current art history as an active partisan force by posing its own conception of value and its own will regarding the future against the will and ideas of the artists it is displaying. In the Dada-Surrealist exhibition the Museum of Modern Art has become a kind of corporate artist using other people's pictures to produce its own collage and parody. This, too, is a heritage of Dada.

THE CONCEPT OF ACTION IN PAINTING

In the history of painting styles since the Renaissance, action is a mode of drawing and of handling pigment that tends to alternate with modes of still-ness. Van Gogh is active, Seurat still; Mondrian is still, Soutine active. Action in the art of the past fifty years has, however, aims much broader than style; it seeks a recasting of life, and it extends painting beyond aesthetics into issues of politics, ethics, psychology, and the future of culture. Indeed, action in twen-tieth-century art implies a repudiation of aesthetics as an objective. With Mondrian, for example, the equilibrium of tensions produced by relations of color, line, and scale is intended to evoke the intellectual state necessary for a new social order. American Action painting at its inception was a method of creation—not a style or look that pictures strove to achieve. In some instances, it was not even a method so much as an attitude, an outlook. Theoretically, the canvases of Action painters could be entirely different from one another in appearance, and in fact they have been different. Many are totally abstract; others are landscapes and figures, plus figures in landscapes and landscapes that *are* figures.

Jackson Pollock was an Action painter, and so was Hans Hofmann, and so is Willem de Kooning. But so also, or very close to being one, is Barnett New-man. These artists have shared a concept of creation based on the intuition that there is nothing worth painting. No object, but also no idea. The activity of the artist became, in their opinion, primary. In this activity, Pollock sought what he called "contact"—that is to say, a certain state in which the artist is

guided by the image he is in the course of producing, with neither object nor preconceived image as aim. But the act of the artist *might* (the "might" is essential, since one could not be certain)—the act of the artist *might* produce an image worth seeing. "I paint in order to have something to look at," said Newman. This joke reflects the sense of being surrounded by a visual void. Existing forms lack significance, and instead of pursuing objective ends the artist therefore falls back on a method of creation that invites possibilities of innovation.

Why should artists of the forties have held such a negative view? Were there not trends and directions in art that could still be developed? For instance, the problem of surface and depth as conceived by Cubism and carried forward by Mondrian? Or some aspect of color and its optical vibrations as investigated by Seurat? Formal problems such as these were the focus of nineteenth-century vanguard art movements. Confronted by new devices and industrial techniques—the camera, optical research—that were usurping the social functions of painting while providing new visual knowledge, the modernists of the last century sought to purify the formal elements of their art and to liberate those elements from utilitarian ends and from association with the way things look. Some wanted painting to be painting, music to be music, and nothing else. Others wanted to detach color, drawing, composition from nature and to use them independently to stimulate the spirit and the imagination. "Pure art" was one of the most powerful slogans of the late nineteenth century, though for every concept of pure art there was another that called for mixing forms with reality in a more direct way. This formal modernism, or modernist formalism, came to an end in 1914. "By World War I," testifies David Jones, the Anglo-Welsh poet-painter, who is one of the keenest commentators on the art of our epoch, "even academicism, let alone tradition proper, was already moribund," and the sacred words of the old aesthetics— "form," "shape," "composition," "represent"—were all in the process of shifting their inner meanings.

Modern modern art—that is, art since the World Wars—arises from the conviction that the forms of Western culture, including its art forms, have permanently collapsed. What does the collapse of forms mean? It means that while they may still be repeated, the forms of Western art are no longer capable of arousing deep feelings or affecting major experiences. They can no longer be taken as a guide or developed to a higher level. The notion that art can be vanguard in 1968 by elaborating the color theories of 1880 could

PAUL KLEE, *BENDING TAUGHT BY A STAR*, 1940, COLORED PASTE ON
PAPER MOUNTED ON BOARD, 14⅝ X 16½ IN. COLLECTION F. K., BERN

WILLEM DE KOONING, *FIGURE IN MARSH LANDSCAPE*, 1966, OIL ON
CANVAS, 30 X 25 IN. M. KNOEDLER & CO.

FRANZ KLINE, *CHARCOAL BLACK AND TAN*, 1959, OIL ON CANVAS, 112 X 82½
IN. ESTATE OF FRANZ KLINE, COURTESY MARLBOROUGH-GERSON GALLERY

JACKSON POLLOCK, *SEARCH FOR A SYMBOL*, 1943, OIL ON
CANVAS, 43 X 67 IN. MARLBOROUGH-GERSON GALLERY

occur only to the bright design students of *Art Forum*. Traditional forms
have become, in T. S. Eliot's phrase, "fragments I have shored against my
ruins"—shored, that is, as a means of slowing the flood of the new so as to find
elements of order in it. "Modern life," wrote Delmore Schwartz, comment-
ing on Eliot, "may be compared to a foreign country in which a foreign
language is spoken." He might have added, "And in which there are no
natives."

Being convinced of the collapse of forms is Axiom One of the vanguardism
of the past fifty years. It is the basis of the major moves in art, from Dada anti-
art to electronic spectacles and mixed media. The *modern* modern poet or
painter, as distinguished from the old modern artist, picks his way among the
bits and pieces of the cultural heritage and puts together whatever seems cap-
able of carrying a meaning. The Action painter does this putting together in
an original and lively way. He starts an action and observes what kind of
image it will magnetize out of the formal accretions piled up in his mind. He is
a kind of archeologist, one who digs in himself, not just among modern art
movements. Action painting is an attempt by artists to project themselves into
the present, to shake off a past that has become a mental harness. In this re-
spect, Action painting is a precursor of psychedelic and other magical moods
that also aim at a plunge into the present moment. But the present of action is
different from that of hallucination.

The general model for *modern* modern art is thus given by Jones: "A series
of fragments, fragmented bits, chance scraps, really, of records of things, ves-
tiges of sorts and kinds of *disciplinae*, that have come my way by this channel
or that influence. Pieces of stuffs that happen to mean something to me." Is
this a description of de Kooning's *Gotham News?* Of collage? Of Pop Art?
What difference does it make? All have the same cultural physiognomy and
different individual content, whether or not the works look like "chance
scraps" and "records of things," as do the "combines" of Rauschenberg. In
regard to form, Jones's key phrase concerns the *vestiges* of disciplines. There
are no disciplines, only vestiges of disciplines; no forms, only vestiges of
forms. It is vestiges of disciplines that are found in de Kooning, Pollock,
Kline, Guston, as it is vestiges of forms that constitute the motifs of Gorky
and David Smith—vestiges of the discipline of Cézanne, of Cubism, of a form
of Miró, of strokes of Monet, of a contour of Michelangelo. The Action
painter fuses these vestiges into a single vision by the intensity of his psychic
concentration in the course of painting. He doesn't know which form of the

past he is going to draw on, and he will therefore tend to draw on more than one.

The artists I have mentioned, and most consciously de Kooning, produce what I have called a "transformal" art—the only kind of art that is consistent with the recognition of the present formless state of our culture, on the one hand, and of the indispensability of form for human consciousness, on the other. The transformal art of Action painting stands between the sterile formal exercises of academic modernism and the liquidation of art into data and into aimless spontaneity. Its product is a fragment—something typically sketchy and incomplete compared with the masterpieces of the past. But this fragment, this sketch, is a succession of wholes, in that each gesture of the brush that goes into its composition is a totality in itself. One might say that an Action painting begins by being complete and develops toward being a fragment. The process was made clear in de Kooning's celebrated *Woman I*, of the early fifties, into which dozens of paintings disappeared, while the final canvas was the result of an arbitrary interruption.

In Action painting, the problem of beginning and ending, of entrance and exit—for both artist and spectator—becomes the focal question. (The opposite approach is for the artist, intending an "object in itself," to project a work from a blueprint or order it from the factory.) The fragmentary art of transformal Action painting engages itself within the fragmentary inner world of contemporary man and the fragmentary outer world of a civilization in which the cultures of all times and places are being blended and destroyed. The notion of producing formal wholes in such a situation—in a word, of formal art—is, if not an absurd illusion, an act of repression directed against the individual as he is. No matter by what technique a work is produced, it cannot constitute a whole, since the condition of the artist and the spectator must be taken into account. In the constantly disintegrating social context, the artist can, as Paul Klee said, create only "parts." And after an interval these parts, too, fall to pieces. The vision of the collapse and disintegration of forms is repeated in the art and literature of our time in thousands of metaphors, ranging from programs of the prearranged physical destruction of works of art to recognition of their inevitable deterioration in the mind of the spectator Joyce makes art out of the disintegration of words, Beckett and Ionesco out of the disintegration of action, Peter Weiss out of the disintegration of history. More than a hundred years ago, Edgar Allan Poe measured the maximum number of minutes that poetic excitement could be maintained. Du-

PHILIP GUSTON, *AIR I*, 1965, OIL ON CANVAS, 72 78 IN. MARLBOROUGH-GERSON GALLERY, NEW YOR

DAVID SMITH, *SUSPENDED CUBE*, 1937, ESTATE OF DAVID SMITH, COURTESY MARLBOROUGH-GERSON GALLERY, NEW YORK

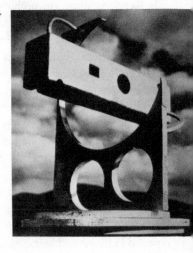

GIACOMO BALLA, *SWIFTS: PATHS OF MOVEMENT AND DYNAMIC SE-QUENCES*, 1913, OIL ON CANVAS, 38¼ X 47¼ IN. COLLECTION THE MUSEUM OF MODERN ART, NEW YORK

champ has spoken of a work's loss of aroma, which turns it into an object for academic study. In sum, paintings and sculptures have lost their character as enduring objects and have been reincarnated as *events*. This happens as well with works inherited from the past, insofar as their existence as art is concerned. The *Mona Lisa* arrives from Paris and is greeted at the dock like a movie star. She has suddenly come to life, which means that she must also anticipate periods of eclipse. In a recent book on museums, the curator of the Louvre complains that the new crowds of visitors threaten the physical survival of masterpieces. On the philosophical plane, all values are crowded into the present; i.e., into future oblivion or myth.

"Thirty years ago," declared Paul Valéry in 1935 (that would make it 1905), "it was still possible to examine the things of the world *in historical perspective;* that is, everyone in those days expected to find in the present (the present of those days) a fairly intelligible sequel and development of the events that had taken place in the past. Continuity reigned in their minds. . . . What made up civilization was quite easily linked with the past. But during the thirty or forty years we have just lived through, there have been too many innovations in every field. There have been too many surprises, too many things created or destroyed; and too many great and sudden developments have brutally interrupted . . . that continuity I spoke of. More and more numerous problems every day, perfectly new and unexpected problems, have arisen on all sides, in politics, in the arts, in science." This was written before the Second World War, the collapse of France, the discovery of nuclear weapons, and the emergence of the United States as the world's great power. With these developments, the link between the present and the past has grown infinitely weaker. It is this aggravated situation that Action painting has confronted with its techniques of evoking the present. "Since henceforth," Valéry said in another discussion, "we must deal with the *new*, of the irreducible type I have mentioned, our future is endowed with *essential unpredictability*, and this is the only prediction we can make." Valéry, too, decided that art was action, in which inherited forms had no function but to provide an arbitrary resistance calculated to heighten the concentration of poetic energy. Art is an act of the mind in which the body has its part. Valéry describes how one of his most renowned poems originated in the rhythm of walking. Bad art, he decided, is art that arises out of the principle of *"least action."* This standard, properly understood, could serve as a guide in contemporary art criticism.

That culture has collapsed carries radical implications. Collapse is taken for granted by revolutionists of both the left and the right. Both foresee the need for reshaping life as well as for replacing social institutions and disciplining the arts. In the breach of cultural continuity, radical politics sees the end of history and the beginning of the reign of an Idea. The avant-garde artist is also aware of the inner collapse of culture, and he, too, is a radical who demands a new kind of life and a new kind of art. But the artist cannot give himself to political Utopianism. He knows that in the reign of the Idea, whether it be in Plato's Republic or Stalin's Russia, the imagination is outlawed and the free artist is treated as superfluous and a nuisance.

Thus, avant-garde art since the First World War has kept shifting its position along the frontiers of politics. At times, as was true of the Dadaists and Surrealists, it has produced parodies of political action. At other times, as with the Social Realists, it has conceived of itself as a political weapon. In American postwar art, Action painting became a mythical substitute for the myth of the American social revolution. Political relations are a key quantity in postwar modernism.

The outlines of art as action began to emerge in the nineteenth century. Marx speaks of the liberation of work, and defines free work as work for the sake of the worker, as distinguished from work for the sake of the product. In this idea, which puts creation above the object, whether artifact or commodity, Marx anticipates the thought of Klee and of the Action painters—a thought that Jones beautifully formulates in his concept that in art "one is trying to make a shape out of the very things of which one is oneself made." In Marx, Klee, Jones, we have entered a dynamic world dominated no longer by things but by the activities of men. Beyond Marx, the idea of art as action looks back to Hegel and his concept that truth does not reside in essences but is brought into existence by historical events.

Art as action took on body when the First World War revealed the chaos of the West. It reached the level of philosophy in the writings of Valéry and Klee. Is the negativity of the postwar outlook still relevant? Hasn't it become desirable in the sixties for art to turn once again to formal disciplines? The issue, as Jones pointed out fifteen years ago, is not a matter of choice. For the problems of art to reach an objective resolution in new forms, said Jones, a radical change would have to have occurred "not in our own inclinations or wishes but in the actual civilizational situation." A new tradition would have had to arise, "for no 'external discipline' can be real, invigorating, and inte-

BRADLEY TOMLIN, *No. 11 — 1952-53*, COLLECTION THE METROPOLITAN MUSEUM OF ART, COURTESY BETTY PARSONS

ALEXANDER LIBERMAN, *GOD, 1*, 1959, INK AND GOUACHE ON PAPER, 26⅛ X 40⅛ IN. THE SOLOMON R. GUGGENHEIM MUSEUM

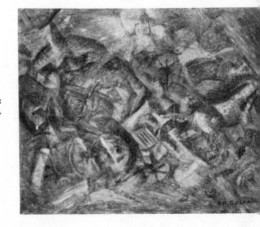

CARLO CARRA, *JOLTS OF A CAB*, 1911, OIL ON CANVAS, 20⅞ X 26½ IN. COLLECTION THE MUSEUM OF MODERN ART, NEW YORK, GIFT OF HERBERT AND NANNETTE ROTHSCHILD

grating unless it comes to us with the imperatives of a living tradition." But who will claim that a new civilization has been achieved in the past twenty years?

Such, in outline, is the cultural-historical background of Action painting as a philosophical development in American art—one might say the first philosophical development, since never before had there been in the United States such a concentration of informed reflection, subtlety of analysis, enthusiasm, and technical insight and experience as in the milieu of artists, mostly self-educated, like Gorky, de Kooning, Pollock, Rothko, Matta, Baziotes, Still, Newman, Gottlieb, Reinhardt, Tomlin, Guston, Lassaw, Motherwell, David Smith, Nakian, Kline, Hofmann, Steinberg, Hare. Human action is form-making. It is imitative but inevitably original. It is the common denominator that animates work, combat, and sign language—a primitive human base to fall back on, and the means for constituting an order in individuals and society. It embodies decisions in which one comes to recognize oneself as well as what is useful or destructive. Action is also a means of probing, of going from stage to stage of discovery. If someone asks me a question, my answer will come from the surface of my mind. But if I start to write the answer, or to paint it, or to act it out, the answer changes. What is being done provides a clue to another thought. The materials I use—words, paint, gesture—become the means for reaching new depths, for unveiling the unexpected. Thus, the activity that transforms materials is essential to thinking. It is for this reason that a work of art that carries out an idea conceived by someone else—as in commercial art, or art made under the intellectual prodding of dealers, critics, or cultural managers—is bound to be inferior to art brought into being through a continuous passage between the mind and the hand of a free individual.

Action painting is philosophical art, but art is not obliged to be philosophical; it has the privilege of being commonplace, obvious, boring—even idiotic. On the other hand, it has not the right or the power to coerce our interest by pretending to participate in a grandeur that at the given moment it does not possess. The notion that art deserves respect as art no matter what it is doing is bait set out in the interests of a profession.

I do not believe that art needs to be defended any longer against hordes of howling philistines intent on destroying it. The situation has changed, and the stockade syndrome, the feeling of holding out against the philistine-redskins,

has become an anachronism. Today, the redskins are inside the stockade whooping it up for art, and the more extreme the better. The issue in art today is still the question of creation—a question now much sharpened, compared with the situation in the forties, by the merging of the art forms into the mass media and design.

This new aspect was brought to the surface by Pop Art, an offspring of Action painting in that it capitalized on the latter's lack of respect for the integrity of existing art forms. Action painting repudiated these forms in picking up "vestiges of disciplines" and recasting them for its own purposes; as de Kooning once put it, in a meeting at the Artists Club, "we are all working on the basis [i.e., the formal basis] of ideas in which we no longer believe." Pop Art rediscovered the conventional forms of art in their daily use in the street and the marketplace, and ironically demonstrated that the only difference between the commercial media and art was one of location. One of the pioneers of Pop Art declared that art is anything in an art gallery or a museum. This is an oversimplification: in order to enter a gallery or a museum, a work has to be linked to certain precedents or comply with certain prejudices concerning the history of form.

Thus, Pop Art developed an aesthetic of displacement; the conversion of beer cans and comic strips into art is carried out through changes in the scale and color values of the commercial originals, and through sly references to past art, all these being introduced not for their own sake but as a bow to the etiquette of so-called high art. In turn, masterpieces of the past are converted into Pop, as in Lichtenstein's parodies of Cézanne and Mondrian. In this procedure, form is an insiders' joke, which the public is induced to take seriously because of its logical consistency.

None of the maneuvers of Pop has a radical content, in the sense of carrying a demand for a new kind of life. Pop Art represents the stasis reached by American art with the decline of Action painting into a style in the late fifties. But Pop Art is hospitable to radical content. Indeed, it is the art mode most favored by leftists in Europe and Latin America. In the United States, certain Pop artists—Oldenburg, Segal, Rosenquist, Red Grooms, Oyvind Fahlström, Peter Saul—have understood that an indispensable ingredient of avant-garde art, if it is not to degenerate into parody, camp, or schoolroom art-history demonstrations, is social dissent. Cool, or non-rebellious, avant-gardism is an absurdity of the modern art museum and university art department. It rests on a passive faith in the notion of progress; it assumes that human life will be

steadily improved without the intervention of the imagination and that art will progress by an evolution applying exclusively to art forms.

Pop is traditional in regard to form; thus its rebellion tends to take on the character of the radicalism of the thirties. Oldenburg's *Models for Monuments* conveys with lyrical *élan* the essence of absurdity in the functions and physical features of the contemporary metropolis. Segal and Red Grooms provided the most effective items in the recent anti-war exhibit at the New School. In their paintings and collages, Fahlström, Rosenquist, and Saul have attacked American foreign-policy adventures. This is social action by a mode of art that is not itself active.

In emphasizing the creative act rather than the object created, Action painting, or—by the testimony of Allan Kaprow—the *idea* of Action painting, led logically to the Happening. Action painting is ambiguous; it asserts the primacy of the creative act, but it looks to the object, the painting, for confirmation of the worth of that act, and for clues that will lead to beginnings of new paintings. Action painting is subjective, yet it is bound to a *thing*, even though a thing in process. In the end, the action results in an artifact, which, as everyone knows, takes on a life of its own; it enters into the art market, is acquired as a treasure, is displayed in museums as a contribution to twentieth-century culture. Action painting does not escape the law of the fetishism of commodities, by which Pollocks, for example, have carried on all kinds of magical shenanigans—such as becoming the parents of Nolands and Olitskis long after the artist himself was hurled into his violent grave. As in all art, there is inherent in Action painting a temptation to chicanery. Presumably, the artist carries out the action in order to constitute a self. But this act, equivalent to an experience of love or warfare, is repeated on canvas after canvas, presented in frames, and floated on the market. Allan Kaprow, who has a penetrating understanding of the art world, realized that once the Action painting had left the seclusion of the studio the old art game was going on as usual.

Happenings can be seen as an attempt to advance or modernize Action painting by severing the act from the object, i.e., the painting. With the object out of the way, all kinds of leftover attitudes seem to be cleaned up. In particular, the formal essences still hovering over the rectangle of the canvas and over the color chart are given the *coup de grâce*. The Happening, like its twin, Pop Art, carries to a logical conclusion the offhandedness of Action painting in regard to the "vestiges of disciplines" inherited from the old modern art of prewar Europe.

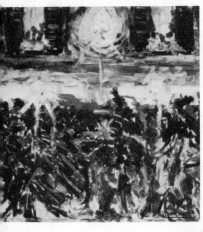

UMBERTO BOCCIONI, *THE RIOT*, 1912-13, OIL ON CANVAS,
19⅞ X 19⅞ IN. COLLECTION THE MUSEUM OF MODERN ART,
NEW YORK, GIFT OF HERBERT AND NANNETTE ROTHSCHILD

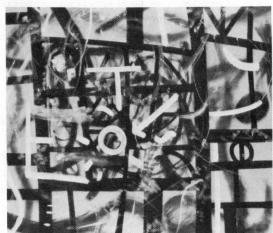

OOLPH GOTTLIEB, *BLUE AT NOON*, 1955, OIL ON CANVAS,
) X 72 IN. COLLECTION WALKER ART CENTER

CHARLES FRAZIER AND ALLAN KAPROW, *GAS*, A HAPPENING, BLUFFS
ABOVE SEA, FIRE TRUCKS, SQUAD CARS, RED FLASHERS ON, LIGHTS,
INTERCOMS, BULLHORN INSTRUCTIONS, SEEING EYES, BLACK
MOUNDS ON BEACH, ROCKETS RELEASED, FOAM POURING DOWN
CLIFF PAST MOUNDS INTO WAVES, CROWD PASSING, INTERVIEWS

In art, however, it is always a mistake to push a concept to its logical conclusion. Art comes into being not through correct reasoning but through uniting contradictions of reason in the ambiguities of a metaphor. To remove the object and make the artist's action into the work of art is to bring the artist face to face with the audience. But the audience is the personification of the art market; in a Happening the dubious social aspect of an Action painting is all there is. If *Blue Poles* or *Nude Descending a Staircase* is an event, it is an event that can be repeated at different times in persons of different conditions and stages of development. In contrast, a Happening necessarily accepts the audience as it is, in its collective mood of the moment, and makes no demands the audience cannot immediately fulfill. Ultimately, there is more for the individual to "perform" in examining a Hofmann or a Kline than in joining a Kaprow team pushing furniture through the streets.

There are many aspects of Action painting that still require clarification, such as the ancient relation of action to individual identity and to change of identity, as well as the difference between action as practiced by Pollock or de Kooning or Hofmann and the automatism and free association of the Surrealists. The Action painter does not, like the Surrealist, begin with an image, nor does he proceed by the association and combination of images. From his first gesture on the canvas, be it a sweep of yellow or the figure 4, he establishes a tension upon the surface—that is to say, outside himself—and he counts upon this abstract force to animate his next move. What he seeks is not a sign representing a hidden self, the unconscious, but an event out of which a self is formed, as it is formed out of other kinds of action when those actions are free and sufficiently protracted. It is in this sense that Action painting could be said to break down the barrier between art and life—not by merging art into the environment, as in Pop and Happenings, but through engaging in art as a real (that is, total) activity.

Surrealism never lost its character of a *collective* movement, and all collective movements are held together by ritual and ideology. Its articles of belief were repeated in manifestoes and statements of faith paying tribute to the irrational. Action painting was never an ideology, and no one adhered to it strictly. Indeed, no one would have known what "strictly" meant. Still, many painters and sculptors found its insights to be pertinent, and still do. I read, for instance, on the opening page of a 1968 issue of *Cimaise*, "The act is creation. It contains the entire nature of the artist. It is independent of the will and

of control," and so on—insight, commonplace, and error all mixed together.

The aim of vanguard art is to build a new kind of life in an epoch in which forms have collapsed or turned into purposeless restrictions. Some people deny this ABC of advanced art; they believe that art is carrying on business as usual, that de Kooning or Newman or Judd is engaged in the same enterprise as Grünewald and Rembrandt—the enterprise of building a system of forms for the edification of an ideal spectator who lives only for art. For such a hypothetical spectator, the real events and transformations of his time are surmounted by a bridge of artifacts on which he can lift himself out of the world. This perfect art lover is an amusing personage of fiction, customarily identified with the eighteen-nineties. Perhaps he existed in that celebrated decade, or came close to existing. The aesthete today, however, is a specialist who has adopted his supra-historical aestheticism for professional reasons; like specialists in other fields, he wants to limit the substance of his study in order to be able to deal with it more effectively.

But art is an activity that engages the entire being of individuals—not a set of skills employed in order to provide wall decorations for penthouses or public bomb shelters. The aesthetic avant-garde is potentially the cultural nervous system of the political avant garde, although, as I have noted, a theoretical and physical convergence between them is a menace to art. The advantage of the artist over the political radical is that he can create a world of symbolic signs and perfect himself by action in it. He can build his Utopia now, in the present, as Mondrian did, and he can protest now, as the Dadaists and Surrealists did. When the moment of social action arrives, he can transfer his energies from the symbolic world to the world of real struggle, as did the painters and sculptors who fought in Spain. Thus, art can be action—in the half-fictional world of history or the half-real world of the imagination. Or it can be a sanctuary. But whether art seeks action or release from action, the purpose of the artist in regard to the works themselves is doomed to be defeated by the social process that transforms his creation into an artifact hanging as a trophy on the wall of the collector or acquired by an institution as an educational datum. In sum, the reality of art remains a subjective reality, the reality of creating it. All its other attributes belong to sociology and mass psychology. To repeat Duchamp's dictum, a work of art has a short life. Most people make its acquaintance as a corpse.

Art has its official pallbearers, charged with removing works as quickly as

possible to their place in the cemetery. It is not, however, the function of criticism to make the life of the work of art still shorter. Works of art need to be continually resurrected through new enactments of their meaning by artists and through new encounters in the minds of spectators. It is through the action of living imaginations that the dying of art, which nothing can prevent, is overcome in a constant renewal.

PHOTOGRAPHERS' CREDITS

Oliver Baker, pages 69, 221, 225; Maurice Berezov, 129; Rudolph Burckhardt, 29, 39, 182, 186, 194; Geoffrey Clements, 85, 86, 103, 110, 151, 160, 166; Friedman-Abeles, 163; David Gahr, 25; Sherwin Greenberg, McGranahan & May, Inc., 180, 183, 186; Shunk Kender (Paris), 27; Paulus Leeser, 160, 215; Mathews, 110, 155, 210, 218; Donn Moir, 135; Peter Moore, 151, 153, 225, Hans Namuth, 163; O. E. Nelson, 64; R. Petersen, 25, 34, 37, 104, 108, 110, 121, 133, 135, 138, 169, 180, 197, 203, 221; Eric Pollitzer, 51, 52, 121, 141, 197, 215; John Reed, 70; David Van Riper, 147, 149, 210; Walter Rosenblum, 169; John D. Schiff, 106, 207; Aaron Siskind, 193; Adolph Studly, 215; Soichi Sunami, 39, 61, 69, 163, 166, 169, 203; Charles Uht, 43; John Veltri, 133; Dietrich Widmer (Basel), 201.

ACKNOWLEDGMENTS

My thanks to *The New Yorker* in which the chapters of this book appeared with the exception of "Art and Its Double," which appeared in *Preuves* in France; and to *Art News* magazine for the plates on pages 35, 36, 53, 54, 71, and 72.